photo idea index:

People playing, working, hanging out and acting up in both candid and created settings.

people

People playing, working, hanging out and acting up in both candid and created settings.

photo idex: index

people

JIM KRAUSE

HOW
BOOKS

CINCINNATI, OHIO
www.howdesign.com

For more excellent books and resources for designers, visit www.howdesign.com.

14 13 12 11 10 5 4 3 2 1

Distributed in Canada by Fraser Direct
100 Armstrong Avenue
Georgetown, Ontario, Canada L7G 5S4
Tel: (905) 877-4411

Distributed in the U.K. and Europe by David & Charles
Brunel House, Newton Abbot, Devon, TQ12 4PU, England
Tel: (+44) 1626-323200, Fax: (+44) 1626-323319
E-mail: postmaster@davidandcharles.co.uk

Distributed in Australia by Capricorn Link
P.O. Box 704, Windsor, NSW 2756 Australia
Tel: (02) 4577-3555

Cataloging-in-Publication data is on record at the Library of Congress

Edited by Amy Schell
Designed by Jim Krause
Art directed by Grace Ring
Photography by Jim Krause
Production coordinated by Greg Nock

Big thanks to Laurie, Gene, Sophia, Evan, Juliet, Katherine, Brian, Diane, Jason and Victoria

About the Author:

Jim Krause has worked as a designer, illustrator and
photographer in the Pacific Northwest since the 1980s.
He has produced award-winning work for clients large and small and is
the author and creator of ten other titles available from HOW Books:

Idea Index, Layout Index, Color Index, Color Index 2,
Design Basics Index, Photo Idea Index, Photo Idea Index: Places,
Photo Idea Index: Things, Type Idea Index and *Creative Sparks.*

WWW.JIMKRAUSEDESIGN.COM

Table of Contents

Introduction

If you've already flipped through the pages ahead, you've probably noticed that this book isn't a lot like others about photographing people. The most obvious difference between *Photo Idea Index: People* and other books in this category is that most of the others feature dozens or hundreds of different people in their images. This book, on the other hand, contains just three recognizable characters: a woman, a man and a young girl (four, if you include the fellow appearing with one of the above-mentioned models in chapter 8). Why just three main characters? Because this book is not a showcase of people pictures; **this is a book of ideas.** *Photo Idea Index: People* offers—through pictures and text—hundreds of creativity-boosting ideas that can be applied to the photos you take of friends, family members and clients. And if you ask me, I'd say **there's no better way of demonstrating the power of creativity than by showing how much can be done with how little.**

Photographers face a huge range of choices when shooting a portrait. In this book (as well as in its two companions, *Photo Idea Index: Places* and *Photo Idea Index: Things*) these choices are never regarded as things the shooter *has* to consider. On the contrary, these choices are presented as things we *get* to consider. Things like the environment in which we choose to shoot; the attire, expression and actions of the model(s); the camera's settings; the type of lens used; the way light is handled; and the digital finalization of our images. This book is designed to help photographers consider—and expand upon—options such as these whenever they take a picture.

Some of the idea-generating prompts are contained in the text that appears on the last two pages of each chapter (more on that, ahead). Mainly though, it's each section's photographs that are meant to provide the viewer with ideas. How do the photos offer ideas? Simply by being there, ready to interact with the reader's eye and mind to produce a series of "what if" questions. For example, take a look at the image on the next spread. The reader is encouraged to look at this photo of a woman in a black dress and ask a series of exploratory questions such as these: "Why is this well-dressed woman lunging at the camera? Aren't people supposed to pose elegantly when they're dressed formally? What if I encouraged my subject to act up the next time I am snapping a portrait? What if I asked her to jump, spin, balance on one foot or juggle a set of bowling pins? How should I handle my scene's backdrop? What about that downtown parking garage, or the all-glass office building next to it? How about taking advantage of the scene-bending perspective of my fisheye lens? What if I were to zoom in on the subject, tilt the scene or frame the composition in a strongly horizontal or vertical format? Should I use Photoshop to convert my image to monochrome? How about applying more extreme digital effects?"

Text relating to the images appears at the end of each chapter. The text has been intentionally separated from the pictures so the viewer won't be affected by the captions when looking to the images for brainstorming prompts. This text offers additional creative ideas, anecdotal stories related their capture, camera and lens information and

notes concerning the photos' digital processing. You'll notice the camera and lens info relates mostly to digital SLRs and their lenses. If you shoot with an SLR, take note of these details and experiment by applying them to images of your own. If you don't own an SLR, and shoot mainly with something like a pocket digital camera, don't worry; every photo in this book contains ideas that can be applied to any type of camera (even a cell phone camera).

Photoshop is my software of choice when it comes to finalizing images. And since it's also the software used by more photo professionals worldwide than any other, I've chosen to refer to it exclusively in the book's text to describe digital treatments. Readers with a fundamental understanding of Photoshop should have little or no trouble understanding the straightforward treatments, effects and filters I've applied to this book's images.

It was a lot of work—and a lot of fun—shooting and sorting the photos for this book (a process that lasted nearly three years). I'd like to express my sincere thanks to the three main characters that appear in its photos: Laurie, Gene and Sophia. Each was as uncomplaining, enthusiastic, fearless and full of great ideas as any model I could dream of photographing. And thank *you* for picking up a copy of *Photo Idea Index: People.* I hope the ideas contained in its photos and text mix well with your own resourcefulness and creativity.

1

Portrait Possibilities

What is a portrait? Is it a photo of a well-dressed person sitting with folded hands, combed hair and a smile on her face? Sure. But that's just one kind of portrait. And it's been done before. Many times.

Wouldn't you rather shoot portraits that not only look good, but also look... different? It's not that hard to do—especially if you begin each photoshoot by asking yourself questions and exploring a variety of answers. In the case of a portrait, the questions might be along the lines of: *What should my model be wearing? What should she be doing? Should she be serious or silly? Should she be looking at the camera or not? Should she even know I'm taking her picture? Where should I shoot this photo? What sort of lens should I use? What kinds of digital treatments should I consider?*

Note: See the last two pages of each chapter to find text relating to that chapter's images.

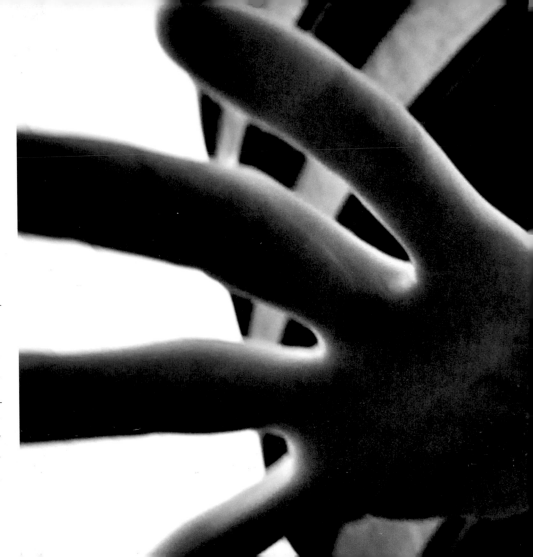

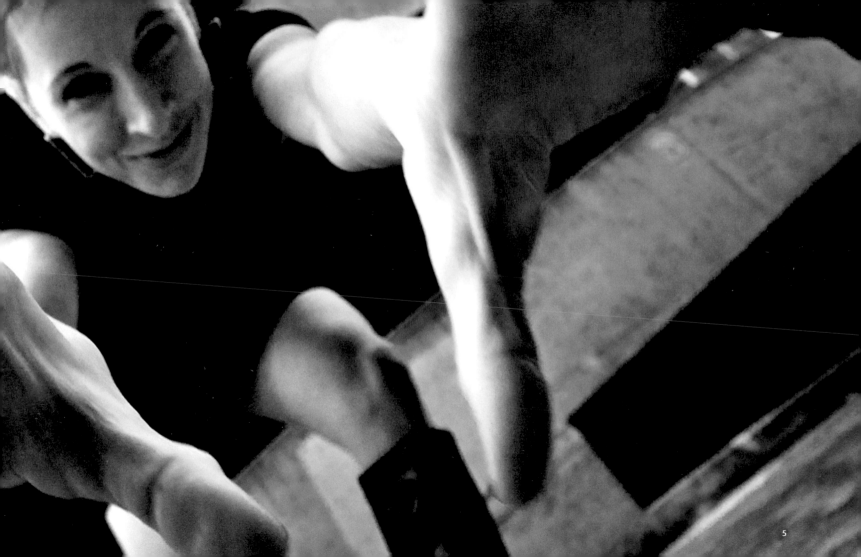

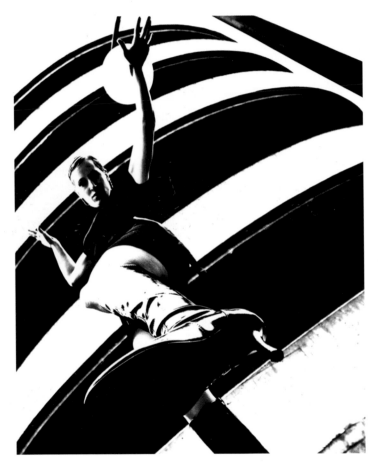

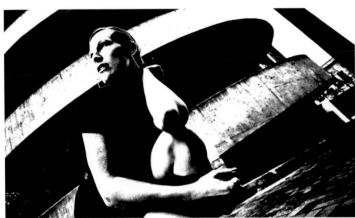

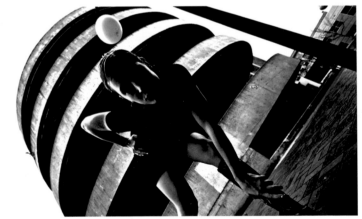

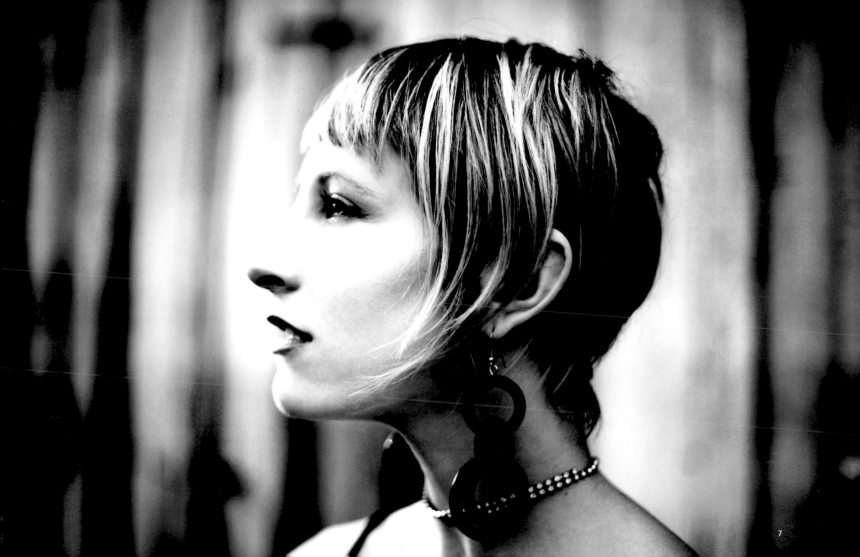

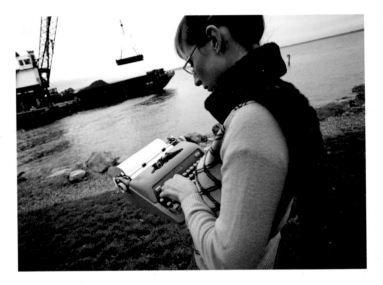

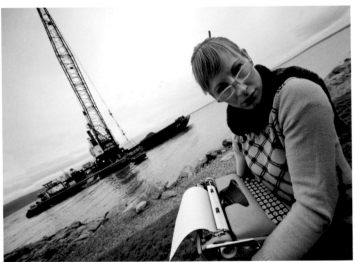

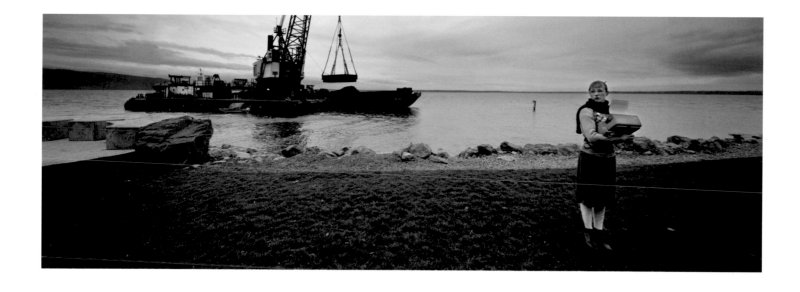

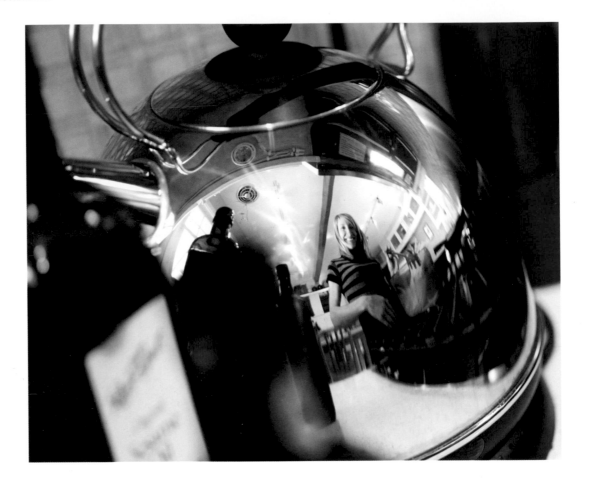

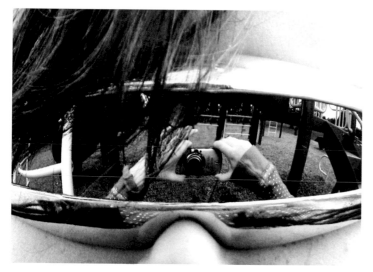

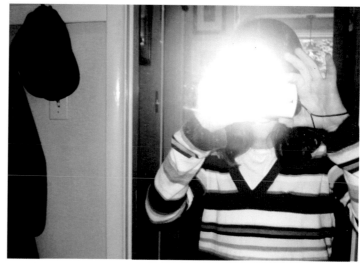

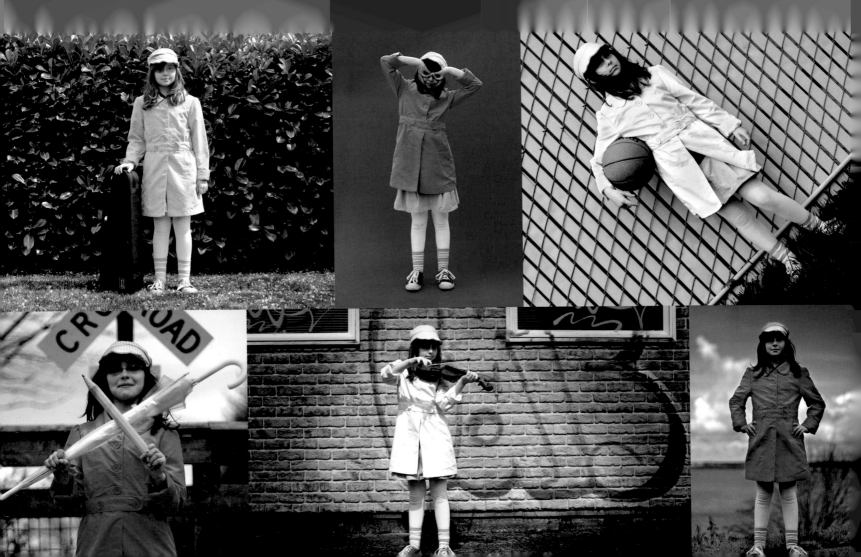

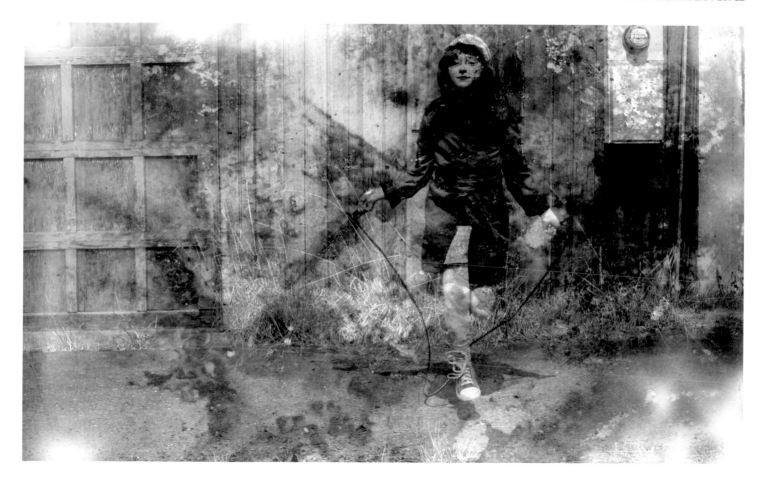

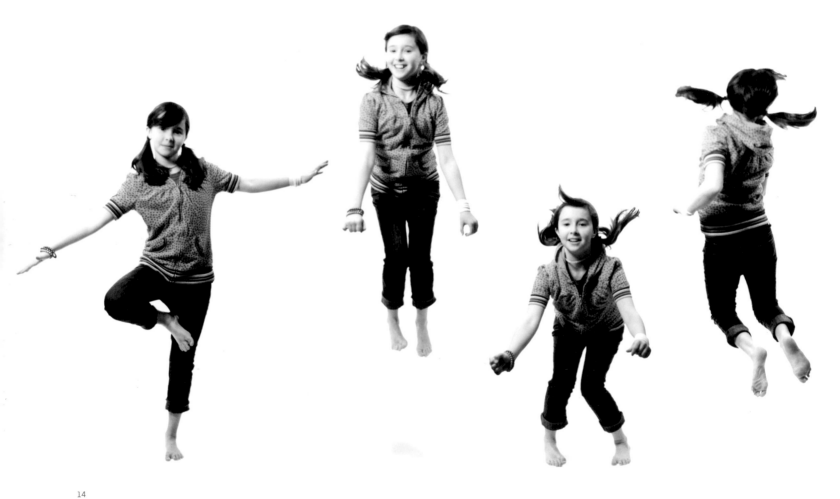

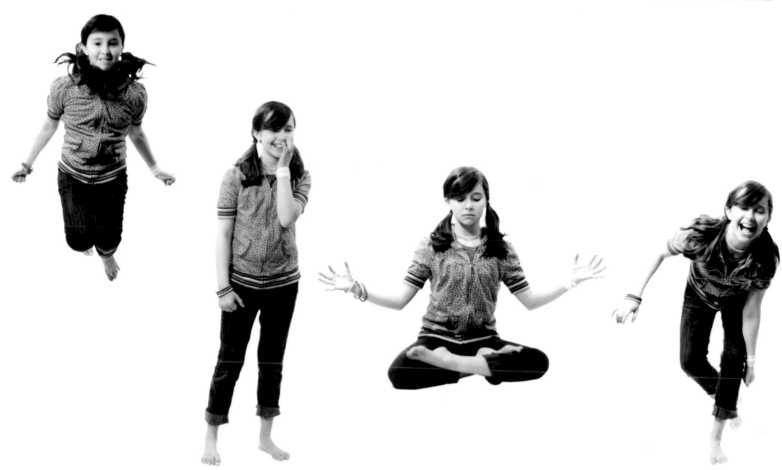

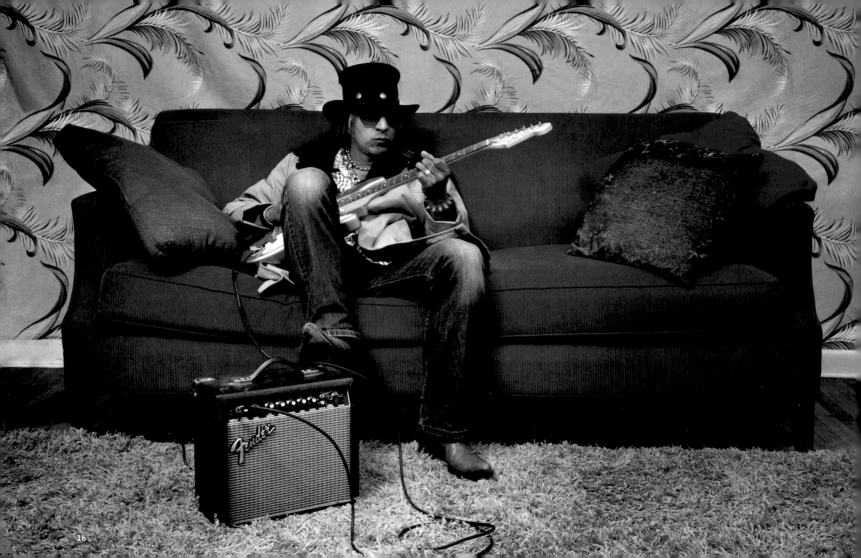

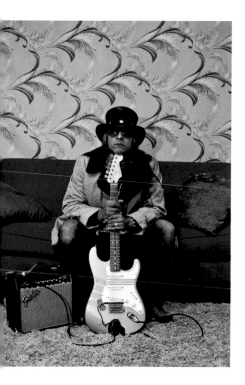
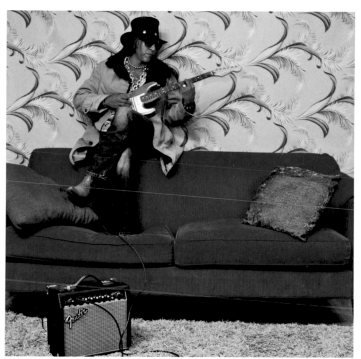
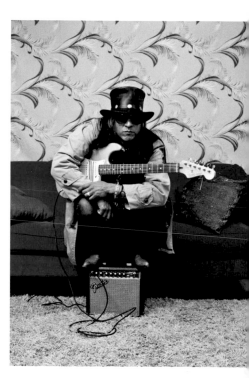

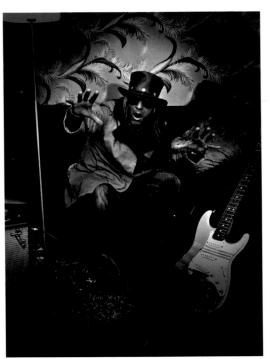
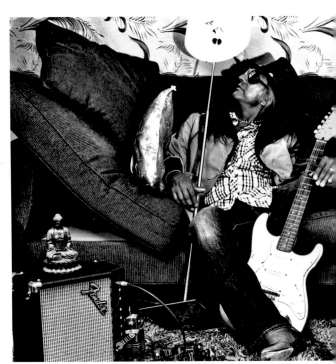

Inside the camera, all portraits start out the same: as rectangles of darkness. You could say the differences between a photo shot by one person and a photo taken by another all come down to the choices each has made in bringing areas of light and darkness into a blank rectangle. The possibilities are infinite.

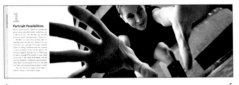

4

5

Consider using this word list to help brainstorm for portrait ideas: jeans, slacks, dress, shorts, shirt, shirtless, tie, sweater, coat, scarf, hat, shoes, boots, barefoot, jewelry, costume, props, makeup, body paint, seated, standing, kneeling, jumping, spinning, posed, impromptu, serious, smiling, laughing, making faces, looking at the camera, looking away, eyes closed, indoors, outdoors, natural light, electric, candle, plain backdrop, busy backdrop, telephoto, wide-angle, 50mm, in focus, blurred, color, monochrome, special effect.

Imagine you've been assigned to photograph a well-dressed model. Your client is expecting the kind of exquisitely posed and choreographed shots we've all seen and enjoyed before. Go ahead and fill a data card or two with photos of this sort. Then, how about cutting loose and going after something different—something that displays a little more creative spark and visual intrigue? Who knows, the client might just prefer your out-of-the-ordinary images (and you just might bolster your reputation as an innovative photographer).

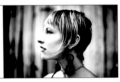

6

7

Great sandwiches are built using combinations of ingredients that complement—or contrast pleasantly with—the bread that holds them. And, believe it or not, the same goes for a portrait: Just think of your model as the filling between a slice of backdrop and the camera's lens. The visual sandwich on this page was created by placing the model's clear and smooth profile between the blurred forms of an aging barn's rough exterior and a 50mm lens (a lens capable of extraordinarily fine depth of field control).

Three models were used as main characters in this book. Why just three? Because (as mentioned in this book's introduction) there may be no better way to demonstrate power of creativity than by showing how much can be done with how little. The elegantly dressed subject from the previous two spreads shows up on these pages playing the role of an old-school journalist. The images here represent the kind of portraits that could be used with an essay or article about a person of interest.

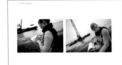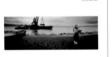

8

9

Your model need not always be looking at the camera when a portrait is taken. How about recording some images when your model is interacting with the camera, and others where she is not? What about having her close her eyes? Try shooting from near the model and from farther away. And what about the photo's composition? Consider placing your model somewhere other than dead center within the scene. What if the camera were tilted?

I was taking pictures of the model in a kitchen when I noticed her reflection in a tea kettle. Interested in the effect, I snapped a half-dozen or so shots. And why not? Photos are cheap when you're shooting with pixels instead of film. Some tips: Keep your eyes open for photo opportunities whenever you have a camera nearby; keep a camera nearby as often as possible; use large-capacity data cards, and don't be afraid to fill them with pixels.

10

11

The difference between these two mirror images and the one opposite is that the model is also the photographer of the photos on this page. How about snapping a self portrait the next time you come across (or are wearing) a reflective surface such as a mirror or a pair of chrome sunglasses?

Backdrop plays a big role in the outcome of any photoshoot. The backdrops on this page are, clockwise from top left: a wall of shrubbery, a sheet of colored paper, a slatted fence, a seaside bluff, a graffiti-painted wall and a railroad crossing. A suggestion: Keep a pocket digital camera on hand at all times and snap photos of photogenic backdrops whenever and wherever you find them. These snapshots can be used as references the next time you're trying to think of a good place to photograph a friend, family member or client.

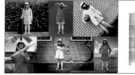

12

13

How about applying a digital treatment to alter your portrait's appearance? Here, a picture of a jump-roping subject has been given an aged look in Photoshop. A photo of a burnt piece of wood was layered over the original image (the top layer's pull-down menu was set to "multiply" and its opacity was put at 25%). A PHOTO FILTER effect (set to "sepia" at 90% strength) was then applied to the composite image. The BRUSH tool was used to paint impressions of overexposed areas along the photo's edges.

Got an energetic kid? What about a friend who likes to jump? How about creating a series of mostly airborne poses and combining them in a sequence such as this? These photos were taken using a digital SLR in "shutter priority" mode. The exposure was set at an action-freezing speed of 1/1000 of a second. (See chapter 13, Anti-Gravity, for more images of gravity-defying models and props.)

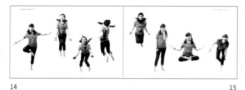

14

15

A photo of a subject without a backdrop is known as a "knockout" image. The knockout images on this spread were created by photographing the model in front of a bright green paper backdrop. The photo was then brought into Photoshop, where the color-sensitive MAGIC WAND tool was used to select the backdrop and delete it from the scene. A pure white backdrop was then added behind the model and a drop shadow was painted beneath her feet using the BRUSH tool.

Who says there's only one way to pose on a couch, chair, bench, rock or sidewalk? This spread and the next feature a progression of presentations. The content of the photos range from normal to abnormal—from inside the box to outside the living room. There's nothing wrong with setting up a portrait in a relatively normal way (as seen in the near photo) but remember to consider pushing the envelope of normalcy once you've captured a conventional shot or two.

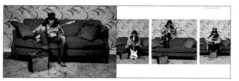

16

17

During this photoshoot, the model was encouraged to do as he liked while I took pictures. When taking portraits in a pre-arranged setting, I sometimes like to pre-aim my camera from a tripod and use a remote control to activate the shutter. That way, I can sit back and interact with the model as he plays around with poses, furnishings and props. Models often feel more comfortable communicating with the photographer in this way (as opposed to trying to talk with someone whose face is hidden behind a camera).

How about tossing a few more props into the scene, messing things up and encouraging your model to really start acting up? And after the shooting is done, consider pushing the look of your images to further extremes by using digital effects to invert, recolor or alter their levels of contrast.

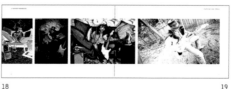

18

19

Once you've exhausted the shooting potential of your set-up portrait environment, how about taking your model outside the studio (or living room, as in the case of these shots) and seeing what you can find in the way of ready-to-go photographic environs? My model and I visited the backyard of some nearby friends to record a few shots using their swing set before deciding to conclude this photoshoot.

2

A Day in the Life

Ordinary ≠ Mundane. Some of the most compelling, communicative and descriptive images of people are those taken during the subject's most commonplace moments. The integrity and true-to-life realism conveyed through pictures of everyday activities make them a favorite pursuit of many commercial, fine arts and amateur photographers.

Interested in recording life-as-it-is photos of a friend? How about spending the better part of a day with your subject and shooting a series of images that record descriptive and informative details of that person's home, work or school life? Not only is the resulting set of images likely to yield an abundance of intriguing individual photos, it also should provide more than enough material for a keepsake-quality mini-album.

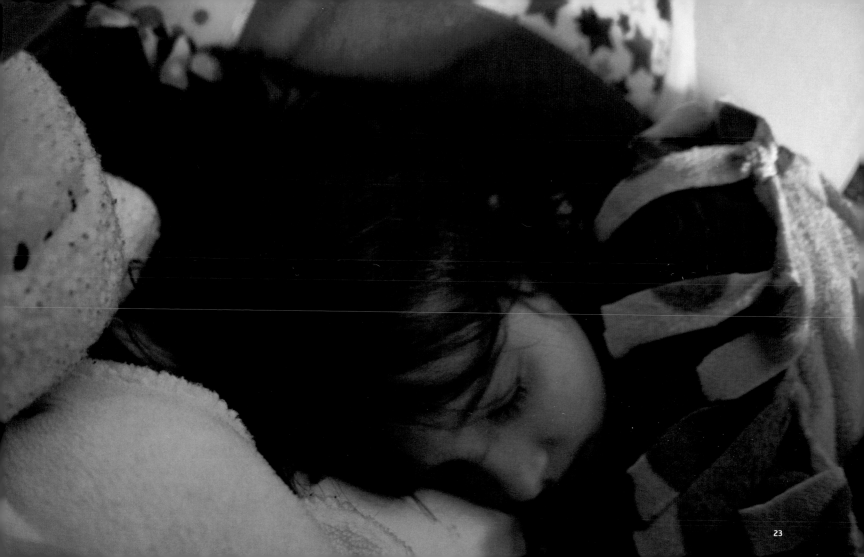

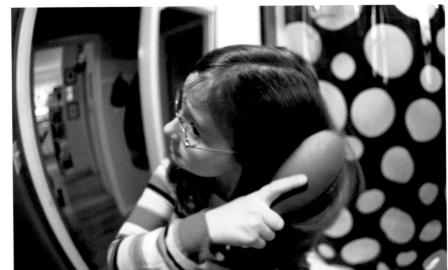

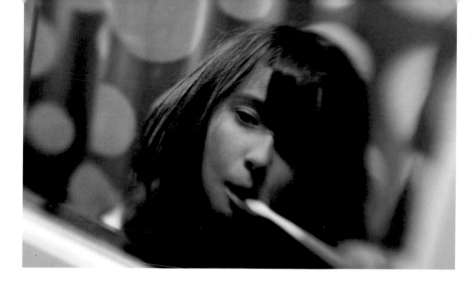

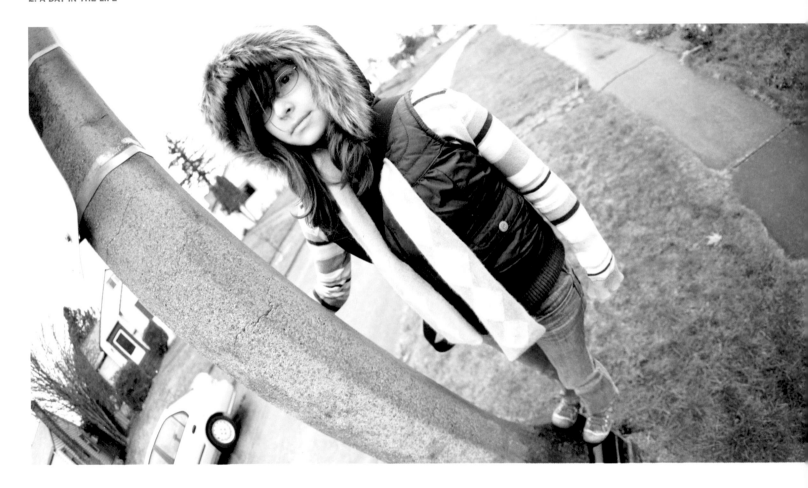

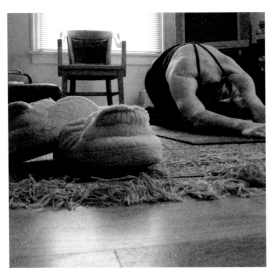

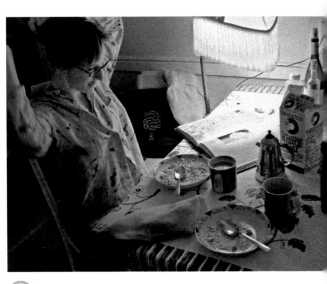

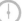

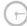

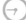

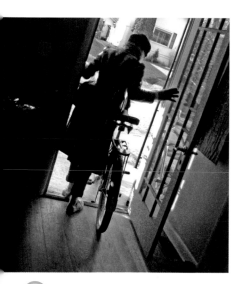

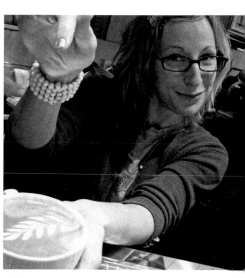

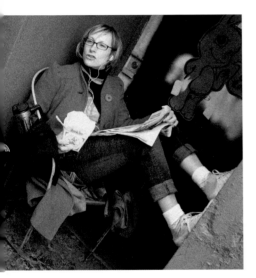

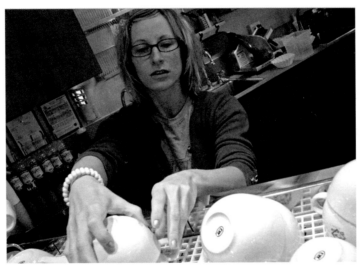

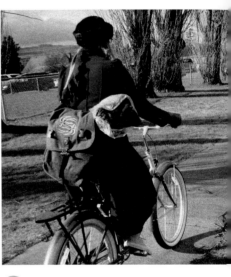

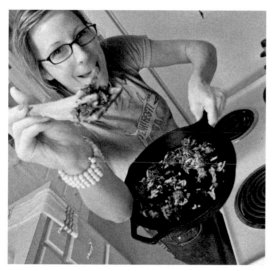

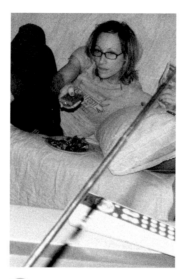

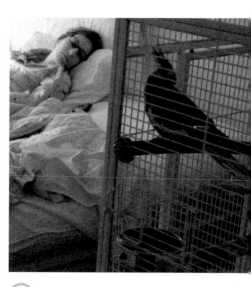

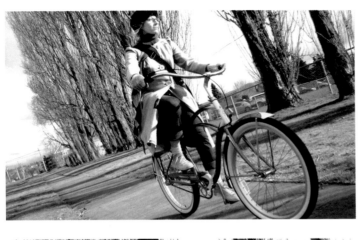

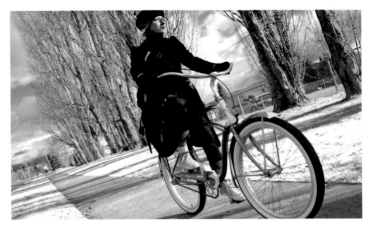

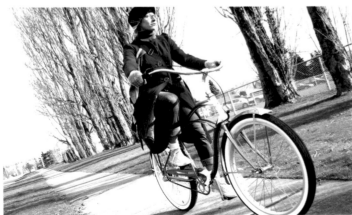

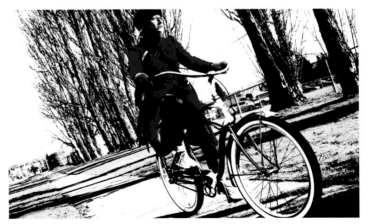

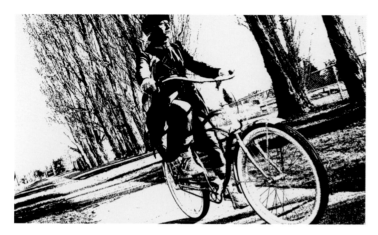
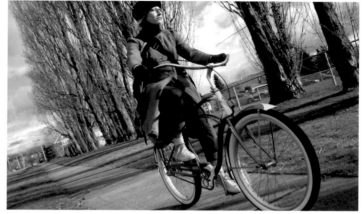
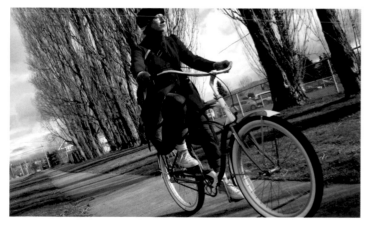
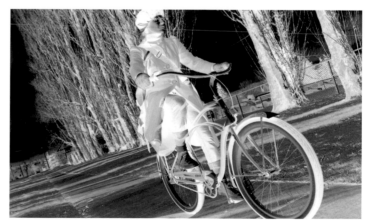

BACK-STAGE:

An actor's routine before and after the big show.

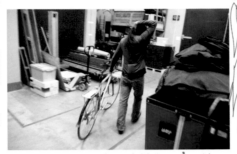

Show time at the children's theater is in about one hour. Just enough time to park my bike and get into costume.

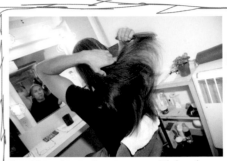

In the dressing room. This is where I change into costume (but only after I get my hair combed and untangled).

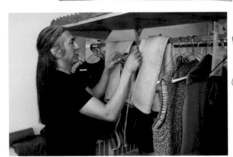

This performance involves authentic Native American costumes. These leather pants were made by a local craftsperson.

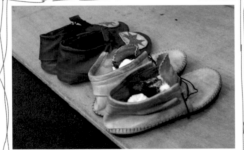

I wear the red moccasins during my performances on stage. The other pair I wear around town. Both are very comfortable.

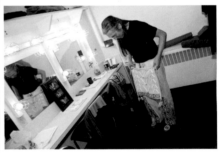

Final touches. In just ten minutes, it will be time for me to head to the auditorium.

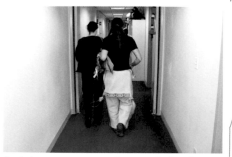

And here we go. An assistant walks with me toward the stage entrance. The audience is waiting expectantly.

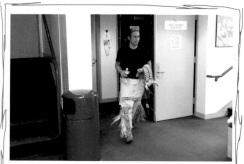

All done! The kids seemed to really enjoy the show. I've just left the stage and am heading back to the dressing room.

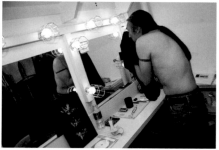

I like to remove my makeup and put on street clothes before going back to the auditorium to visit with audience members.

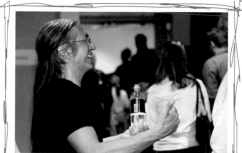

Being on stage is my favorite part of the morning, but I also have a good time talking to kids and their parents after the show.

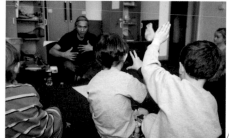

There is a children's acting school next to the theater. I'm spending some time today talking with students who watched my performance.

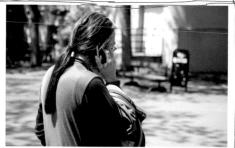

Another show in two hours. Just enough time to answer a few phone calls and get something to eat.

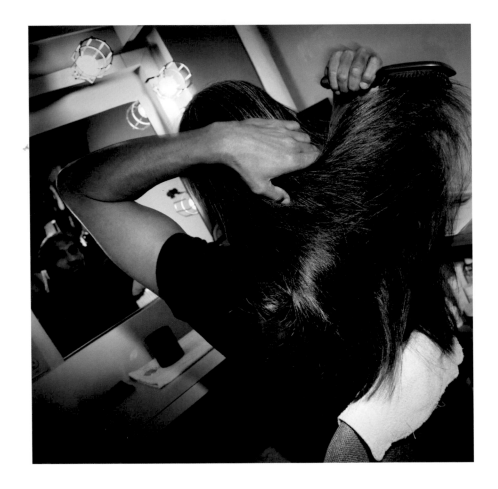

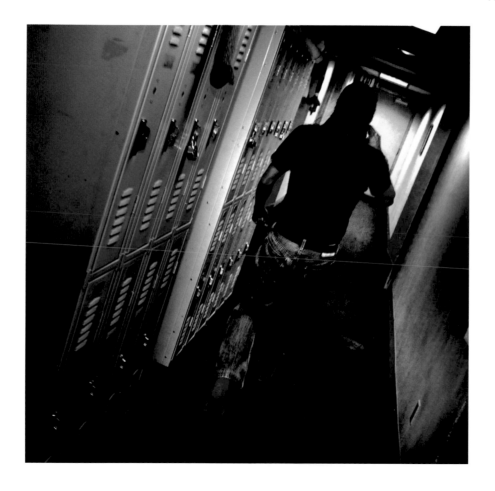

Some photographers use their cameras to document real-life happenings. Others take pictures purely as a means of creating works of aesthetic beauty. This chapter aims—among other things—to demonstrate the idea that the two goals are not mutually exclusive. Train your eyes and mind to notice the endless stream of worthwhile photo opportunities in everyday life.

22 23

If you are a parent, consider this project idea: During the course of a day spent with your child, snap a series of photos that document his or her entire day—from wake-up to bedtime. The day could be one spent primarily at home, or it could contain a special event such as a hike or a visit to a fun place like a pool, park or zoo. The resulting images will provide a series of photos that detail a specific time in the child's life—pictures that might make an especially meaningful gift for the child once he or she enters adulthood.

The thee photos on this page were shot with a 15mm fisheye lens. With its ultra-wide view of the world, a fisheye can be used to capture playfully curvaceous impressions of your subject and her surroundings. The three images on the opposite page were shot with a Lensbaby (a lens with a flexible mount that permits photos to be selectively blurred). A Lensbaby, like a fisheye, makes an appealing choice for potentially ho-hum shots because of the intriguing visual touches it lends to a scene.

24 25

When I'm aiming for photos that are meant to appear natural and un-staged, I make sure to communicate this goal with my subjects. I encourage them not to worry about trying to look any certain way for the photos: no forced smiles, no intentional posing, no nothing. If the model clearly knows that nothing in particular is expected from her, she'll better understand that it's okay to simply go about their daily routine while you handle the picture-taking responsibilities.

For many photographers, it's as though an internal alarm goes off when they are framing a scene at an off-kilter angle. If this alarm sounds in your head every time you depart from the straight and level, learn to mute it—especially when other parts of your brain sense that you're onto something artistically worthwhile with your skewed point of view.

26 27

The contemporary, high-contrast, low-saturation look of these two images was achieved in Photoshop through the addition of BLACK AND WHITE adjustment layers. The lighter look of the far image was obtained by selecting "screen" from its adjustment layer's pull-down menu. The deeper saturation of the near photo was brought about by selecting "overlay" from that adjustment layer's pull-down menu. CURVES controls were used to fine tune the final appearance of each shot.

On this spread and the next, a sequential series of photographs document a day in a person's life. Most of the images in this book were taken with a digital SLR using one of several lenses. The photos in this series were not. These were shot with an ordinary pocket digital camera—a model portable enough to be easily carried along wherever our ongoing photoshoot took us.

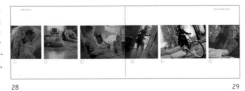

28 29

Due to the low-light conditions of the indoor scenes in this series, a high ISO setting (between 400 and 800) was selected. An elevated ISO allows for shooting with minimal light, but it also invites a certain amount of graininess (digital noise) into the photo. This series' images of brightly lit outdoor scenes contained no such digital noise. For the sake of achieving a consistent look between all the images, noise was added to the outdoor scenes using Photoshop's FILTERS › NOISE › ADD NOISE treatment.

Not many of us can easily spare twelve hours to follow a subject as she goes about her day-long routine. If you are short on time, and interested in the idea of capturing a set of this kind of images, consider blocking out a few hours some morning, afternoon or evening and concentrating on that slice of your subject's day. (An in-depth example of this kind of abbreviated "a-day-in-the-life" photoshoot is featured in the next chapter.)

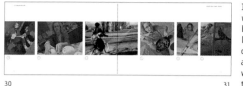

30 31

Ideas: Shoot several a-day-in-the-life sets of images featuring local working celebs (baristas, parking attendants, grocery clerks, garbage collectors, etc.) and create a gallery show of your photos; follow a good friend for a day and create a custom-made flipbook out of your accumulated images; tail a politician, musician or athlete for a day, add short captions to your images, compile the photos and words into an image-oriented essay on your subject and submit it to a local tabloid or newspaper for publishing consideration.

Your set of a-day-in-the-life images is bound to yield photos that are worthy of stand-alone presentation. When you spot one of these stand-out images, you might choose to simply boost its contrast, fine tune its color and call it good. Or, you might want to consider some options (after all, computers and software have made artistic exploration easier than ever). The eight outcomes seen here were achieved by applying effects from Photoshop's pull-down list of readily available adjustment layers.

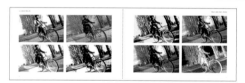

32 33

The adjustment layers used on this spread are, top row, left to right: BLACK AND WHITE (set to "green" and with a warm tint added); BLACK AND WHITE (set to "infrared"); THRESHOLD; and HUE/SATURATION (only the "hue" slider has been used here). Bottom row, left to right: CHANNEL MIXER; EXPOSURE; HUE/SATURATION (individual colors have been desaturated using the control's pull-down menu of hues); and INVERT.

What about creating a storyboard from an afternoon spent with your subject? Here, text has been added to a series of images that follow the subject during a morning at Seattle Children's Theatre. The photos were taken before and after his appearance in a one-man stage production (cameras were not allowed into the auditorium during the performance).

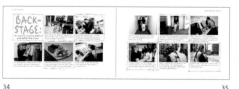

34 35

If you're going to follow a subject around his place of work, it's important to avoiding getting in his way (or in the way of his co-workers). In cases like this, I try to be as invisible as possible while remaining open to friendly conversation with whomever shows an interest in what's going on. The main thing is to be as low-maintenance as possible. That way, your subject will not feel like he has to take care of you—or keep you out of trouble—while he goes about his business.

Since most of the photos taken during this kind of photo session are shot spontaneously (and without the opportunity for re-takes), bring a data card with enough capacity to allow you to shoot without restraint. At the end of the day, go through your abundant catch of images and keep your eyes open for photos that look good enough to be pulled aside and given special attention in Photoshop. I particularly liked the sheen of the model's hair in this photo once it was converted to black and white.

36 37

When taking pictures of a single subject over a period of several hours, you're bound to record a large number of outtakes in addition to keepers. Before tossing your outtakes into the digital garbage can, be sure to look through them for shots that could serve other purposes. This photo—with its subject's identity obscured—for instance, has potential as an image that could accompany a magazine article or a piece of poetry or prose. (For more images of this kind, see chapter 18, Anonymity.)

3

Along for the Ride

This section continues the theme introduced in the previous chapter, only on a smaller scale. What if you only have an hour or so, and want to capture the essence of what a friend or client's personal or professional life is all about? My advice: Give your subject a call, grab your camera and go for it.

One of the best things about shooting an on-the-go set of images of a friend or client is that it leads to photos graced with a down-to-earth look of spontaneity—a believability that promotes a truthful connection between the images and those who view them.

On the pages ahead, the camera follows one subject as she spends a couple hours navigating an urban landscape in her role as a bicycle messenger.

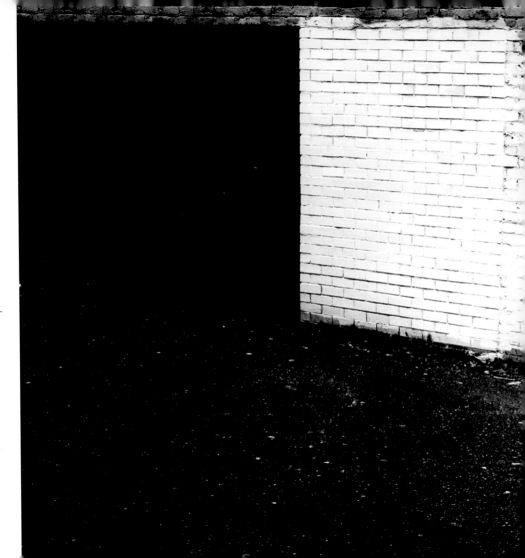

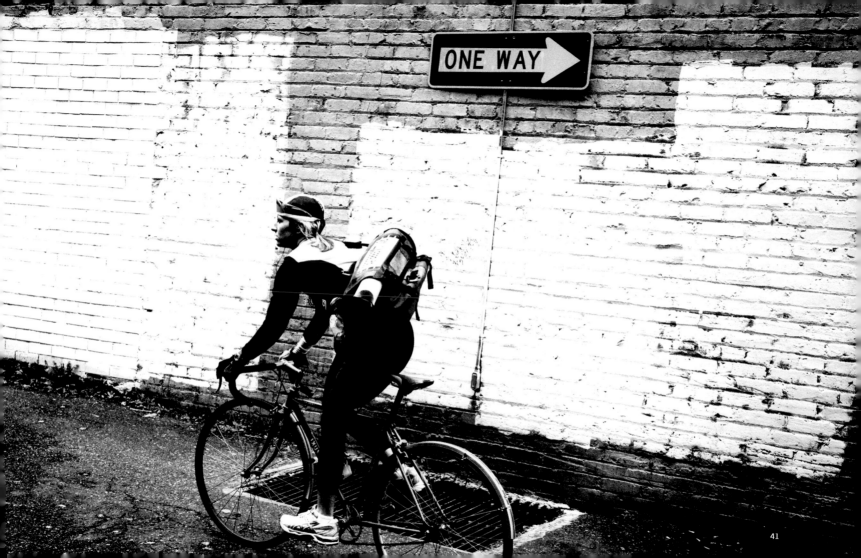

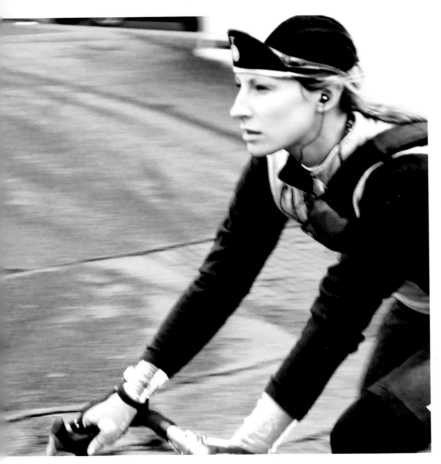

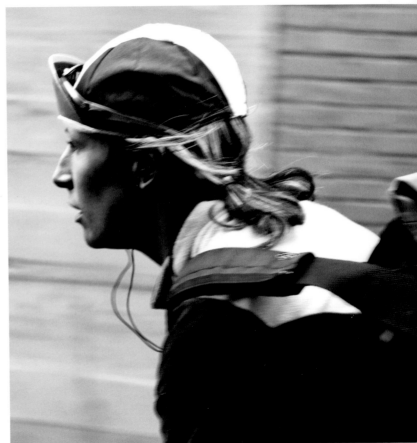

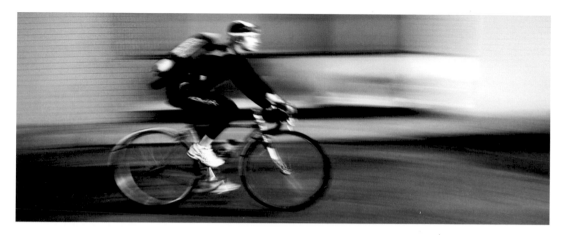

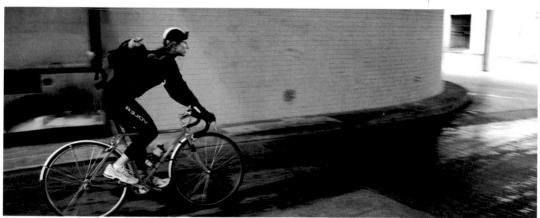

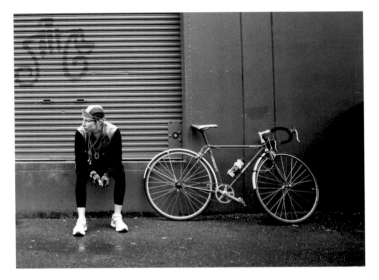

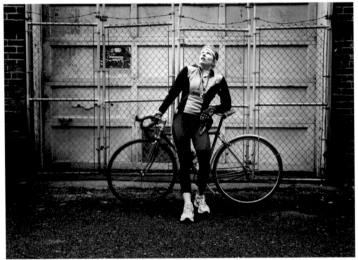

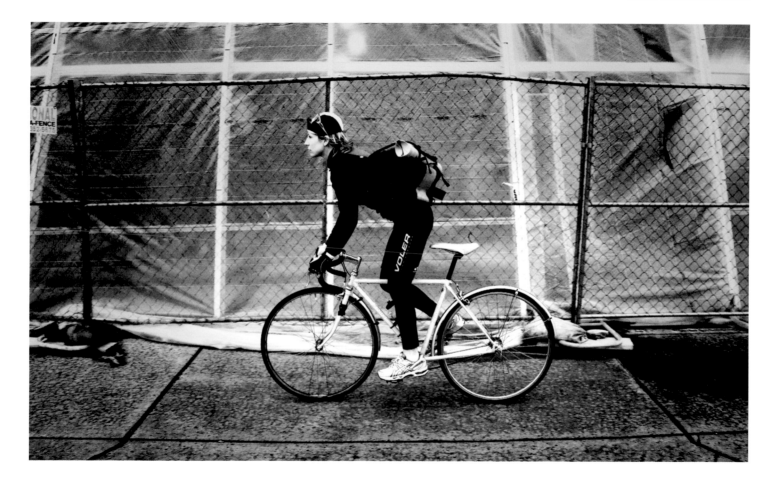

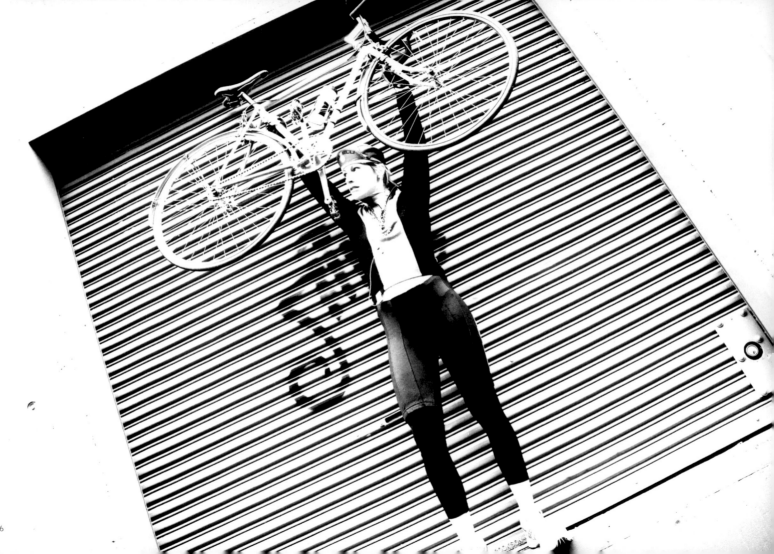

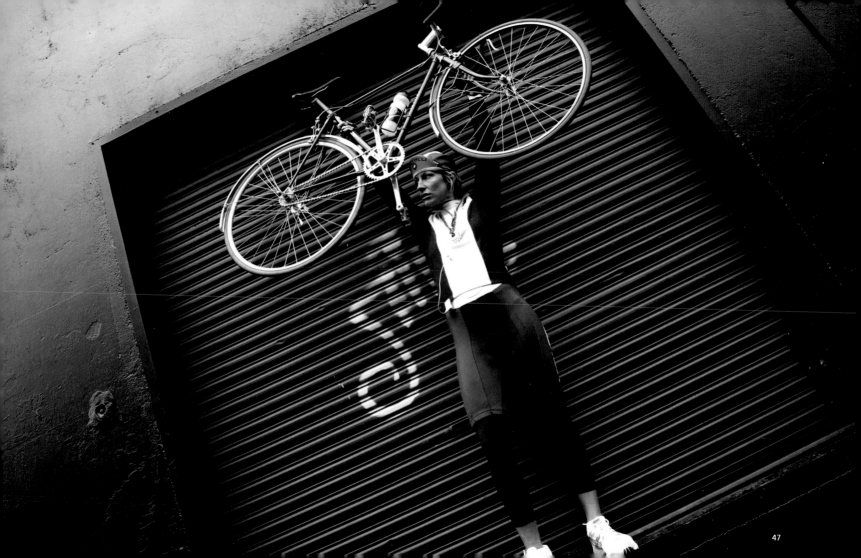

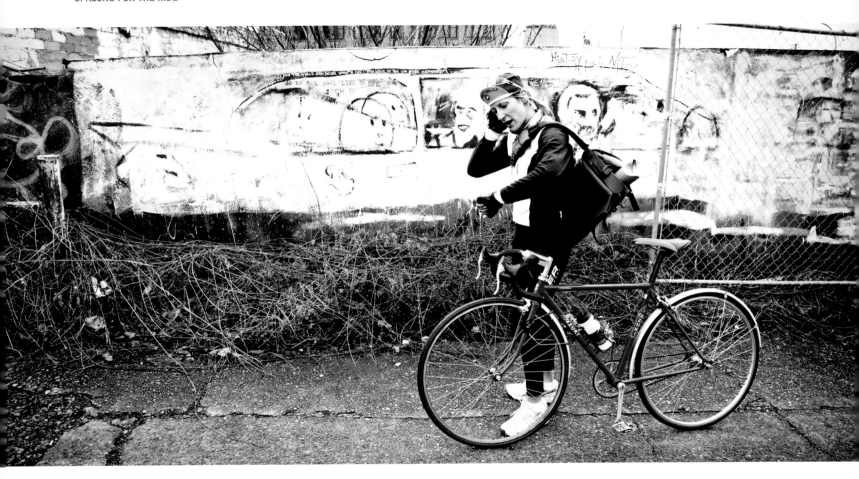

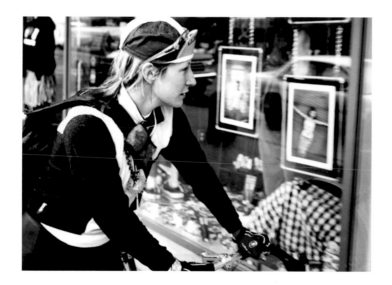

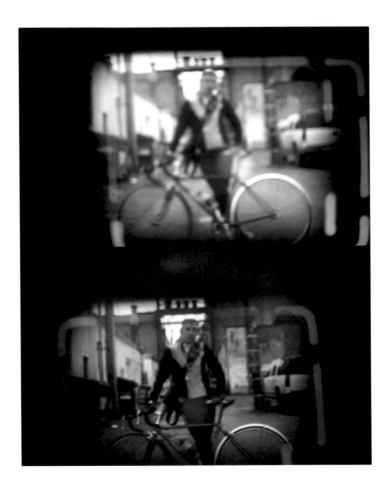

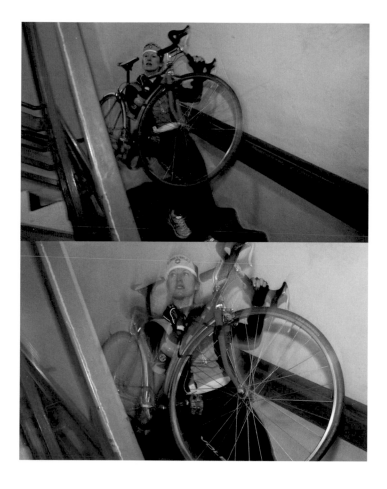

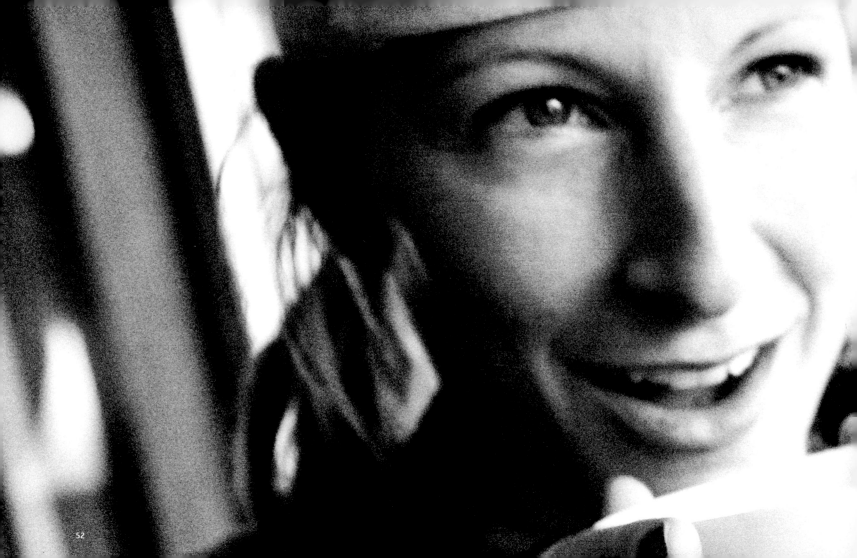

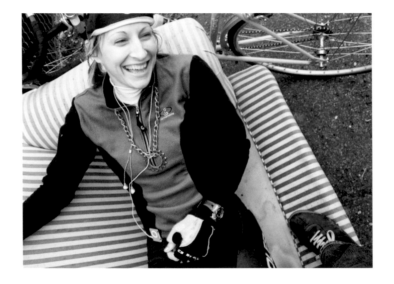

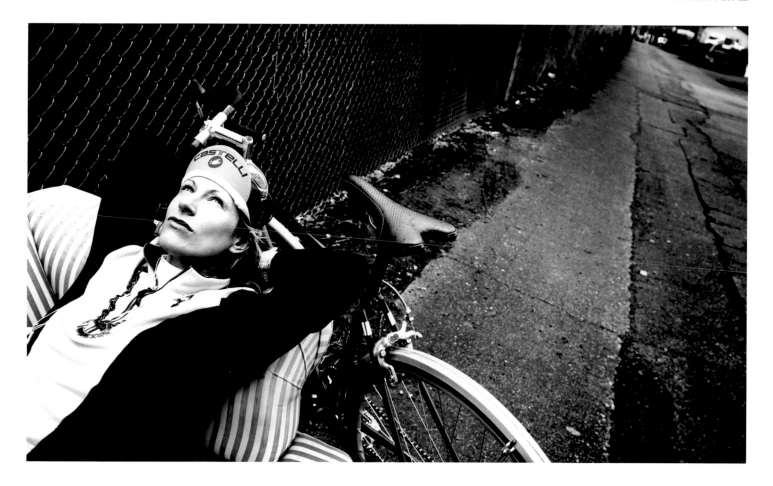

The inclusion of the small street sign in this photo lends a couple of visual extras to the scene. For starters, it adds a small compositional accent to the image (cover the sign with your finger and note how the photo suddenly seems notably less interesting). Additionally, the arrow lends a subtle hint of dissent to the image as it counters the movement of the cyclist. Take advantage of compositional gifts such as these—whenever and wherever you find them—and shoot from vantage points that position them effectively within your scene. 40

41 A PHOTO FILTER adjustment layer was added this image. The PHOTO FILTER's controls were set to "sepia." "Soft light" was selected from the adjustment layer's pull-down menu. This treatment converted the relatively bright colors of the original image into a stark palette of restrained hues—a look that merged well with the minimalist content of the image itself.

Try framing some shots more tightly than others. How close can you get to the action without excluding details that show what your subject is up to? In the near image, a tiny hint of the subject's bicycle at the lower edge of the photo does the trick. The second photo includes no such visual hint—but the image's proximity to other photos that include the bike seems enough to convey the notion that the subject is cycling her way through town. 42

43 A slow shutter speed was inadvertently selected for the upper photo on this page. The resulting image might have been considered a throwaway by some (since nothing in the picture is in tight focus), but the shot's conveyances of speed and movement appealed to me. I decided to keep it—along with the more technically correct photo at bottom (recorded later in the afternoon using a quicker shutter speed).

I did a local search for interesting settings and backgrounds before I got together with the model to record this chapter's photos. I decided the locations seen in the two nearest images would offer ideal settings for short breaks during the photoshoot (breaks for the model, anyway—I used the downtime to compose portraits of her against a pair of intriguing and attractive backdrops). 44

45 On this page, the gridded forms of a chain-link fence and a partially framed storefront (seen beneath a translucent layer of plastic sheeting) lend all kinds of interesting visual, textural and compositional notes to the scene. To capture this shot, I positioned myself across the street from this ready-to-go backdrop and waited for my subject to pedal by. To make sure I'd have plenty of images to choose from afterward, I put the camera in rapid-fire mode and held the shutter button down as she rode through the frame.

Consider your digital options once a picture is recorded. Should you enhance the image's colors? Mute its hues? Convert the photo to black and white? Apply a reality-altering special effect? How about adjusting its values so the image presents itself through a range of mostly lighter tones (as in the case of this spread's near image)? And what about aiming for a darker presentation (opposite)? If possible, try for a look that suits the photo's content, satisfies your personal preferences and is likely to appeal to viewers. 46

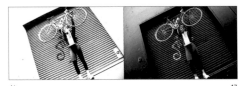

47 CURVES and LEVELS controls are not the only tools capable of generating high- and low-key renderings of a photo's original. BLACK AND WHITE adjustment layers were used to create the two versions shown here (in both cases, the adjustment layers' opacity was reduced until hints of the images' original hues showed through). "Maximum white" was selected from within the BLACK AND WHITE control panel to create the lighter of the two images. "Maximum black" was selected to generate the darker photo.

Candid camera: On this spread, the subject has been caught in unscripted moments that convey hints of her day-to-day routine. In the near image, a panel of artfully rendered graffiti provides a lively backdrop for a cell phone conversation. Opposite, a window display snags the subject's attention as she guides her bike along a row of shop windows. Acquaint yourself well with your camera's functions so you can be quick on the draw when an impromptu photo opportunity presents itself.

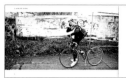

48　　　　　　　　　　　　　　　　　　49

Learn to look beyond the subject. There is no understating the importance of selecting a backdrop that connects well with the actions, attire and expressions of your subject. One excellent way of developing your ability to evaluate backdrops is by examining the works of great photographers—take special note of the relationships that have been established between the people and the settings that appear in their photos.

These two images were snapped by aiming the lens of a pocket digital camera through the viewfinder of an old Kodak Instamatic (purchased a thrift store). This is one of my favorite alternative shooting techniques. The resulting images resemble frames from an old film reel. When shooting in this way, investigate the effects that occur when the digital camera's lens is zoomed, and also the different outcomes that can be achieved by varying the distance between the digital camera and the old viewfinder.

50　　　　　　　　　　　　　　　　　　51

A flash was used to record these images in a dimly lit stairwell. The subtle transparency seen in the model's form, and the faint trails left behind by her movement, are the result of selecting an exposure time that was long enough to allow the shutter to remain open for a split second after the flash had fired. Investigate different combinations of flash and exposure settings using your SLR's manual controls.

When photographing people, I particularly like taking pictures while having a conversation with the subject. Snapping photos of a person while she is talking or listening often leads to images graced by moments of spontaneous emotion or expression.

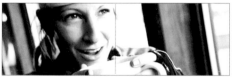

52　　　　　　　　　　　　　　　　　　53

A fair amount of digital noise appeared in certain areas of this window-lit scene since the cafe's interior lights were dim and the sky outside was dark and overcast. If you are forced to shoot in conditions that generate noise in only portions of an image—and you don't want to risk losing detail in the shot's unaffected regions by applying a noise-reduction treatment—consider using Photoshop's FILTER › NOISE › ADD NOISE effect to generate a consistent level of noise throughout the image.

End of the road: A castaway couch in a back alley provides a place of repose after a hard afternoon's work. The couch was a happenstance find, and I was grateful that my model was willing to pose on it since its fabric was still wet from an earlier rain shower. I stood on the couch to take the near photo (hence my foot peeking into the frame). I could have digitally removed my shoe from the image but decided against doing so; I liked the way the shoe added a playful hint of another's presence to the scene.

54　　　　　　　　　　　　　　　　　　55

All the monochromatic images in this book were originally shot in color. Once shot, the images were desaturated in Photoshop using the highly versatile controls available through BLACK AND WHITE adjustment layers. Use adjustment layers whenever possible (versus applying an effect directly to an image). Adjustment layers offer the great advantage of allowing the user to freely alter or remove effects once they've been applied. Additionally, adjustment layers have pull-down menus that can be used to alter a treatment's effects.

4

Parts and Pieces

People are sums. From the outside, we appear as totals that arise when things like a nose, eyes, ears and a mouth are combined to make faces (faces that are components of larger sums, known as bodies).

Most of the photos in this book feature sums on the scale of faces, heads, torsos and entire bodies. In this chapter, the focus is significantly narrowed. Here, the camera is zoomed and photos are cropped so only the individual components of who we are appear in each frame.

You may be surprised to discover how much information about a person—his or her age, gender, personality, mood and the activity he or she is involved in—can be revealed through photographs that feature only a tiny portion of the subject's self.

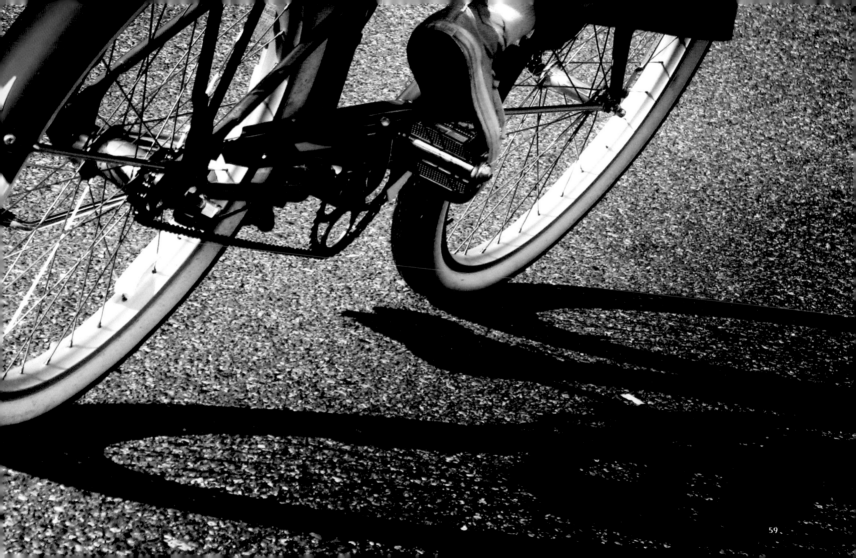

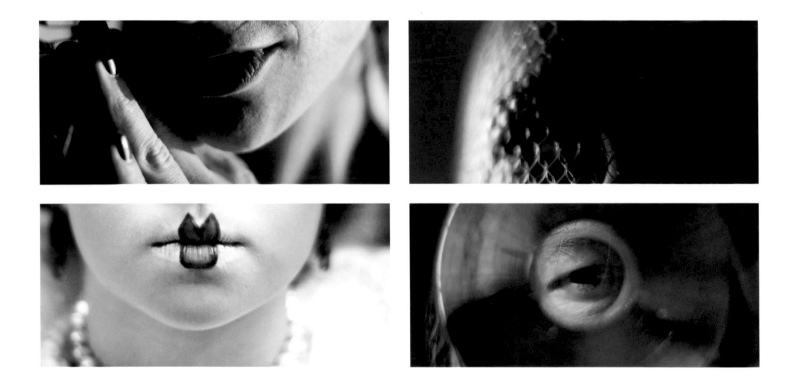

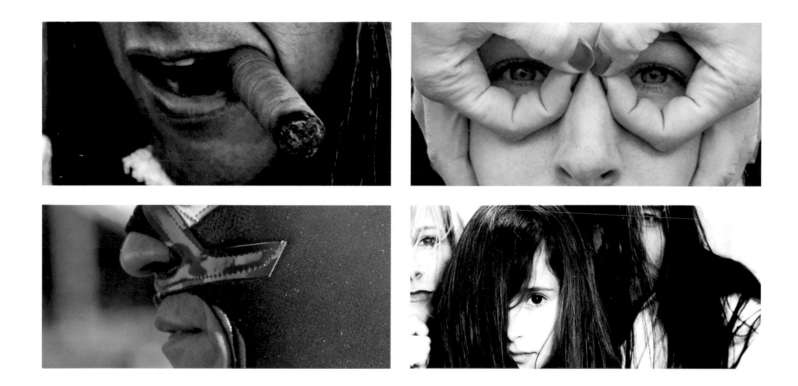

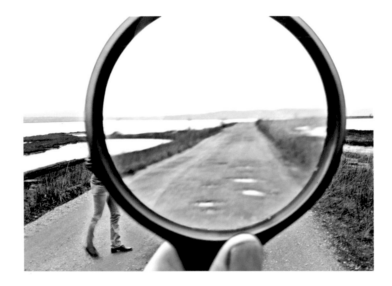

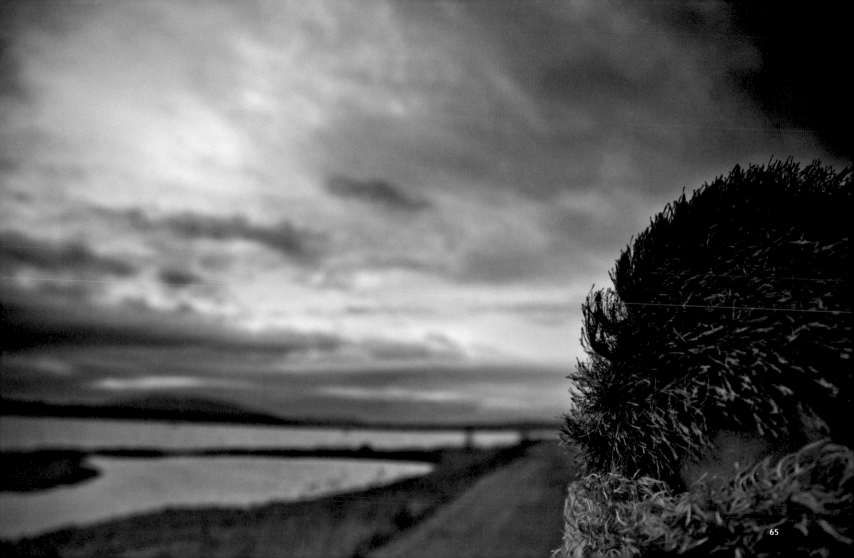

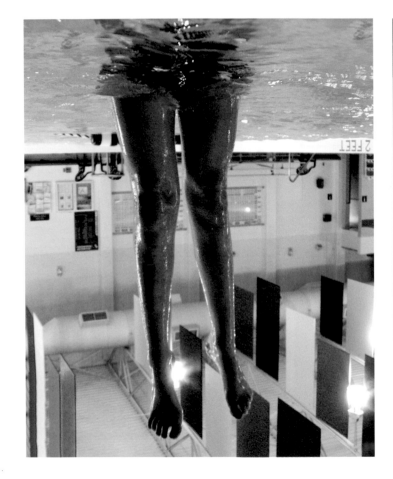

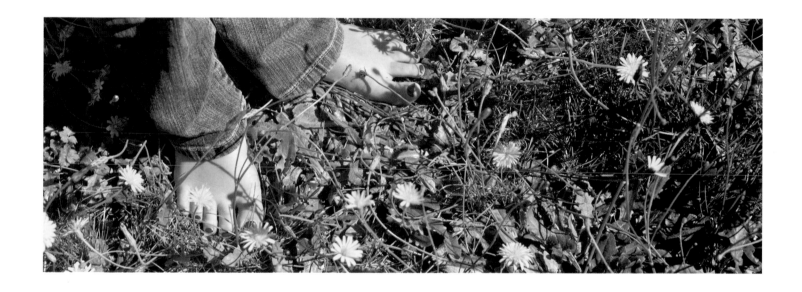

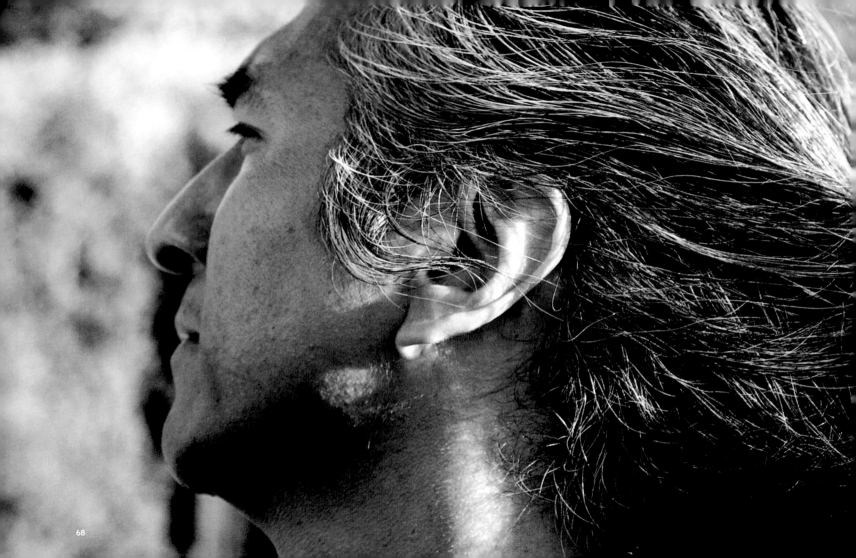

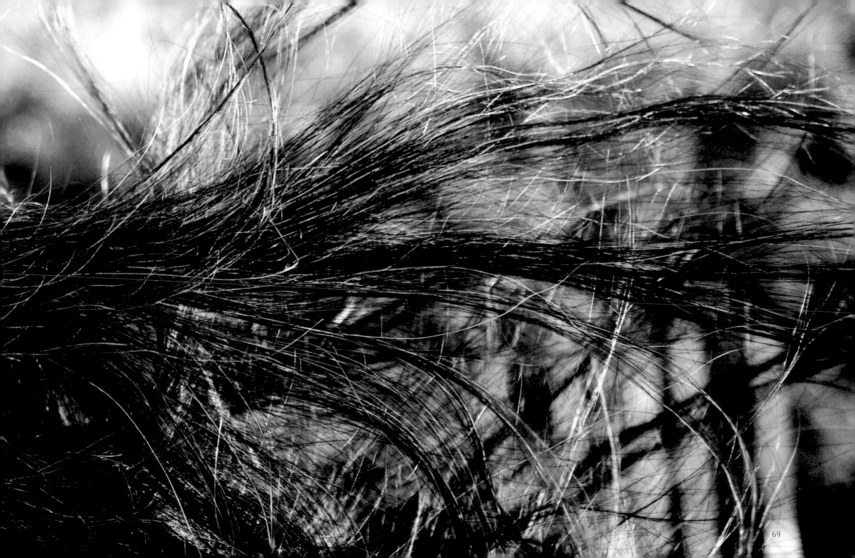

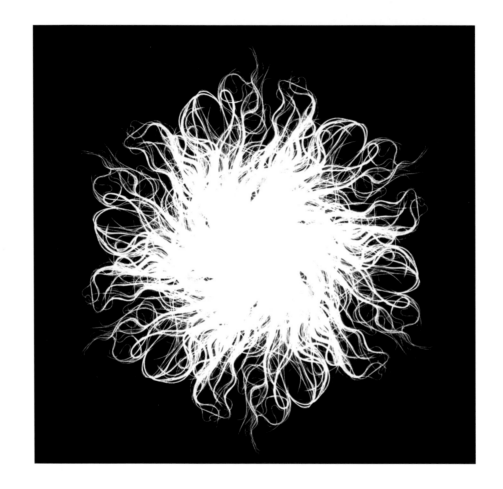

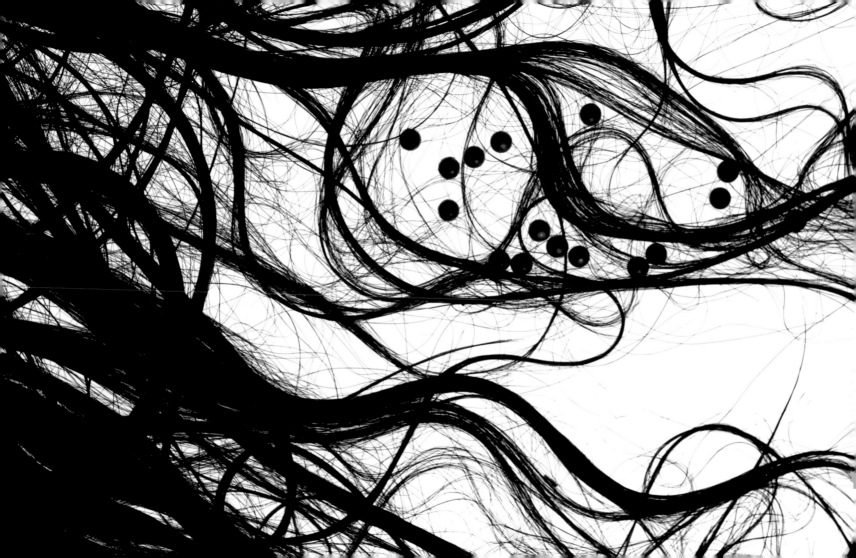

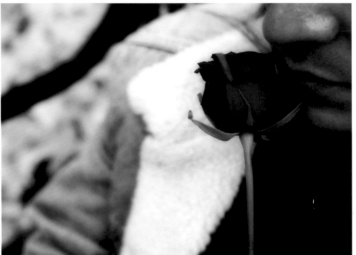

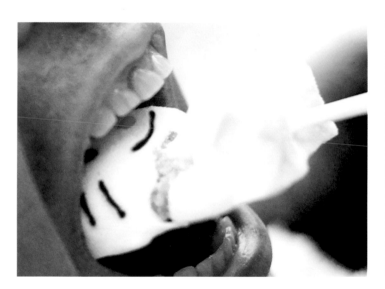

It's interesting how the presence of a single sneaker-clad foot in this scene converts this from a photo of a bike to a photo of a person riding a bike. Interesting, too, how the presence of the shoe (and the associated belief that a person is attached) brings with it hints of human-based conveyances like fun, thrill and escape.

58 59

What if you were to capture a series of images where the only evidence of human participation within the scenes was the presence of fingers, toes, hands or feet? The series could be shot using the body parts of one person, several friends or a few total strangers. A collection of images like these could make for an interesting Web gallery. They could also be printed using an ink-jet printer and hand-bound into few-of-a-kind coffee table books.

The two photos on this page were shot one after the next and looked very similar in their original form. Together, they provide a good demonstration of the range in which raw images can be finalized in Photoshop. The values in the near photo were lightened with a BLACK AND WHITE adjustment layer (set to "red filter") and selecting "screen" from the layer's pull-down menu. The second image's contrast, and the intensity of its hues, were boosted through a CURVES and a HUE/SATURATION adjustment layer.

60 61

The first image on this page was overlaid with a PHOTO FILTER adjustment layer (set to "deep red" at 50% strength). "Hard light" was selected from the adjustment layer's pull-down menu and the BRUSH tool was used to paint small holes over the necklace's beads in this layer's mask. The near photo was also given a PHOTO FILTER adjustment layer, only this time the filter was set to "underwater" and was applied at 100% strength. "Multiply" was chosen from this adjustment layer's pull-down menu.

A series of croppings taken from photos featured elsewhere in this book are displayed here. With the ever-higher resolutions available from modern digital cameras, it's becoming more and more possible to choose smaller and smaller regions of an image for final display. Keep this in mind when you are deciding how to best crop and present your images.

62 63

Photos, like books, tell tales. And just as some books are longer than others, photos too, can tell their tales with different levels of visual verbosity. Try this out the next time you are preparing a photo for presentation: See how tight you can crop the image while still retaining its story and conveyances.

A trick of the glass. The upper half of the model disappears behind the lens of a magnifying glass as she crosses a gravel road. The photo seems ripe with thematic potential and seems ready for the addition of a title, text or a few lines of poetry. A sidenote: This image was snapped while goofing around between the time the photos on pages 65 and 174 were taken. The moral of this sidenote: Keep filling your data card with pixels—before, between and after your planned shots.

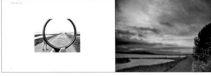

64 65

This photo was shot on a jetty that extends over a bay in the Lummi Reservation in northwest Washington. The jetty is part of a vast, undeveloped plat of grassy fields, saltwater marshes and rocky shoreline. It's one of my favorite places to take pictures, and few people outside the reservation even know it exists (photos on pages 64, 65, 106–107, 109, 160–163, 174, 230–231 and 304 were all shot here). Do you have any favorite and little-known photo-shooting grounds near your home? If not, maybe it's time to go hunting for one.

One pair of legs hangs from the surface of a pool while another extends upward into the depths. Photos of feet that are not in contact with the earth sometimes convey intriguing notes of visual mischief when they are flipped on their heads. Check it out when you're deciding how to best display an image of a person whose soles are not bound to the ground.

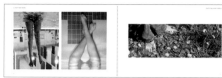

66 67

A set of toes enjoys the heat and texture of a warm lawn on a summer afternoon. The pink paint on the toes and the yellow petals of the dandelions add nice accents of color to the scene.

Got any long-haired friends? What about introducing their manes to a blast of wind and snapping some photos? To freeze the movement of this model's whipping and waving hair, the camera was put in rapid-fire mode and its shutter speed was set for 1/1600 of a second. With these settings, I was able to aim the camera at the subject's head and let it record in bursts of five to ten quick shots at a time. Favorites were chosen from the hundred or so images that were taken during the session.

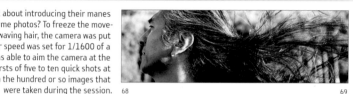

68 69

Actually, the wind was barely blowing on the day this photo was taken. To imitate the effects of windy weather, I sat across from the model in the back of a pickup truck while an assistant sped the vehicle around a deserted parking lot. (I held onto the camera with one hand and the side of the truck with the other.)

Artistic exploration: Hair was used to create the sun-like graphic on this page. The subject lay back with his wetted hair arranged on top of a light table (a table with a surface of frosted glass lit from beneath). Once a photo of the hair had been recorded, it was brought into Photoshop where THRESHOLD and INVERT treatments were applied. The image was then cloned and repeated in a circular array.

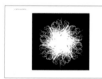

70 71

How about creating an abstract photographic composition using hair and light as mediums? This photo—like the one used for the graphic on the opposite page—was shot by arranging the model's hair on a light table. A handful of round steel beads were sprinkled into the scene to provide visual contrast against the free-flowing strands of hair. A keychain light with a red beam was used to illuminate the beads.

To focus attention on the rose in the near image, its stem and petals were selected with Photoshop's LASSO tool. This selection was used to punch a hole in a BLACK AND WHITE adjustment layer's mask. The adjustment layer's opacity was put at 90%—a setting that allowed a hint of color to show through even in the layer's masked areas. The soft-focus effect of the second image was achieved by placing a blurred duplicate of the original on a layer of its own, selecting "multiply" from this layer's pull-down menu, and reducing its opacity to 20%.

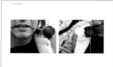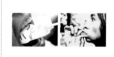

72 73

Passion, pleasure, anger, menace, silliness, humor—mouths are masters of expression. How about spending an entire photo session with a friend and exploring the range of expression that can be generated between a pair of lips, a set of teeth, a tongue and a few props?

5

Talking Hands

Many of the communicative roles of the eyes and mouth can also be performed through hands. For instance, when the mouth is mute, hands can sign, and when it's too far to yell, arms and hands can gesture. Hands also have ways of echoing the emotional conveyances of the face—as when a clenched fist confirms the thoughts behind a wrinkled brow, or when the hands of a gleeful person are clapped in celebration.

Given the expressive talents of hands—and the fact that their communicative powers are particularly well suited to visual media—why not consider featuring hands in addition to (or in place of) the face of whomever it is you're photographing?

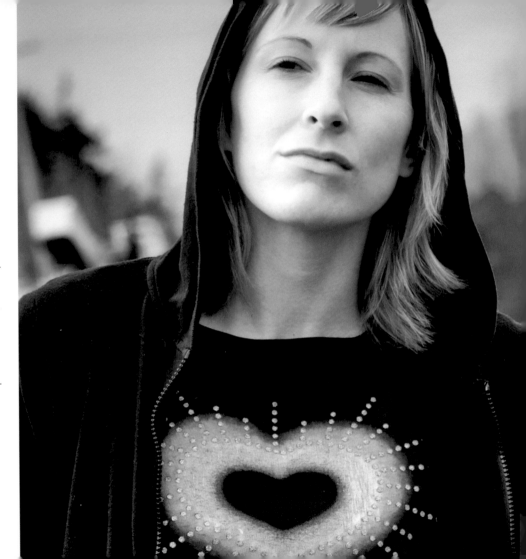

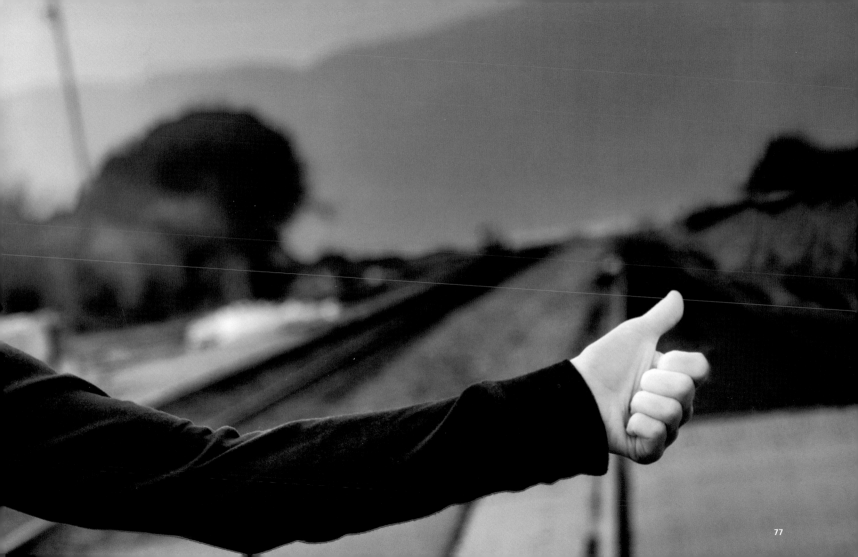

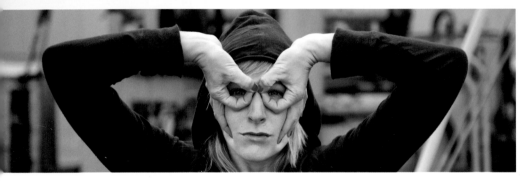
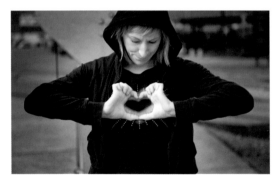

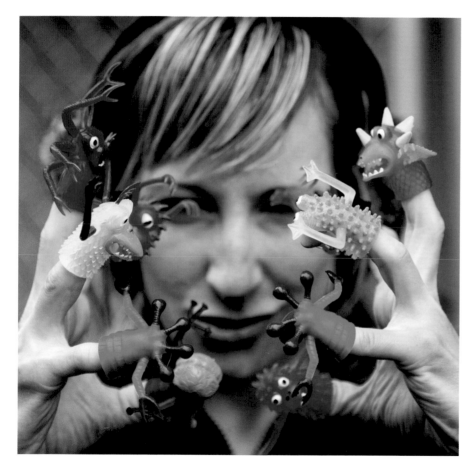

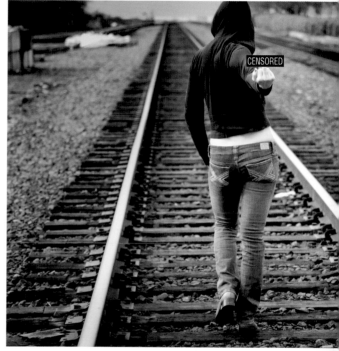

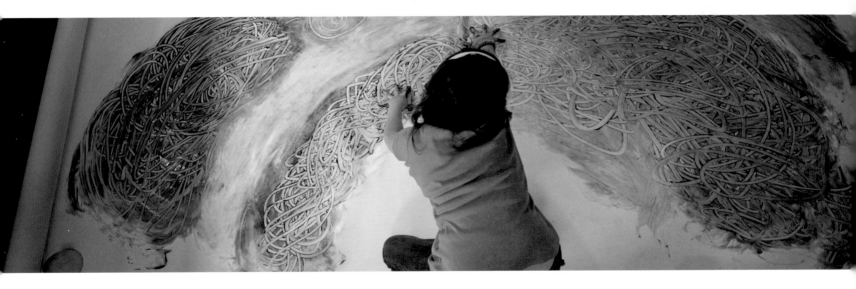

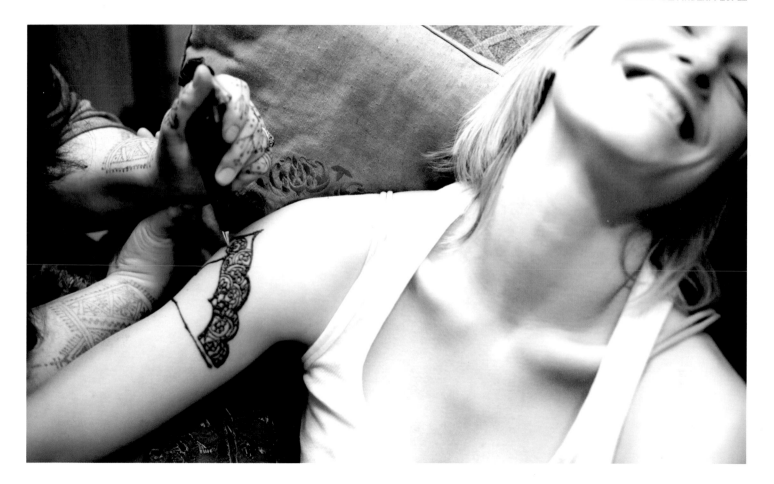

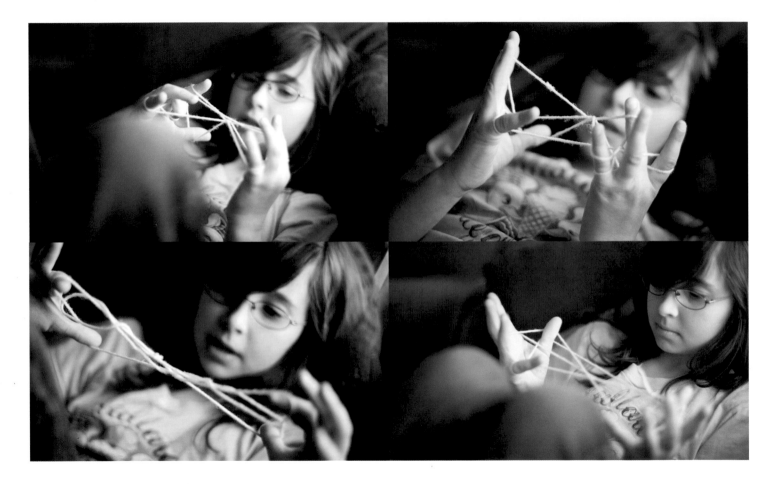

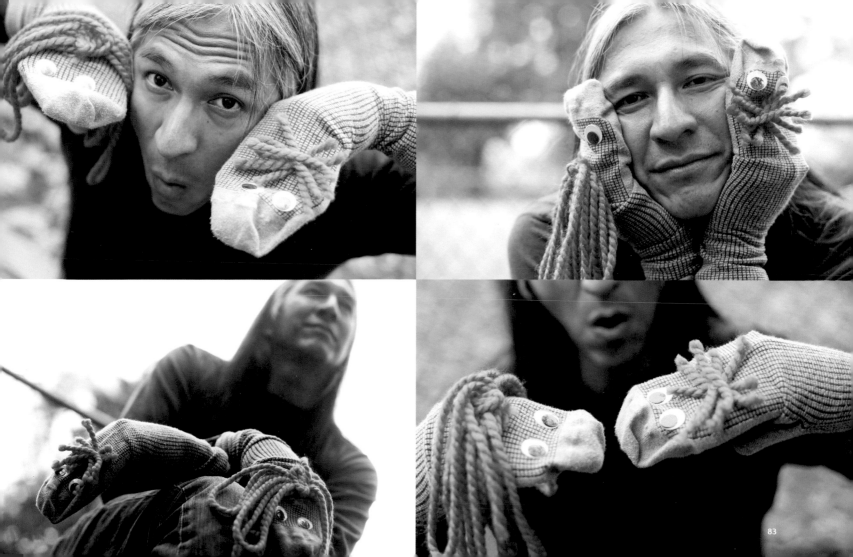

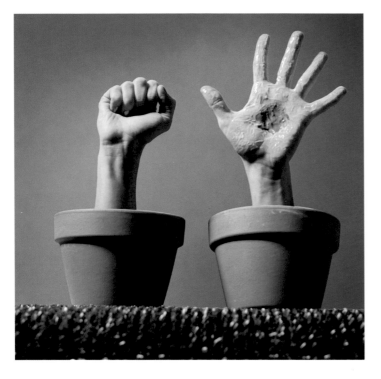

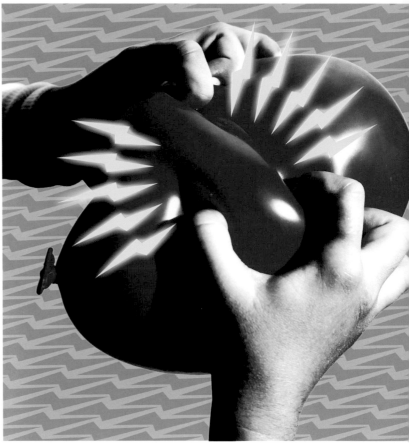

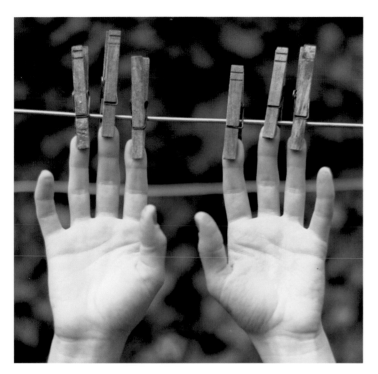

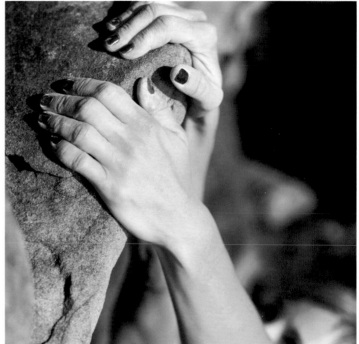

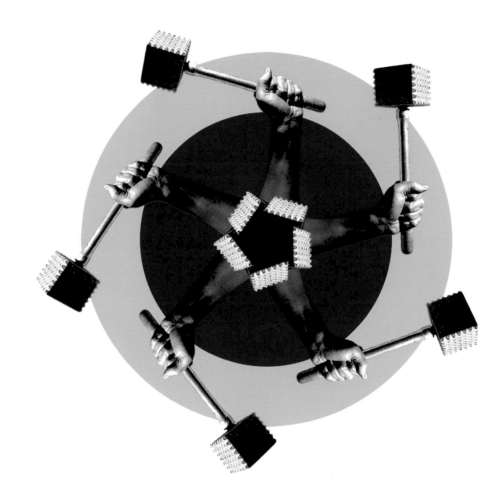

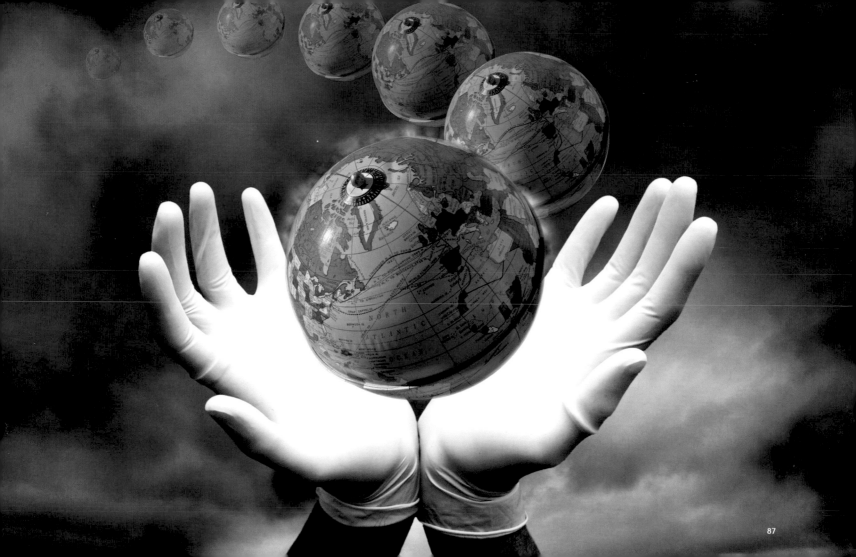

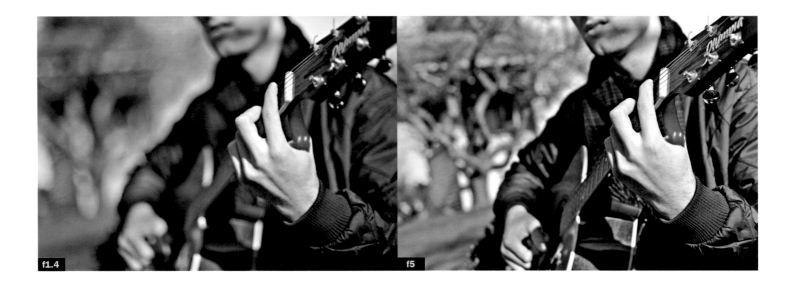

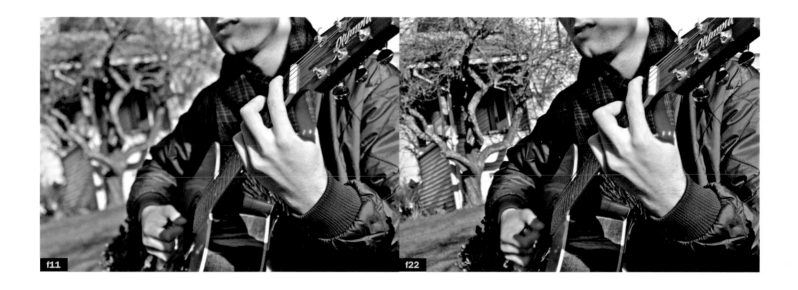

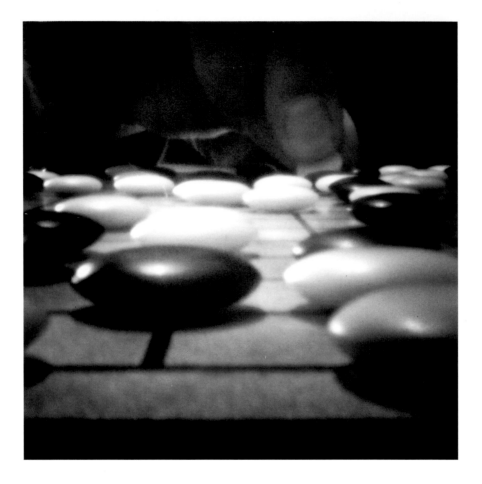

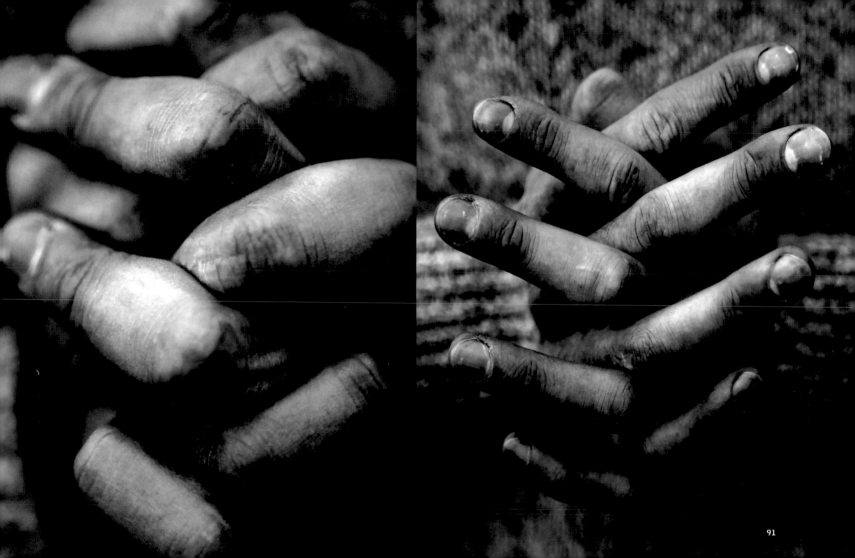

If this woman were using her voice (instead of a familiar hand signal) to call for a ride, we wouldn't be able to discern much about her intentions by looking at the photo. It's her hand—her thumb, in particular—that conveys at least a slice of the story behind this scene. Whether you are taking posed pictures or snapping shots of spontaneous actions, keep in mind the photogenic qualities and communicative abilities of hands and fingers.

76 77

My model and I drove to a railroad crossing near my home to shoot the photos for this spread and the next. I've always seen this particular place as one rich with conveyances of travel, industry, connection, departure, change, fun and sorrow. Given the distant and faintly questioning gaze of the model in this photo, the feeling in this scene tends toward melancholy and uncertainty—conveyances bolstered by the low-key, monochromatic presentation of the photo.

Consider using this "loosening up" exercise the next time you're taking pictures of a friend or client: Have your subject run through a few spontaneous hand gestures and finger configurations (feel free to supply her with ideas if she begins to run short). Not only does this exercise tend to lighten the mood of a photoshoot, it also helps the subject become comfortable with the idea of involving her hands, arms and entire body in the photos that are about to be taken.

78 79

What about supplying your subject's hands with props, such as finger puppets, rings, string, paint, a set of keys, a musical instrument or some coins? Hands can also deliver messages of a less-than-polite nature (messages that can be hinted at even beneath the stamp of censorship), as seen in this page's near image.

In this image, hands find expression through paint and paper. Need something to do with your child, friend or significant other on a rainy afternoon? How about picking up a roll of white butcher paper and some finger paints and initiating some arts and crafts? Include your camera in the fun, too: Have one person paint while the other shoots pictures of the artist and her creation. Explore a variety of vantage points: up high, down low, near and far.

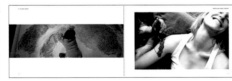

80 81

A laugh passes between a henna artist and her subject. (The ornate design taking shape on the model's arm in this photo can be seen in its final form on pages 98–99.) I decided to lighten the flesh tones in this scene to accentuate the dark color of the henna paste since the image's original colors were saturated and deep. This was accomplished in Photoshop by adding a "deep red" PHOTO FILTER adjustment layer and setting the layer's pull-down menu to "screen." CURVES controls were used to fine tune the image's values.

The shallow depth of field in the quartet of photos on this page was achieved using a 50mm lens with its aperture opened wide. The images were converted to monochrome using Photoshop's BLACK AND WHITE controls (a versatile treatment that allows photos to be tinted once they've been converted to monochrome).

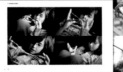

82 83

As a longtime graphic designer, I've spent years composing designs and illustrating images. One thing I've noticed about creating images using a camera is that—for me, anyway—it's a creative outlet that often scores higher on the "fun" scale than processes involving a paintbrush or mouse. Take the photos on this page as a case in point. Not only was it fun to create the puppets from scratch, I also had a great time goofing around with the model as he put the puppets through their paces in front of the camera. Not a bad way to earn a living.

The bottoms of the clay pots in the near image were chiseled open so the model's hands could extend through from below (the pots were supported by planks of wood resting on chairs). An Astroturf doormat was set in front of the pots, and a sheet of paper was hung in the background to complete the scene. The second photo was shot against a sheet of brightly colored paper. The red of the paper was selected in Photoshop and a pattern of illustrated bolts of lightning was pasted inside. Illustrated bolts were also added over the balloon.

 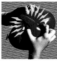

84 85

My model and I noticed some clothespins clipped to a line while taking pictures near an old building. Sensing the possibility of a photo opportunity, we played around with the happenstance find until we came up with this shot. Who knows, a photo like this is bound to be useful for something—maybe as an accompaniment for an edgy article, poem or advertisement. The near image was snapped during the same rock-climbing photoshoot that produced the pictures on pages 242–243.

Here, an iconic graphic has been created by cloning and repeating a photo of a hand clenching a meaty hammer (the "hammer" is actually a wooden meat tenderizer that's been sprayed with metallic bronze paint). The model's arm and hand were given a thin coat of metallic body paint so that their appearance would echo that of the hammer. To finalize the image, the arm-and-hammer graphic was pasted over a simple backdrop of concentric circles.

 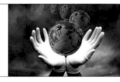

86 87

The hands in this symbolic image were photographed against a blue-screen backdrop. The backdrop was selected using Photoshop's color-sensitive MAGIC WAND tool. A low-key image of clouds was then pasted into this selection. A vintage metal globe was also photographed against a blue-screen backdrop, removed from its backdrop and pasted over the hands/clouds image. The globe was then cloned and resized to create a diminishing trail of worlds. The smaller globes were placed on layers with decreasing levels of opacity.

Demonstrating depth of field, these four photos were taken with the SLR in "aperture priority" mode. The aperture setting was changed for each shot. The camera's primary focus was on the hand in the foreground, so this hand is in focus for each image. Note, however, how the background goes from being a soft blur when the aperture was set at f1.4, to being in nearly complete focus when the aperture was at f22. (Another depth of field demo—this time featuring more than one person—can be found on pages 302–303.)

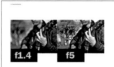 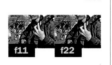

88 89

I generally keep my SLR in "shutter priority" mode. Why? Because if I'm forced to shoot quickly (thus lacking the time or attention necessary to operate the camera in full "manual" mode), I'd rather have some control over the aesthetics of a scene's depth of field than over the speed with which the shutter is operating. The exception to this rule occurs when I know I'll be taking pictures of a rapidly moving subject—in which case I'll switch to "shutter priority" mode so I can choose an exposure time that will properly freeze the action.

A player's hand hesitates before adding a piece to a game of Go (an elegant game of strategy—thought to have originated in China around 4,000 years ago). This image was recorded without a lens—light reached the SLR's sensor through a tiny hole that had been poked through the camera body's protective cap (the plastic cap that attaches to an SLR when no lens is in place). Take a look online to find out more about taking pinhole photos using your digital SLR.

90 91

These are fabulously photogenic fingers. This pair of images was shot outdoors with the subject's back to the sun (thus eliminating strong shadows from the scenes). BLACK AND WHITE adjustment layers were used to convert the images to monochrome. "High contrast blue" was selected from within the BLACK AND WHITE controls since this is a setting that highlights wrinkles, scars and imperfections in flesh (whereas the "red" or "high contrast red" setting tends to hide such blemishes).

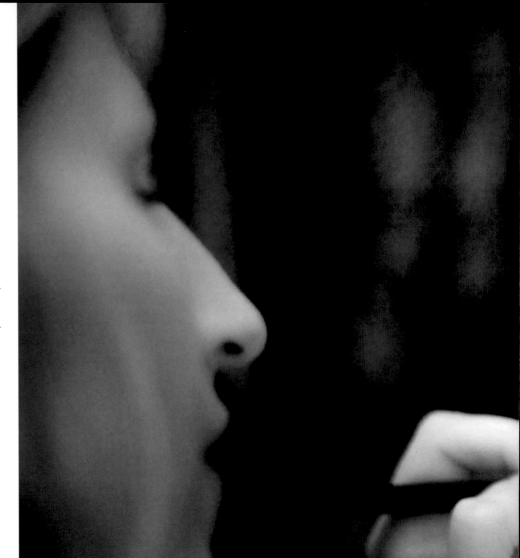

6

Body Decor

Based on some of the earliest known renderings of people, it seems the body has been used as a canvas for expression for a long, long time. And for as long as there have been humans willing to decorate their skin, there have been artists willing and wanting to create depictions of these people and their pigment-enhanced flesh.

Images of subjects whose skin has been decorated with ink, paint, henna or cosmetics can be *captured* by using the camera to record true-to-life photographs. Images of decorated people can also be *created* by using digital effects to simulate the look of appearance-altering body decor. Consider both approaches when using the camera and software to produce portraits of people with decorated skin.

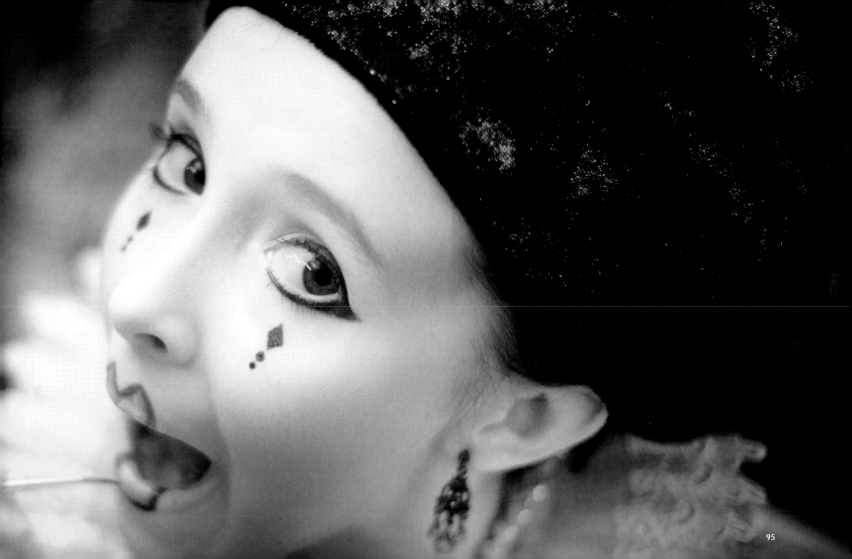

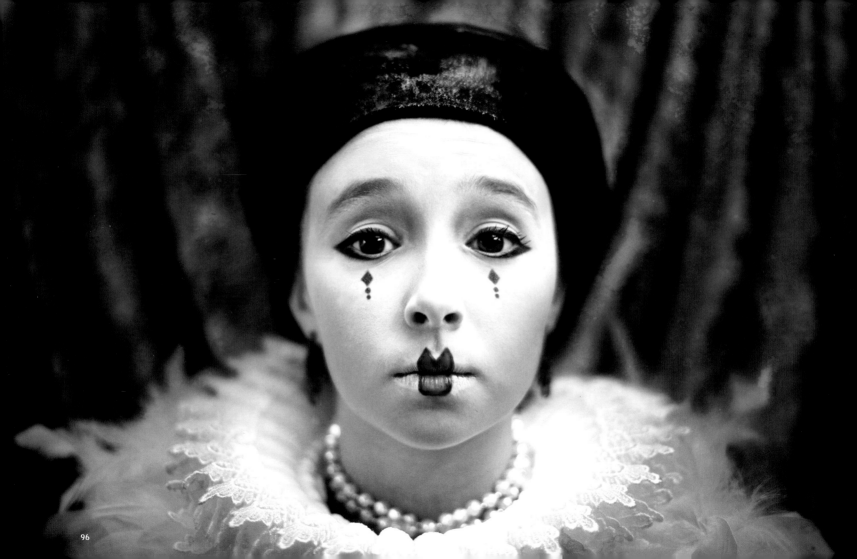

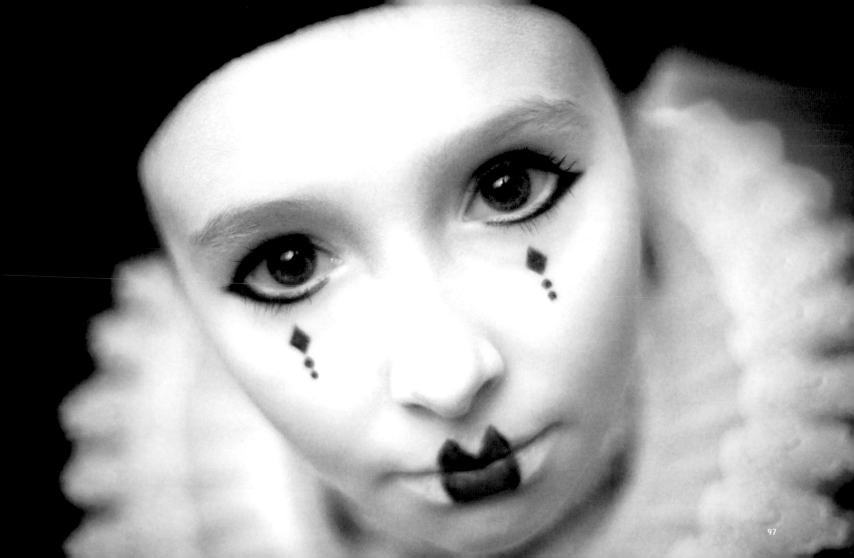

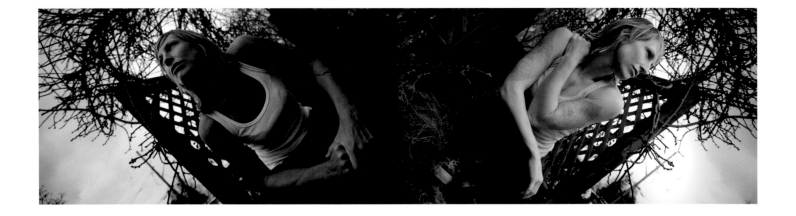

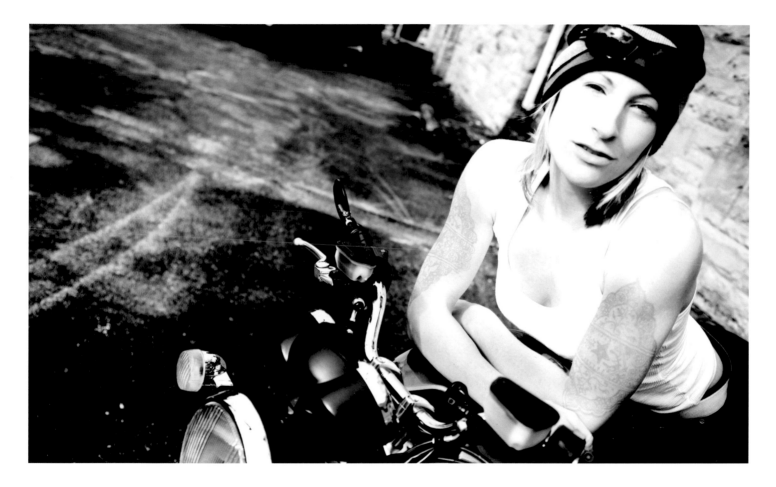

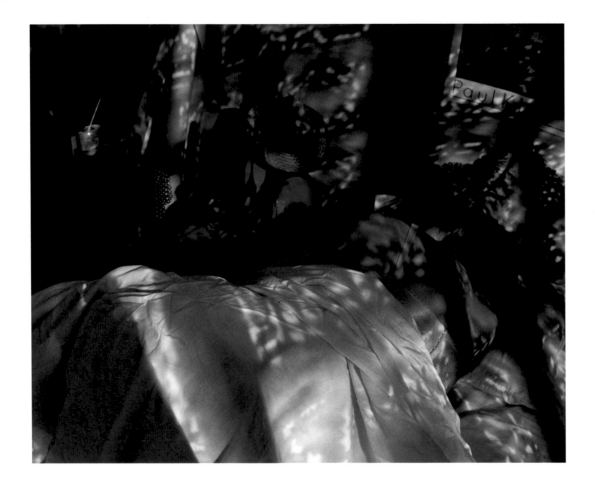

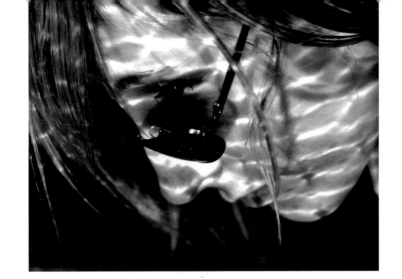

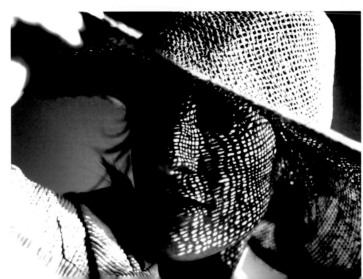

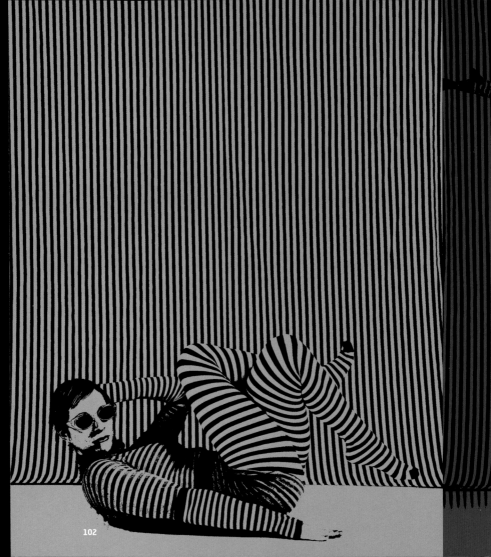

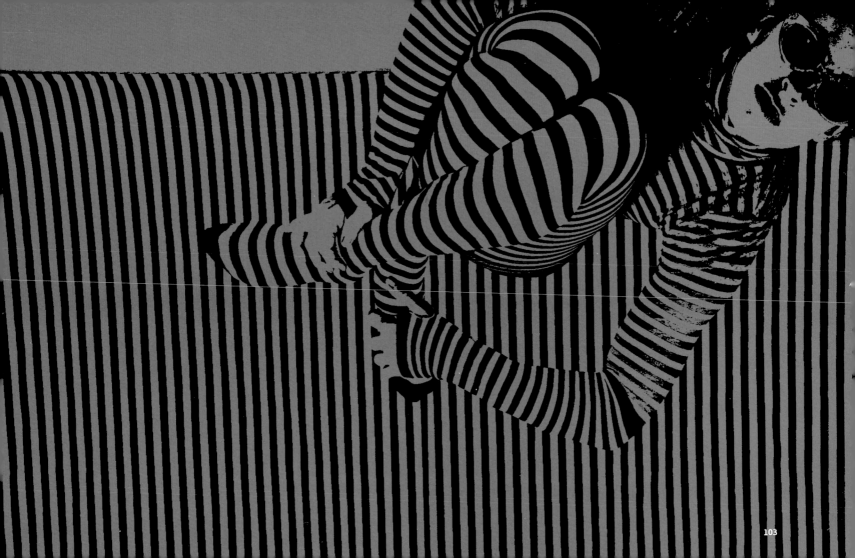

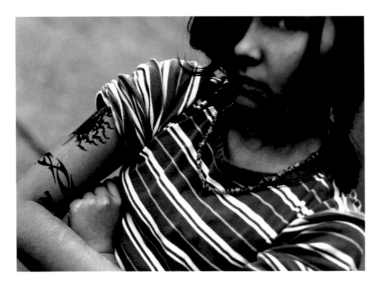
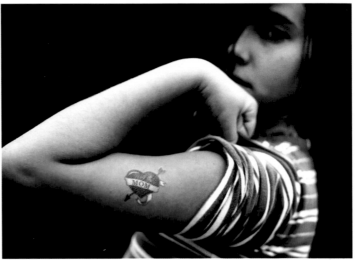

But at that moment he chanced to turn his face so towards the light....

Herman Melville, *Moby-Dick*

...those black squares on his cheeks. They were stains of some sort or other. At first I knew not what to make of this; but soon an inkling of the truth occured to me. I remembered a story of a white man — a whaleman too — who, falling among the cannibals, had been tattooed by them. I concluded that this harpooneer, in the course of his distant voyages, must have met with a similar adventure.

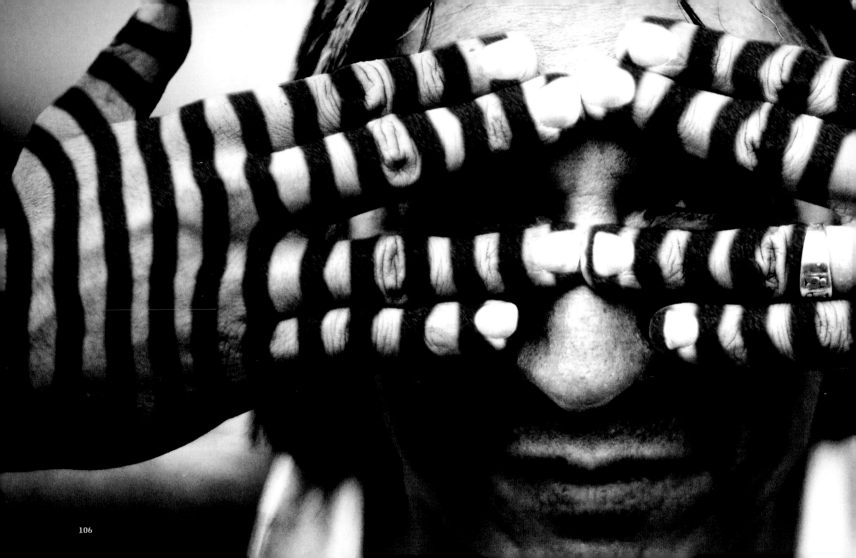

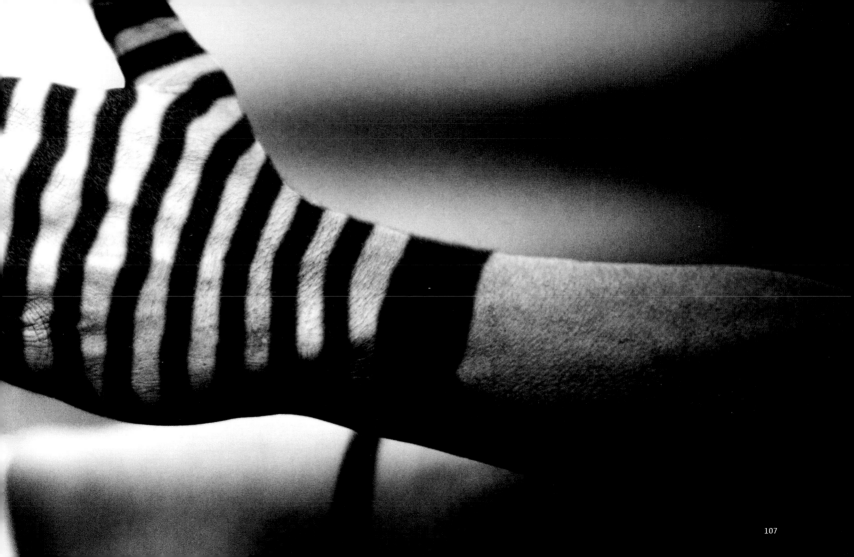

The body can be a moving, breathing and emotionally active surface on which to apply color and decoration, using the flesh as canvas. I enlisted a friend to apply makeup to my model's face for the shots on this spread and the next. It was a fun afternoon for all three of us: my artistic friend got to express herself through the medium of makeup; my young model got a kick out of watching her identity disappear beneath powder and pigments; and I had the pleasure of photographing both the process and the outcome.

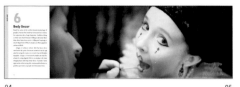

94 95

I know next to nothing about the application of makeup and body decoration. If you are also someone who lacks knowledge of these arts, take heart: that's what friends are for. Most people have connections to someone who knows a thing or two about applying makeup, henna or body paints. Consider working out a trade with a person who possesses these skills—perhaps you could offer to snap some portraits in exchange for her services.

Production notes: The model's collar (a "ruff") was purchased from an online store specializing in Renaissance costumes (the same collar appears in different roles on pages 176–177); the background is a gold curtain that was found at a thrift store; the headpiece is a scrap of shiny fabric that's been wrapped around the model's head and pinned in back; the face powder was purchased at a costume shop; and the makeup came from a convenience store.

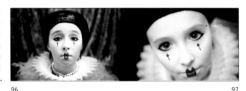

96 97

More notes related to the far image: A 1,000-watt light was aimed at the model from the scene's right. A white panel reflected light from the left. The model sat about three feet in front of the backdrop. The photo was taken with a 50mm lens set at f2.0. Photoshop's BLUR tool was used to soften the focus of the model's ruff and her feather boa. CURVES controls and a "sepia" PHOTO FILTER treatment were employed to finalize the image. The near photo was shot using the room's natural light just after the model's make-up had been applied.

The two pictures on this page were converted to monochrome using Photoshop's BLACK AND WHITE controls. Note the difference in skin values between the two shots: one features relatively dark flesh tones, the other light. This is because "maximum black" was selected from the BLACK AND WHITE treatment's pull-down menu for the near image, and "maximum white" was chosen for the other.

98 99

Henna is a traditional medium used to add designs to flesh. Henna is applied as a thick paste using funneled tubes (in much the same way a cake decorator applies decorations to a cake). Once the paste has dried, it is rubbed away—leaving its skin-staining pigment behind. (And, unlike tattoo ink, henna disappears a few days after application.) See page 81 for a glimpse of the henna artist at work on this model.

Makeup, powder, paint, henna and tattoo ink aren't the only things that can be used to decorate flesh. The sun, too, can add intriguing, unpredictable and fleeting designs to skin. On this page, sunlight streams through the intricate designs of a carved window shade to paint bright designs on the model's back and shoulder—as well as on her bedding and the room beyond. (Okay, so the light is actually from a 1,000-watt halogen bulb, and the "bedroom" and its carved window shade were set up in a studio space—but you get the idea.)

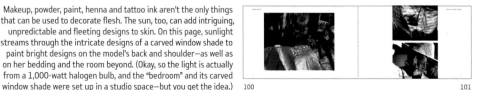

100 101

Sunlight bounces off a textured sheet of metal to project an intense, wave-like pattern in the top photo on this page. In the lower image, specks of sun find their way through the brim of a woven hat and onto the subject's face. A heavy dose of CURVES controls have been applied to this image to make the most of the contrast between light and shadow.

High contrast, high impact. The subject in these photos was asked to dress in striped clothing and to don a pair of sunglasses. Then she was prompted to jump, twist and curl herself in front of a striped sheet of fabric. The photos were recorded under bright light with the SLR's shutter speed set at an image-freezing speed of 1/2000 of a second. The ultra-high contrast of these photos was achieved using Photoshop's THRESHOLD controls. A SOLID COLOR adjustment layer (set to "multiply") was used to add color to the images.

102 103

Other pattern-on-pattern ideas: How about photographing your subject wearing a flower-patterned dress or blouse while she hangs out in a field of daisies or dandelions? What about taking a plain pair of long underwear, covering it with painted polka dots, and then having your model wear this outfit while posing in a room filled with round balls or balloons? How about collecting an armload of patterned fabric scraps, wrapping your model in some, and using the rest as the backdrop for a photograph?

What about using temporary tattoos (the kind that are applied using water and removed with baby oil or rubbing alcohol) to add images or a textual message to your subject's skin? Temporary tattoos can be printed using a special kind of ink-jet paper; they can also be purchased in stores and online in a wide variety of designs.

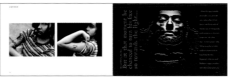

104 105

The text surrounding this subject's decorated face is from Herman Melville's novel *Moby-Dick* (the excerpt is from the chapter where the book's central character meets the heavily tattooed and phenomenally skilled harpooner, Queequeg). The squarish tattoos on the model's face were added in Photoshop after the image had been treated with BLACK AND WHITE and CURVES controls. Got some favorite literary passages that you could combine with customized photos of your own?

The bold artwork on this model's hands were not added with body paint, henna paste or tattoo ink. These stripes were created from 100% electron-based pixels, rendered in Photoshop. The sepia bands were added using the BRUSH tool on a layer above the original image (a layer mask was used to confine the stripes to within the area of the hands and arms). The layer's opacity was set at 80% and its pull-down menu was set to "multiply." A subtle texture was added within the stripes by applying the SMUDGE STICK filter.

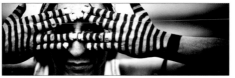

106 107

The presence of the bold stripes in this photo seemed to call for a bold treatment of the image itself. The saturated, high-contrast look seen here was created by adding a BLACK AND WHITE adjustment layer with its pull-down menu set to "hard light." A masked CURVES layer was used to lift the image's values in the especially shadowy area around the model's eyes.

Here, the model has been photographed as an artist displaying a recent painting. Elements from the painting have been digitally inked onto the model's skin. This effect was achieved by creating masks in the areas of the model's arms, hands and feet (using Photoshop's LASSO tool) and then pasting resized and rotated portions of the artwork into these masks. The pull-down menu on the pasted images' layers was set to "multiply."

108 109

The tattooed armband seen in this page's far image is ink on flesh. The ornate swirls in the near image were added in Photoshop (the real armband was removed from this photo using the CLONE STAMP tool). Photoshop offers a variety of tools and treatments that can be used to add effects such as these—sparingly, or in the extreme. With a little practice, patterns, designs, illustrations and photographic images can be added convincingly to the skin of your models.

7

In Character

Two of my favorite things to aim for with a camera are images that reflect absolute reality, and images that absolutely don't. On the following pages, the emphasis is on creating—and taking pictures of— scenes that toy with the notion of life-as-we-know-it.

Interested in recording images of altered reality? How about talking a friend into dressing up in costume and letting you snap some pictures? Or what about taking an ordinary photo of a friend and using software to add a digital costume or mask to the image? Either way, be sure to consider the context in which your character appears. Should he be placed in an environment that matches the look of his make-believe character, or should he be set in an environment that conveys notes of nonsense, humor or whimsy?

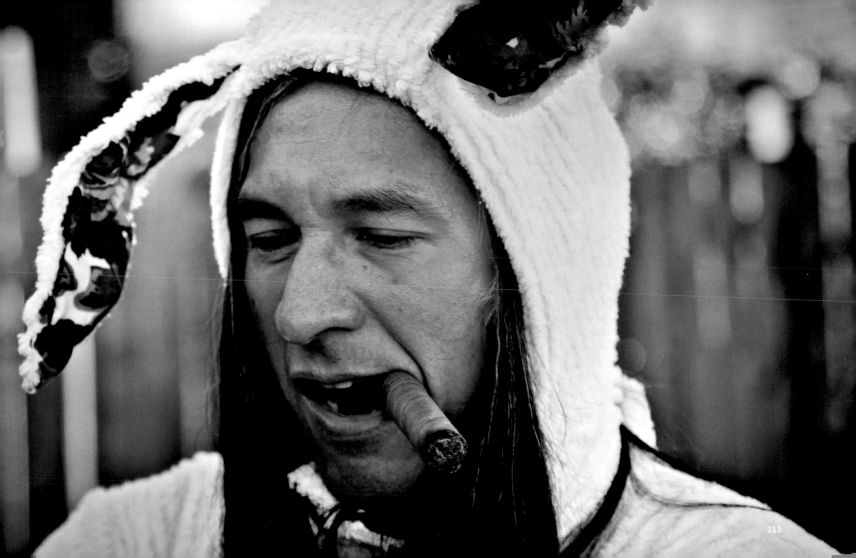

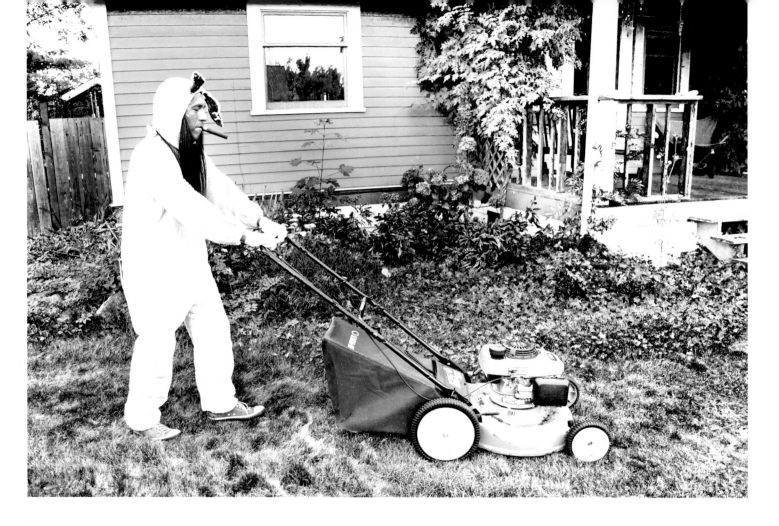

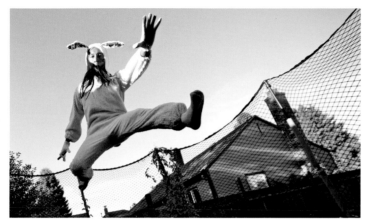
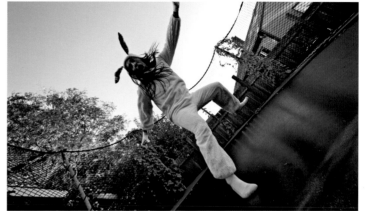
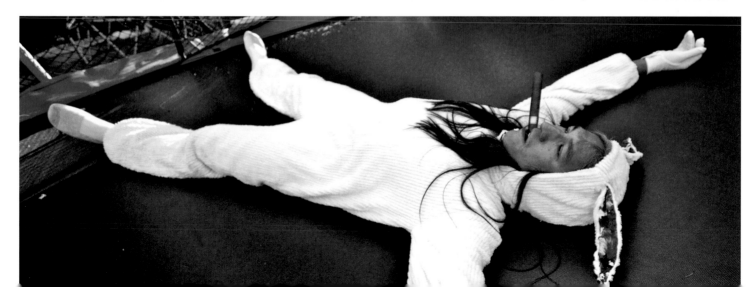

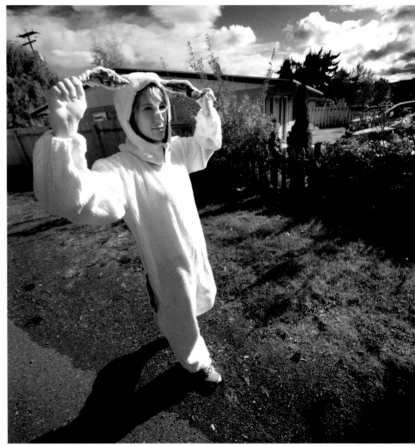

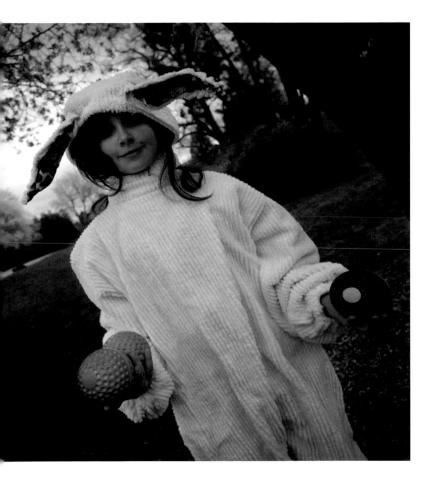

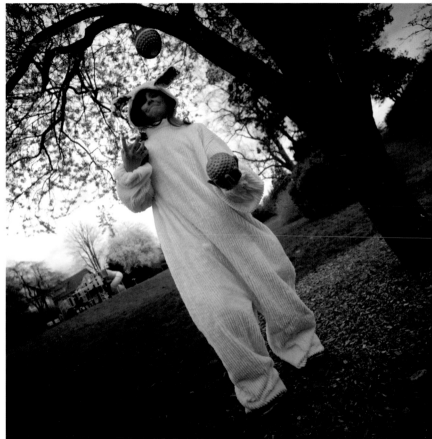

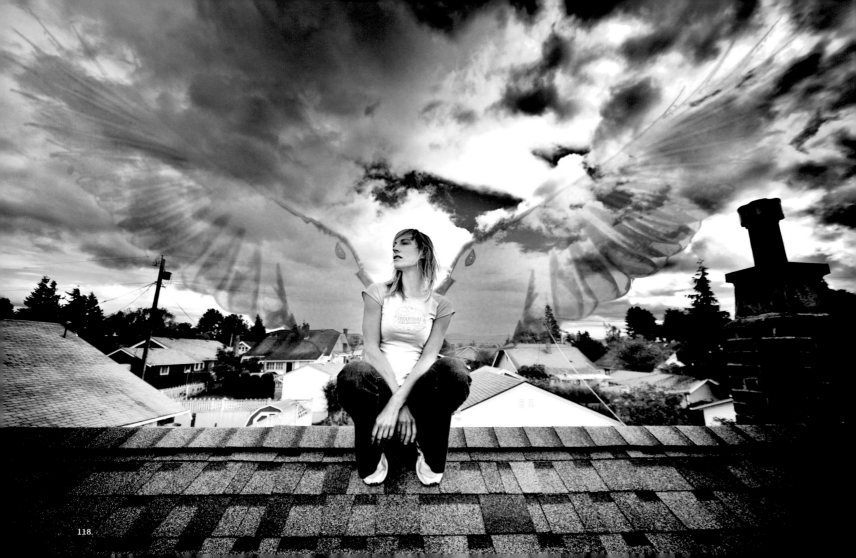

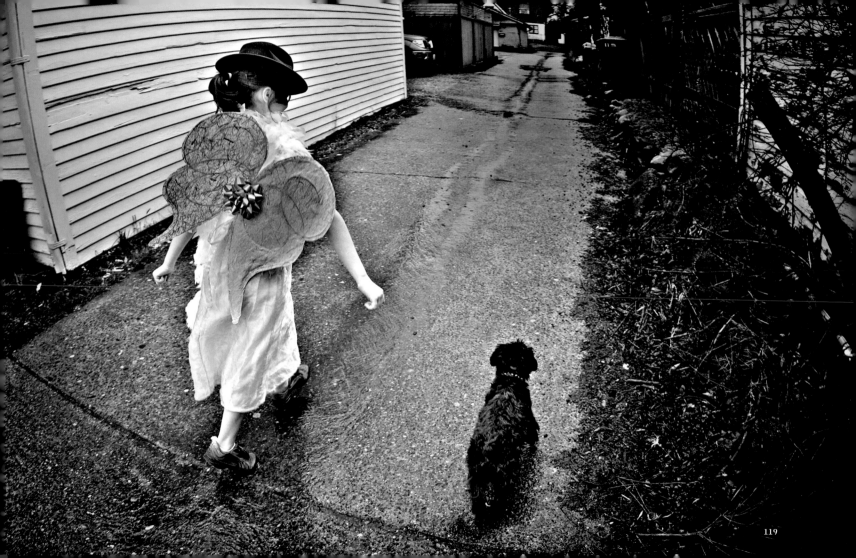

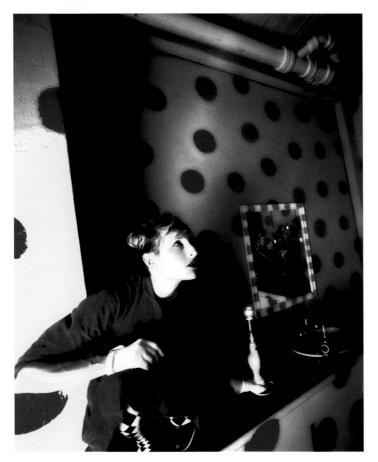
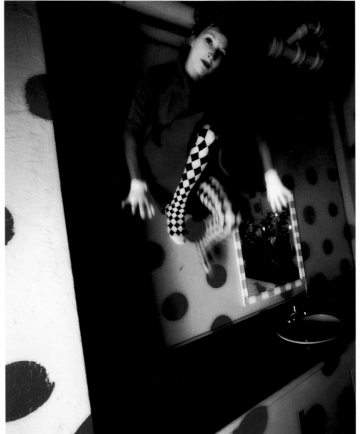

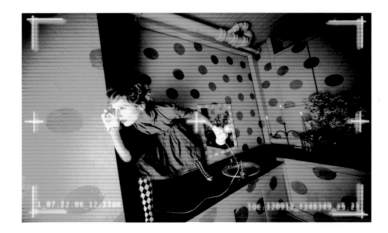

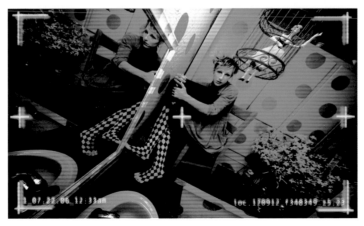

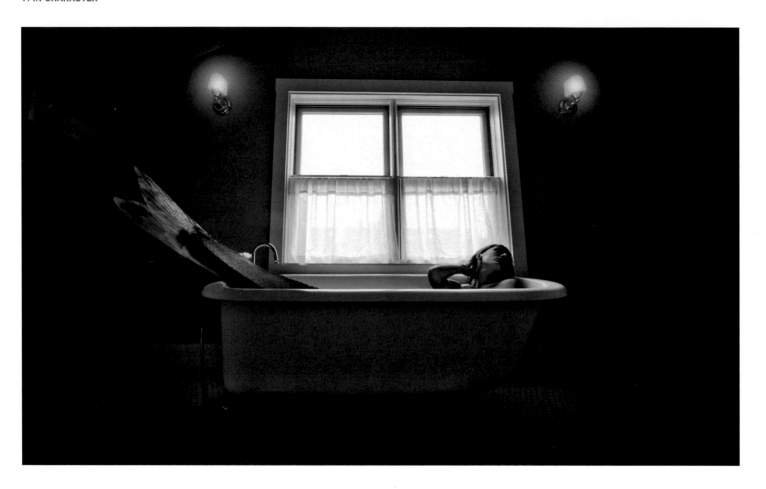

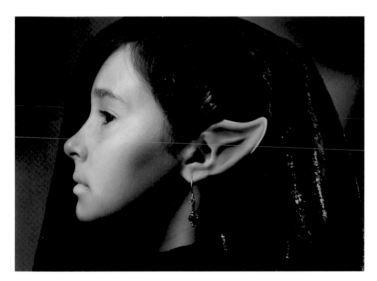

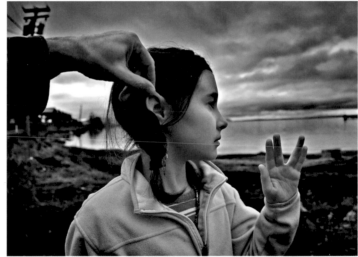

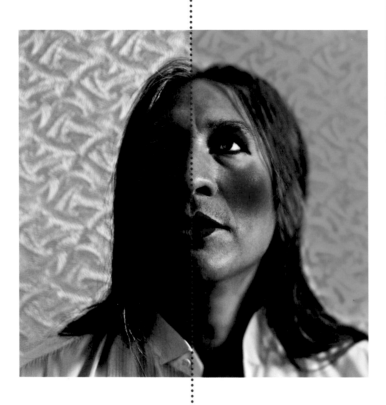

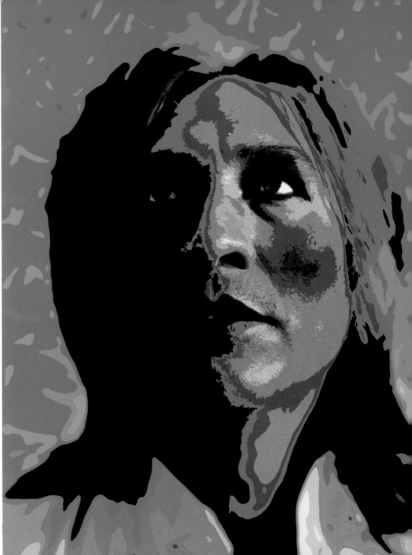

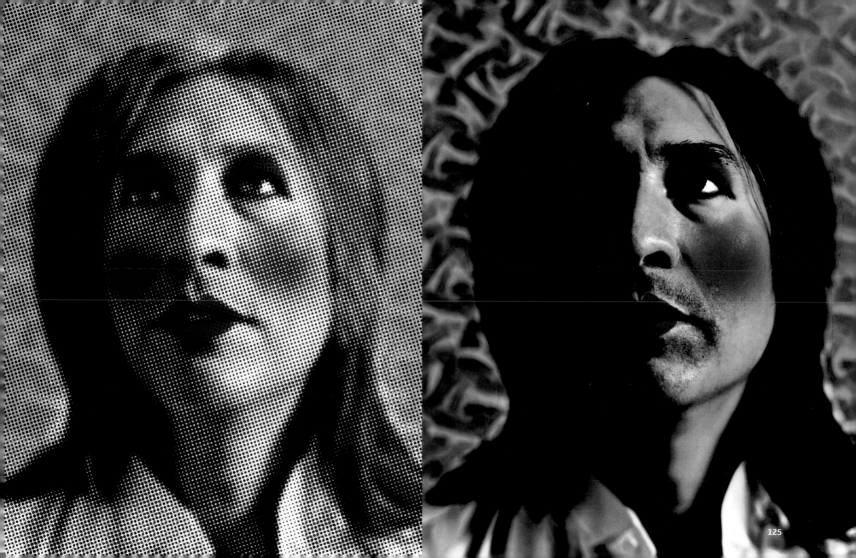

Certe, toto, sentio nos in kansate non iam adesse.

Some authors write fiction, and others write nonfiction. Photographers, too, can be split along similar lines: those who aim for true-to-life images, and those who prefer snapping photos that are more make-believe than believable. I had all three of this book's models pose in the same yellow bunny suit (sewn by a local craftsperson) so I could take photos of them in similar settings and compare the resulting conveyances. Got a one-size-fits-all costume? Got a few friends willing to pose in it?

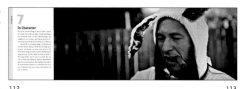

112

113

To expand upon something Freud once said: *Sometimes a cigar is just a cigar, and sometimes a man in a bunny costume is just a man in a bunny costume.* There's no real story to this scene, but one thing's for sure: A photo of a man (or a woman or a child) wearing a bunny suit is almost guaranteed to get a second look from viewers—viewers who might not look twice at a normally clothed person doing something as mundane as smoking a cigar or mowing the lawn.

There's a formula I've noticed in comedy—especially British comedy. The formula has two sides. It either involves ordinary people doing out-of-the-ordinary things (ever seen the Monty Python sketch "The Ministry of Silly Walks"?), or an outrageous character participating in an ordinary task—something along the lines of a giant rabbit mowing the lawn with a cigar in its mouth.

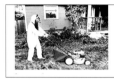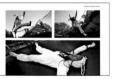

114

115

How can you stop an energetic and athletic model in a bunny suit from having a hop once he's caught sight of a trampoline? Turns out, I couldn't. (This trampoline happened to be behind the house in the lawn-mowing photo, opposite.) Powerless to argue against this unplanned diversion from our photoshoot, I grabbed my wide-angle lens and joined the oversized bunny on the giant backyard toy. It was late afternoon, and when the man-sized hare jumped high enough, his head and ears were lit by the setting sun.

My model discovered the tire swing in the near photo hanging from an apple tree in a vacant lot a day or two before we were scheduled to take pictures using the bunny costume. It seem like too good an opportunity to pass up. The second photo was actually snapped as we were walking from the parked car to the tire swing. (I mention this detail as a reminder that—when it comes to photoshoots—it's never too soon to sling the camera around your neck and start taking pictures; you never know when a photo opportunity will arise.)

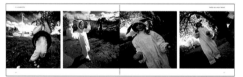

116

117

And finally, it was the youngest model's turn to climb into the bunny suit. Color-muting HUE/SATURATION adjustment layers were used to restrain hues in the periphery of these scenes. Adjustment layers come with masks that can be selectively opaqued to block their effects. To preserve the colors in the model's costume and juggling balls, the BRUSH tool was used to fill in these areas of color-muting adjustment layers (thus allowing the photos' original colors to escape these masks' effects).

A pair of digitally rendered wings have been added to this rooftop portrait. Drawn in Adobe Illustrator, the wings were copied and pasted into a layer above the original photo. "Overlay" was selected from the upper layer's pull-down menu. A PHOTO FILTER treatment (set to "underwater") was applied to the base image so the warmly hued wings would stand out well against the aqua-tinted clouds beyond. A CURVES adjustment layer was used to add contrast to the composite image.

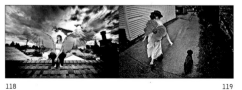

118

119

A pair of paper wings hangs loosely from the shoulders of this subject as she makes her way through an alley with a furry friend. Try the "following your subject as she walks" camera angle sometime (and follow from slightly off to the side of your subject so that your camera can catch hints of her face). To help your chances of recording a moment when your subject's feet are in a photogenic, mid-stride position, set your camera in continuous-shooting mode and snap your images in bursts of three of four quick shots at a time.

Know of any fancifully decorated homes or rooms nearby? Interiors that could provide a ready-to-go setting for a whimsically themed photoshoot? I know of just such a room: the polka-dotted restroom in a Belgian bakery in my hometown. Fortunately for me, my model worked next door to the bakery and was able to gain permission to use the space for a photoshoot after hours.

120

121

Something about snapping photos in a bakery that was closed for the night made me think of surveillance cameras. I decided to colorize these two images and add some faux-lettering and linework to mimic the look of security camera images. The effect definitely adds a candid note of secrecy to the goings-on within the scenes.

The rare, long-finned mermaid seen taking a bath in this image was actually born in a layered Photoshop document—not the depths of the sea. A photo of the tail of a small fish (a smelt, purchased at a grocery store for 24 cents) was added to an image of the model reclining in a claw-foot tub. The image of the smelt was pasted into a layer of its own—a layer that included a mask that hid the fish's fore-half behind the tub's rim.

122

123

How about purchasing a collection of inexpensive costume props, like plastic ears, wigs, gloves, funky glasses and fake teeth? They're bound to be of service one day when you are brainstorming for ways to have some fun with your camera and a friend. On the other hand, if you want to snap some fanciful shots but don't have any costume props on hand, you can always improvise (as demonstrated in the near photo).

How about blurring the lines of gender with Photoshop's BRUSH tool? (A glimpse of the original photo—before and after airbrushing—is featured in the near image.) And why stop there? What about exploring some of the more exotic artistic enhancements offered through Photoshop's list of filters and treatments?

124

125

The treatments applied to the three large images on this spread are, from left to right: ARTISTIC > CUTOUT; PIXELATE > COLOR HALFTONE; and ARTISTIC > FRESCO. The majority of this book's images are presented using effects that mimic the outcomes possible through traditional darkroom processing effects. If you are interested in outcomes of the more nontraditional variety, Photoshop offers endless possibilities.

Plastic horns and phony fangs transform this bright and huggable youngster into a disquieting figure of the dark. A single bulb was hung above the model to achieve the moody lighting on her face. A separate light was beamed onto the dark fabric behind the model so her head would stand out well against the backdrop. Blackletter typography was added to the photo to lend it a gothic flavor. (The phrase, in Latin, translates as, *You know, Toto, I have a feeling we're not in Kansas anymore.*)

126

127

Photoshop's PHOTO FILTER treatment was used to tint the image on the opposite page. The model's lips were painted using the BRUSH tool. The subtle vertical texture in the image was achieved by pasting a photo of a piece of linen into a semi-opaque layer above the original (the upper layer's pull-down menu was set to "screen.") In the near image, the appearance of the devilish character has been reinterpreted using a fisheye lens. If you have multiple lenses for your SLR, consider switching things up mid-photoshoot.

8

Masking Identity

When shooting a portrait, a photographer's usual goal—at the very least—is to capture recognizable impressions of the person being photographed. And as admirable as that goal is, have you ever considered how much more fun you might have with portraiture if you tried to hide your subject's identity? At least occasionally?

Here's an idea: From now on, every time you set out to record a portrait (whether as part of a formal sitting or an impromptu photo session) take at least one or two shots that introduce a theme of anonymity to the scene. Consider using a mask, hair, clothing, props, body position, light or shadow to obscure the identity of whomever it is you're taking a picture of. An accumulated collection of these hidden-identity photos could make for an intriguing series.

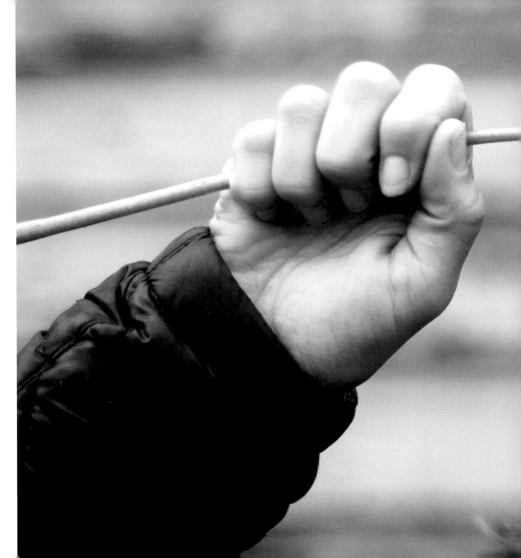

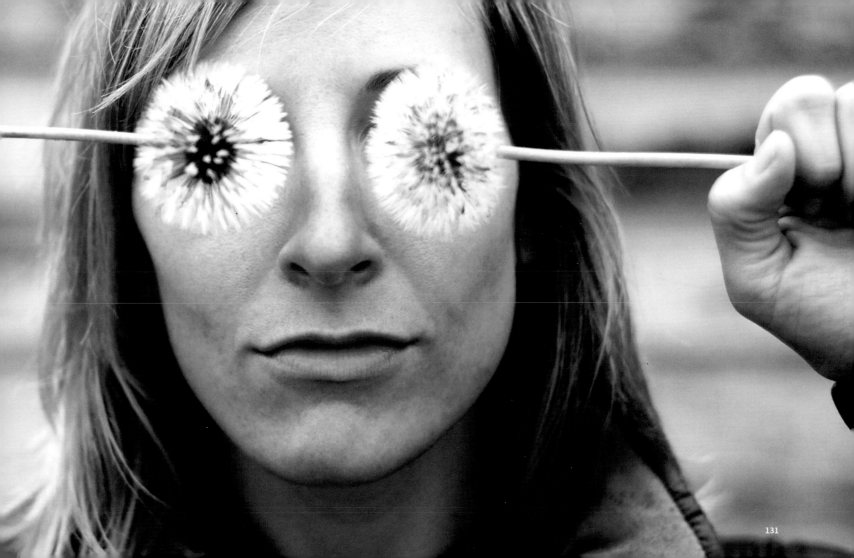

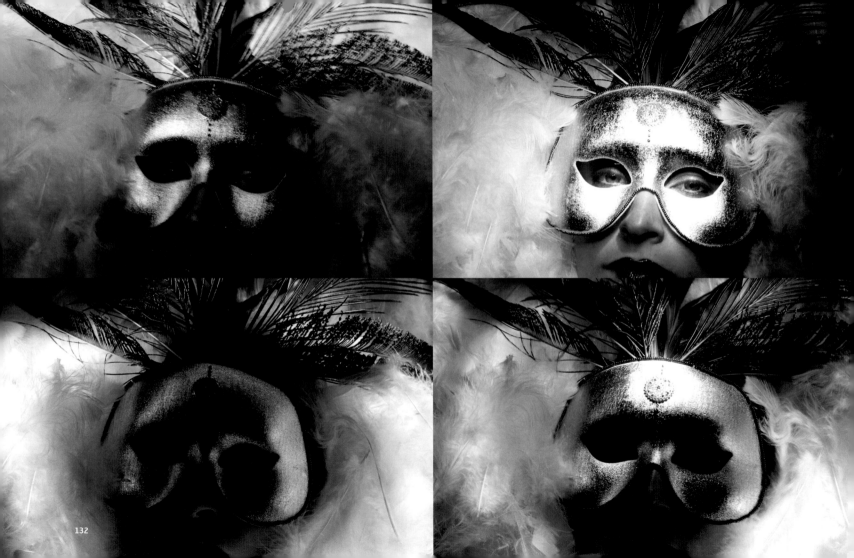

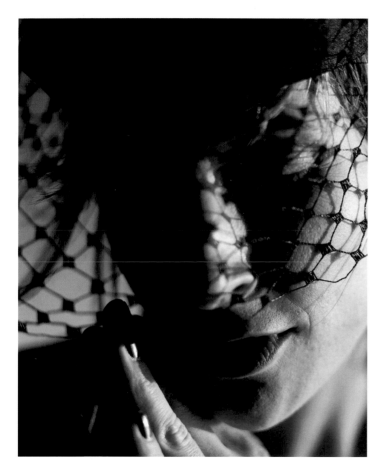

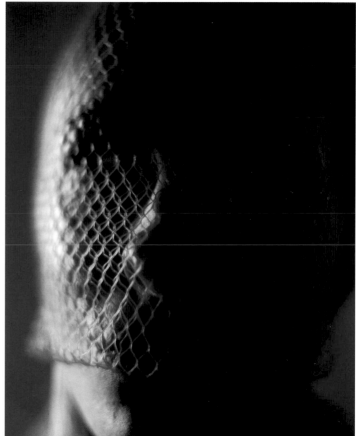

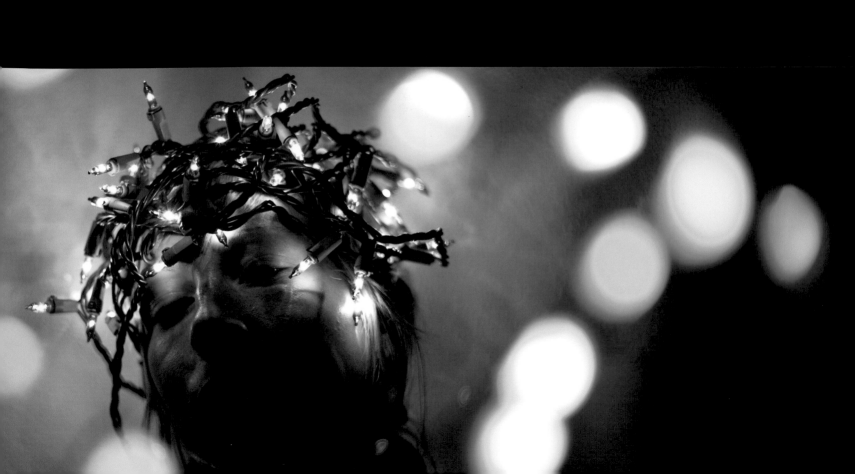

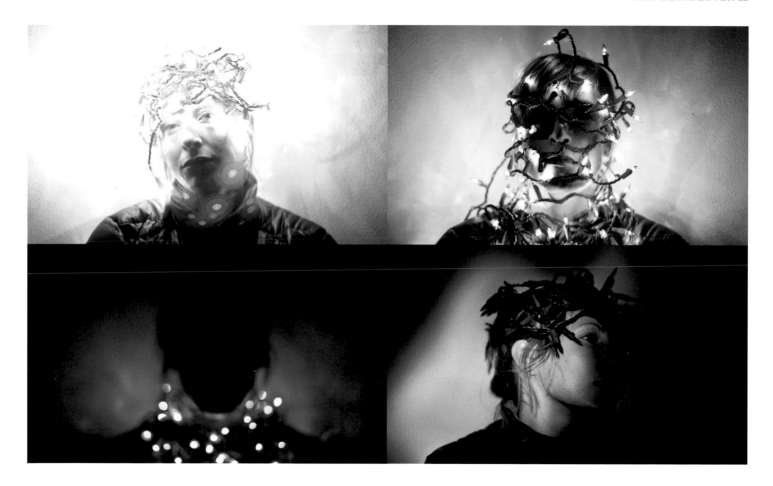

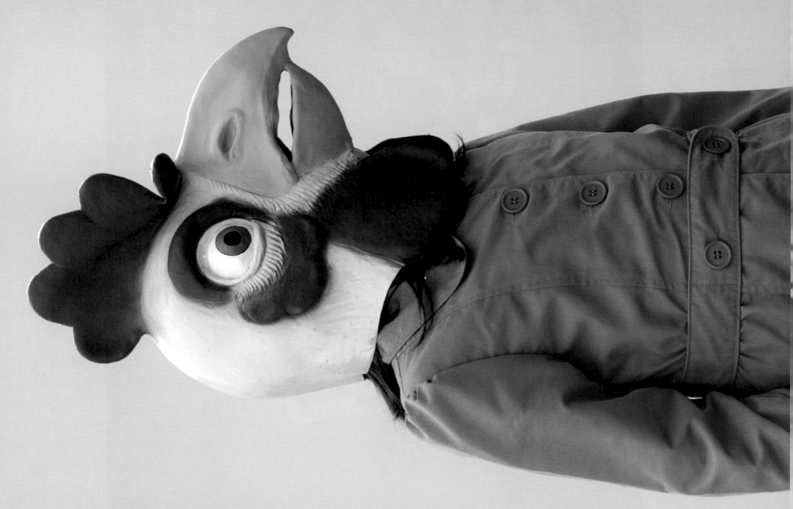

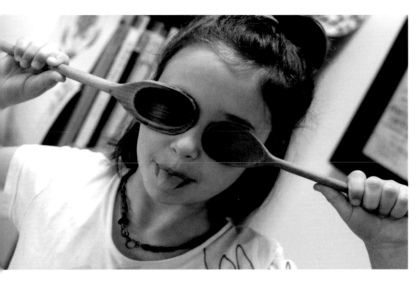

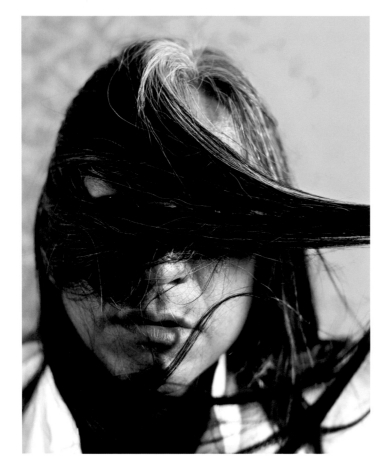

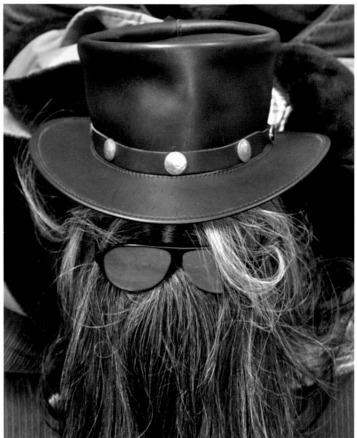

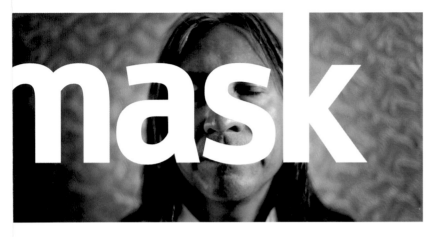

mask

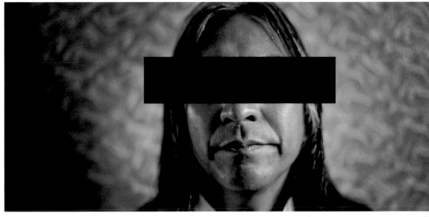

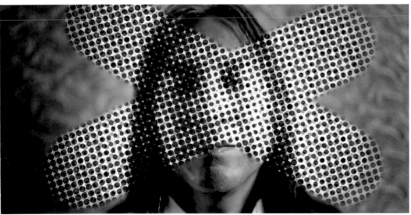

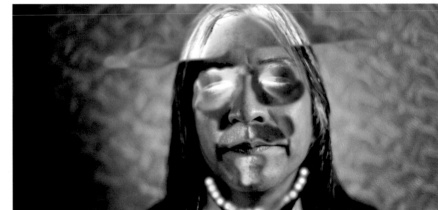

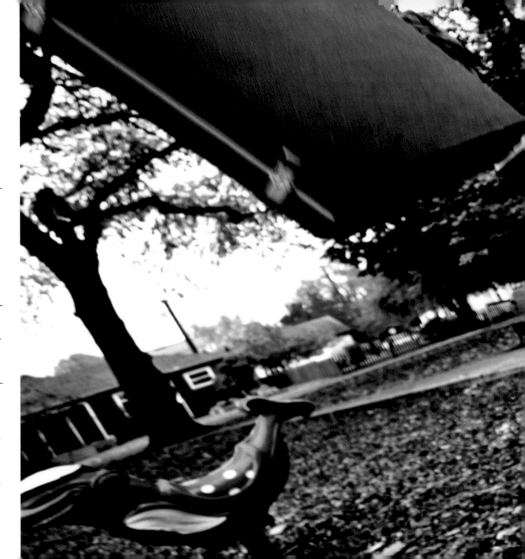

9

All Dressed Up and...

Picture a man wearing a business suit in an immaculately appointed executive office. He's sitting behind a desk of polished oak adding his signature to a sheet of stationery with an engraved fountain pen. Now imagine a child wearing a pair of shorts, a propeller beanie and a colorful sweatshirt playing in a park. Nothing particularly unusual or attention-grabbing on the surface of either scenario, is there?

But what if things were switched up? What if we handed the gold-plated fountain pen to the child and placed her in the swank setting of the executive's office? And what if the dressed-for-success businessman grabbed his briefcase, took a cab to a park and went for a gonzo ride aboard a springy playground toy?

Now, all of a sudden, things are starting to look a little more interesting. Wouldn't you agree?

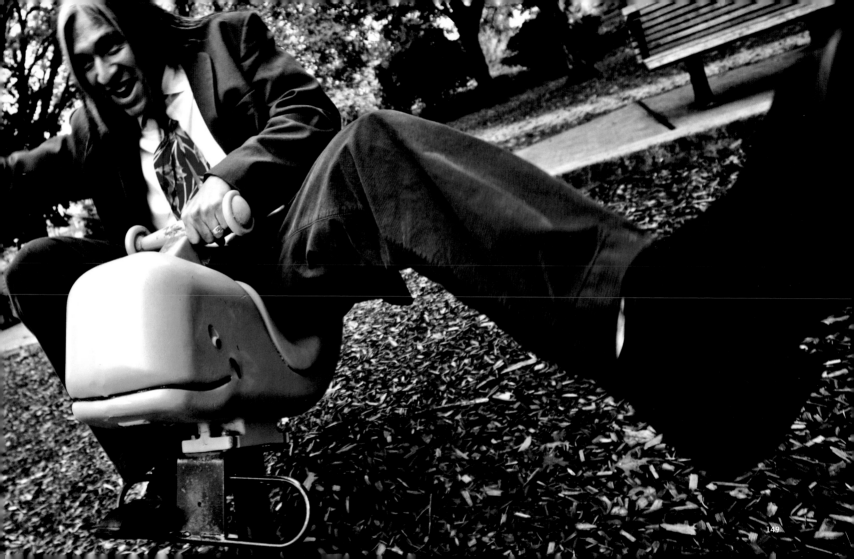

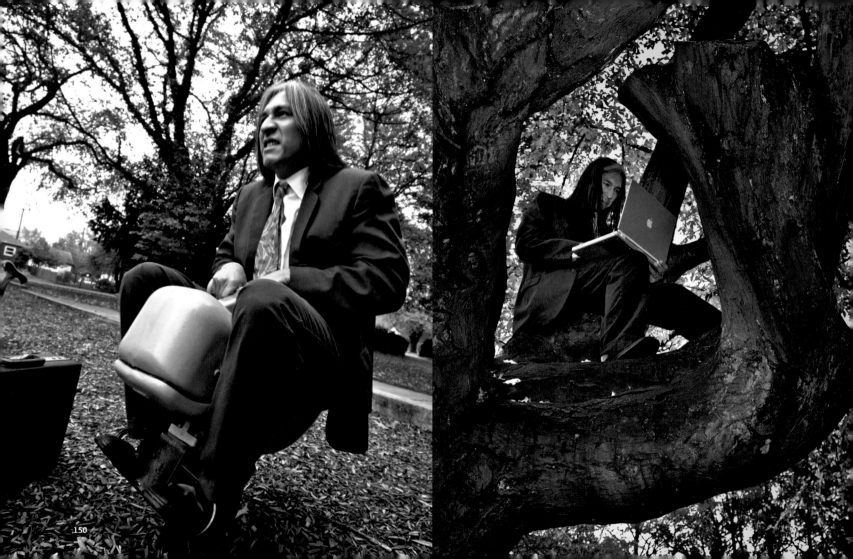

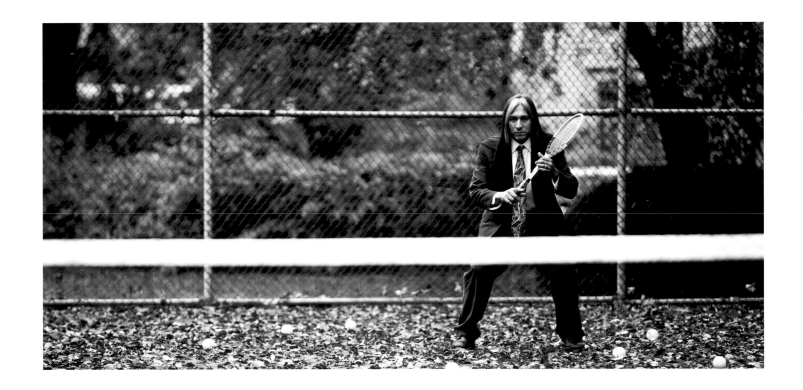

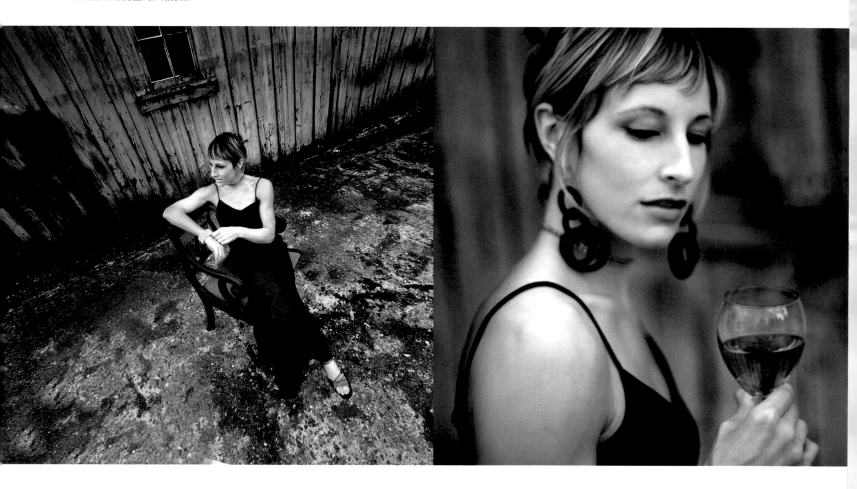

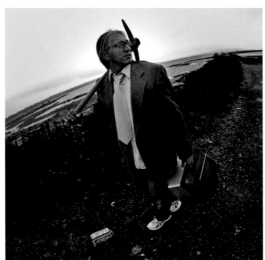

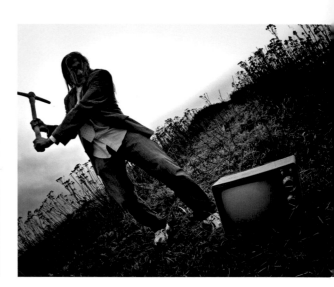

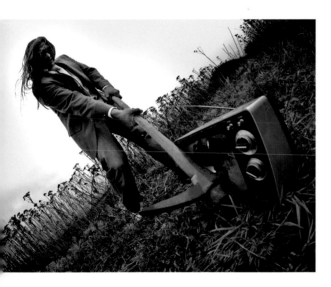
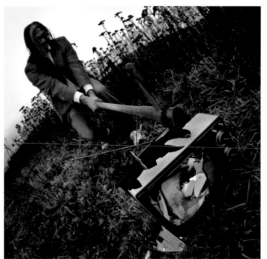
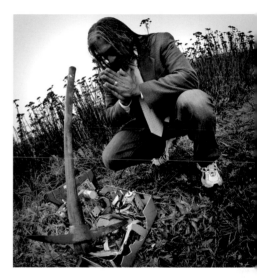

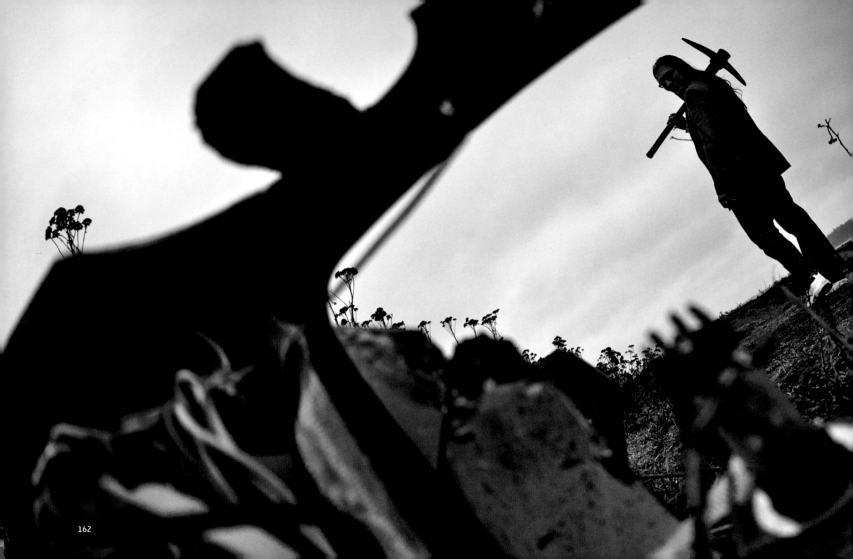

Ride 'em, businessman. In this image, the model hams it up on board a playground rocking-whale. In the next spread's photos, his delivery is more deadpan. When it comes to photographing a person who is dressed for one activity and being photographed doing another, half the fun is exploring the effects your subject's facial expressions have on the scene's conveyances. Try out as many ideas as you can when shooting so you'll have a plenty of options to choose from afterward.

148 149

A 12–24mm wide-angle lens was used to capture this photo and the first one on the next spread. If you're willing to accept some distortion in your images, get as close to the action as you can when shooting with a lens like this (the model's foot in the foreground of this scene was only a few inches from the camera when the photo was taken).

A model willing to put on a business suit and ride a child's toy, climb a tree carrying a laptop and stand in the rain holding a tennis racquet in November is worth his weight in gold. I ran into this fellow at an airport in 2007 and ended up asking him if he'd work with me on this project. A lucky find indeed. Are you the kind of person who finds it easy to approach strangers and ask if they'd like to be in pictures? I'm not(!), but so far I have yet to receive a "no" from anyone I've been brave enough to ask.

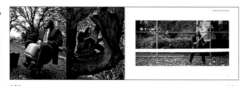

150 151

A businessman with a racquet awaiting a serve on a leaf-strewn tennis court—is it a photo or a riddle? How about both? Advertising executives love images that seem to promise a compelling message or punch line without quite giving away what that message or punch line is. Why do advertisers like photographic riddles so much? Because visual puzzles encourage the viewer to seek answers in the headline or text of the advertisement in which they appear (and advertisers just love it when people read their ad's text).

A spotlight effect has been used to highlight context-bending portions of these two images. This effect was achieved in Photoshop by adding CURVES adjustment layers to darken each image significantly. Holes were cut into the adjustment layers' masks using a soft-edged BRUSH tool. Both images were also treated with a warming PHOTO FILTER effect and a color-boosting application of HUE/SATURATION controls.

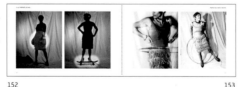

152 153

Cooling PHOTO FILTER adjustment layers (set to "underwater" at 60%) were applied to the images on this page. The adjustment layers' pull-down menus were set to "screen"—a setting that lightened the photos' values considerably while tinting the scenes' backdrops with a hue that contrasted nicely with the model's red dress. CURVES controls were used to fine tune the presentation of both images.

This scene is all about contrast (both visual and conceptual): A brick wall covered in a tangle of leafless vines vs. a smooth steel door; a well-dressed model vs. a back-alley setting; bright blues vs. dull grays; and a strongly vertical pose vs. a decidedly horizontal image format. BLACK AND WHITE adjustment layers were added to both the images on this spread. The adjustment layers' masks were used to block their effects in areas of the model's clothing and her blue wig.

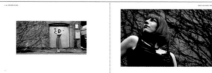

154 155

Up and out; the model's gaze, the cut of her hair, the angle of her shoulders, the slant of the image, the flow of the vines in the background—pretty much everything in this photo points to, and beyond, the scene's upper left. The strongly directional composition of this photo is very different from the extremely static presentation of the image opposite. Be decisive when framing a scene. Aim for compositions that are what they are: straight and level, skewed, minimalist, complex, precise, jumbled, angular or curvaceous.

Here, our well-dressed model has been placed in an environment where the smooth fabric and fine cut of her dress stand out sharply against the aging siding of a barn and its crumbling concrete surrounds. These images were taken during the same photoshoot that produced the images on pages 170–171—shortly before the model decided to have a dance with the wooden chair (the glass of wine seen on this page may or may not have had anything to do with that decision...).

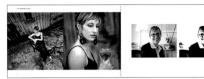

156 157

If you are a graphic designer working on a promotional material for a client and want to add a little zest to the piece, consider applying a high-contrast treatment to the photos of your client's employees and executive staff. To convert the ordinary original on this page into the modern, high-contrast image to its right, a PHOTO FILTER adjustment layer (set to "orange" at 50%) was used. The adjustment layer's pull-down menu was set to "vivid light."

Faux jewels on a pair of over-the-top eyeglasses add sparkle to a relatively cheerless streetscape beyond. A 15mm fisheye lens was used to record this scene. It's difficult to coax a shallow depth of field from a wide-angle lens, but I was able to do just that here by opening the lens' aperture to its maximum and shooting from as close to the subject as the lens would allow (about eight inches).

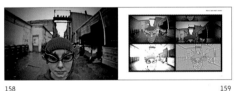

158 159

These four variations were created with the set of "other" options available at the bottom of Photoshop's pull-down menu of filters. Clockwise from top left, the filters used for these images are: OTHER > MAXIMUM; OTHER > OFFSET; OTHER > CUSTOM (try this filter and see what happens when you insert different numbers into its grid of settings); and OTHER > HIGH PASS.

A story is told on this spread and the next. It's the story of a man whose displeasure with television has led to a bold course of action. A fisheye lens was used to record the images in this sequence. The lens' extremely wide field of view allowed me to get very close the action while taking in enough overall detail to show what was happening in each scene.

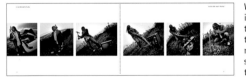

160 161

Why include this tale-telling series of images here, instead of in chapter 11, Suggesting Story? Because of the model's attire, that's why. By dressing the model in the clothes of a city slicker, the distance between where he is now and where he normally resides has been emphasized—along with the notion that the subject has felt the need to travel to a location remote enough to allow for an unhindered demonstration of his feelings toward television.

I had to lie flat on my belly to record this final shot of the storyboard. The vacant face of the television did a nice job framing the model as he took one last look at his handiwork. I chose to tilt the camera as I composed each of this series' images to lend feelings of unsteadiness and zeal to the scenes.

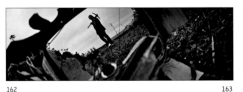

162 163

Sidenote: While it's true that a real-life television was harmed (terminally) during the making of this storyboard presentation, no debris was left behind. My model, assistant and I painstakingly raked the grass and used our fingers to collect every last fragment of plastic, twisted metal and shattered glass before departing the scene.

10

Playing With Props

In theater, the word "prop" usually refers to an object that has been intentionally added to a scene. A prop could be a pencil, a plant, a pillar or a piano. On-stage props can be used as backdrop items, or they can be worn or handled by a performer.

This definition of a prop also applies to photography, but when it comes to taking pictures, the definition doesn't end there. In photography, anything a photographer comes across during a photoshoot has prop potential—whether or not the item was originally intended to be used as such. And not only is it up to the photographer and the model to decide what objects should be counted as props, it's also up to these individuals to decide whether the items should be used in ways that are logical or illogical, planned or improvised, serious or silly. The pages ahead provide examples of all of the above.

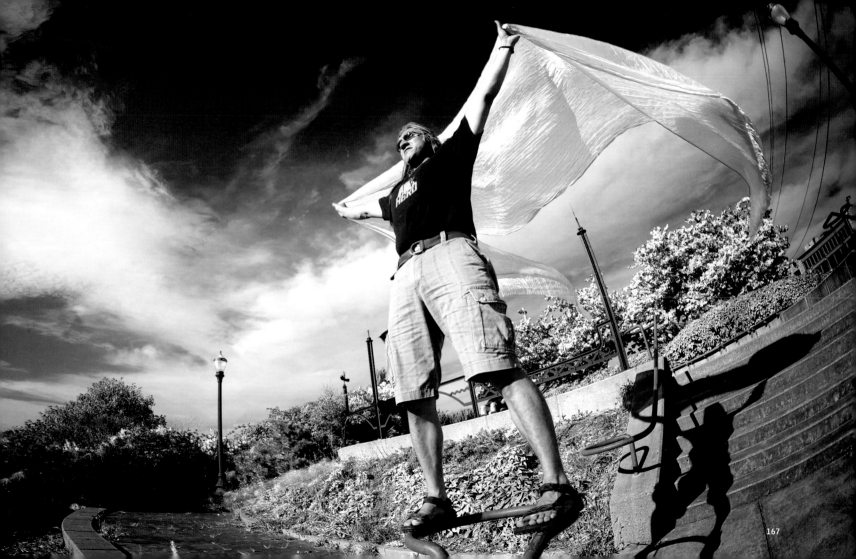

167

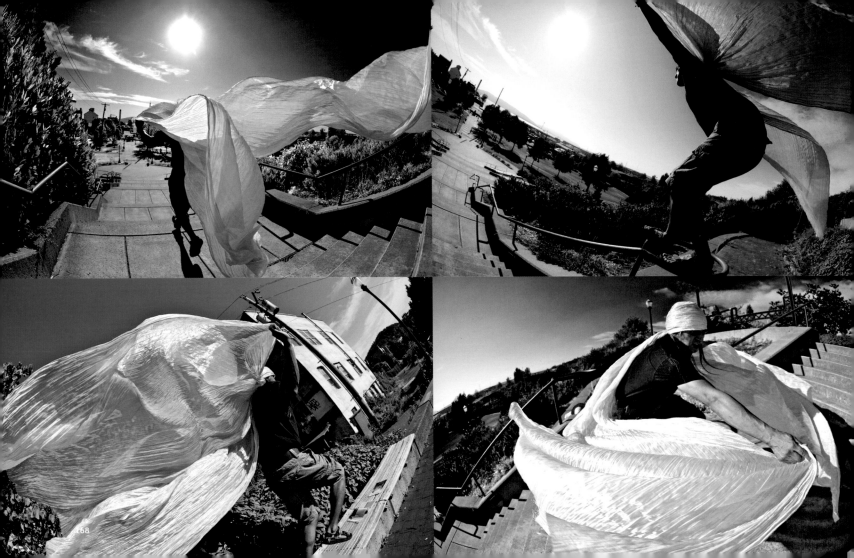

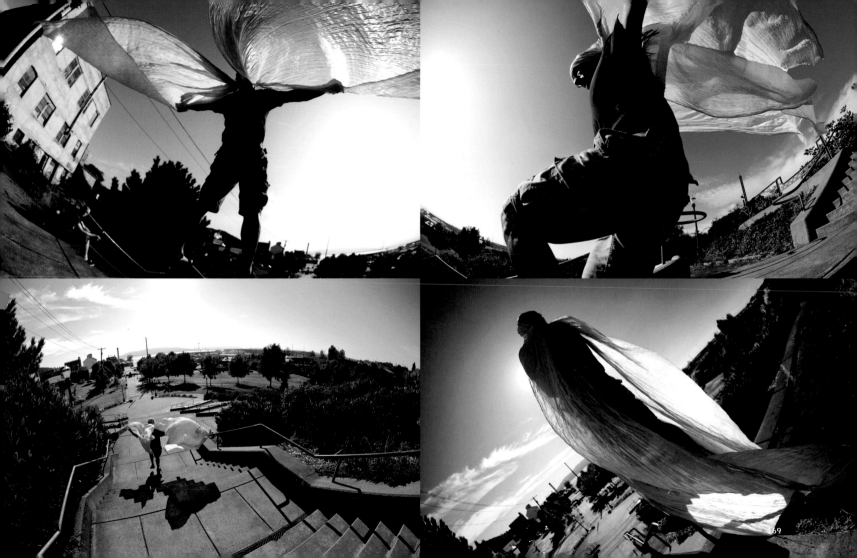

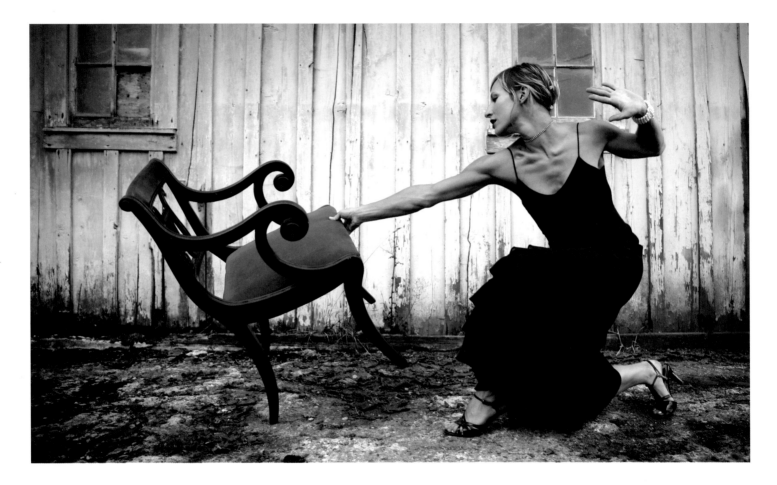

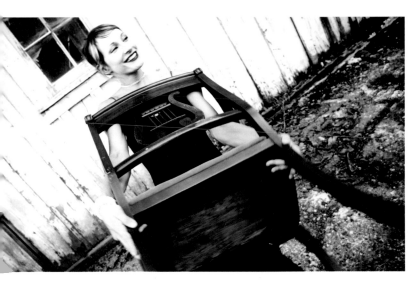

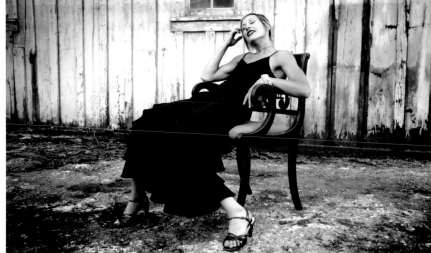

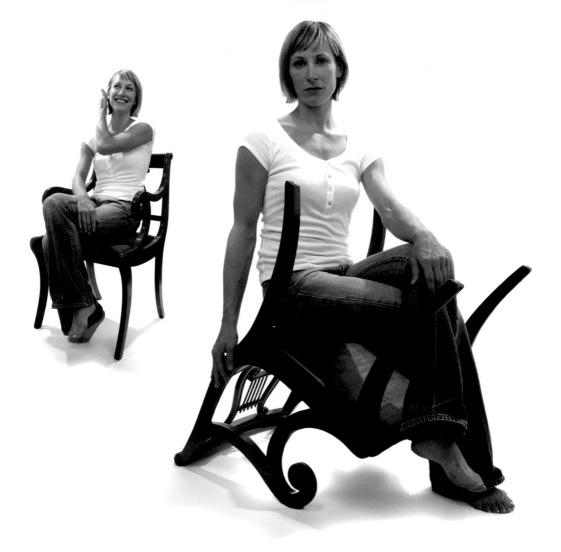

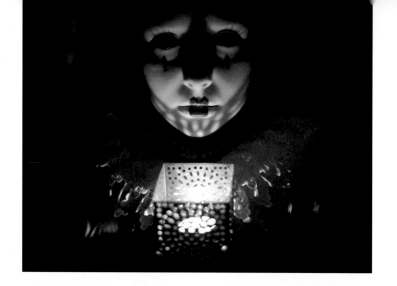

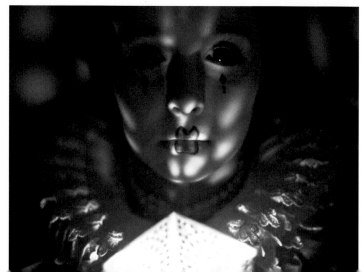

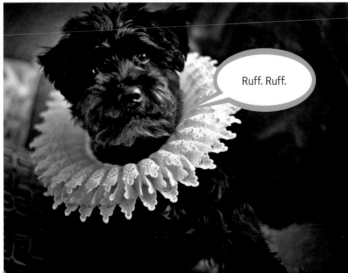

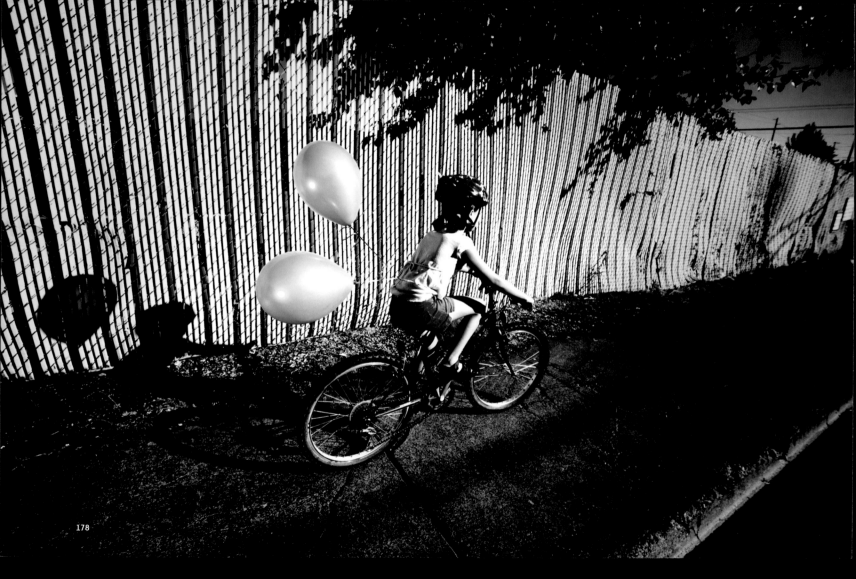

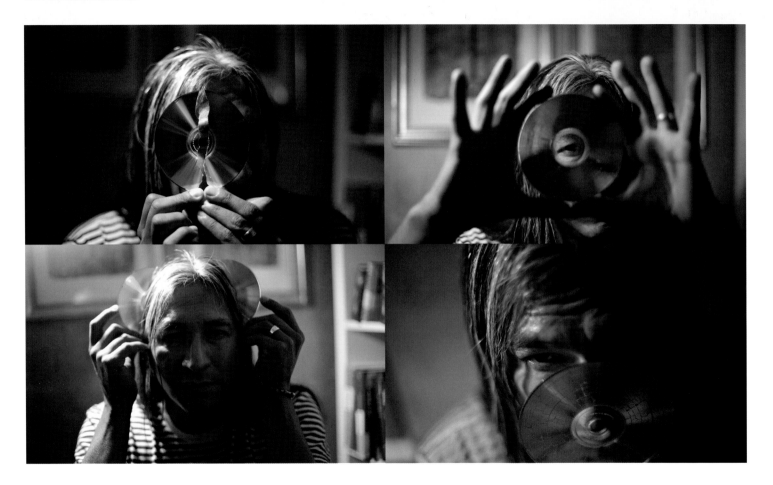

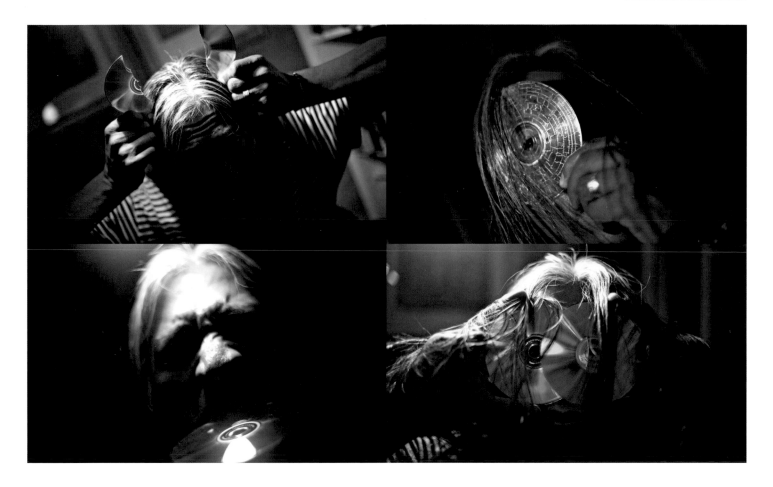

Ready, set, pose... *click*. Ready, set, pose... *click*. (And so on.) Here's all you need for a photoshoot overflowing with creative possibilities: A sunny, cloudy or rainy afternoon and a model willing to interact with a 25-foot. sheet of sheer fabric in front of the camera.

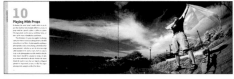

166 167

Other ready-for-play prop ideas are: a 50-foot rope; a dozen handkerchiefs; a bucket of oatmeal (cooked or uncooked); a giant pile of leaves; a yard full of fresh snow; a half-dozen bowling balls (not hard to find on-the-cheap at thrift stores); a large bag of packing popcorn; a large bag of real popcorn; a bouquet of helium balloons; a sizable collection of plastic dolls (again, check out the thrift store); a box of toothpicks; a deck of cards; one or several garden hoses—all spraying at full blast.

We spent about forty-five minutes taking pictures with this sheet of fabric (and we could have easily continued for much longer except that we needed to take several other photos before the sun set). A suggestion: Approach this kind of photoshoot with little or no pre-planning. Let spontaneity be the order of the day. Encourage your subject to improvise while you interject with ideas of your own. If you come across a pose or an action that looks especially good, snap as many shots as you can before moving on to the next.

168 169

Taking pictures in public often means dealing with looks, questions and sometimes interference from passersby. This is especially true if you're shooting photos of a person doing something as out-of-the-ordinary as playing around with an enormous sheet of fabric on a public stairway. If you're used to working in your home, an office or a studio, don't be surprised if you have to add some skills of diplomacy to your set of photographic skills when you start taking your camera into public.

All we knew going into this photo session was that we wanted to contrast the model's elegant cocktail dress against the weathered environs of an old barn (two more photos from this session are featured on page 156) before my model suddenly decided to initiate a dance between herself and a wooden dining room chair. "Wow" was all I could say when I saw this photo among the string of shots I snapped while she and the chair were cutting loose on the barnyard patio.

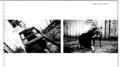

170 171

The model swings her partner, round and round, in this page's first photo. When snapping photos of a quickly moving subject, consider putting the camera in continuous-shooting mode and recording bursts of images (rather than trying to record perfectly timed shots, one by one). After the shooting is done, review your photos and select keepers. The near image features the dance-a-thon partners at rest, one on the other.

Here, the dancing chair featured on the previous spread demonstrates yet another feat of physical prowess: a headstand. Remember, even if you're shooting something as straightforward as a seated portrait, consider your prop-play options.

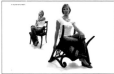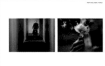

172 173

Photoshoots begin whenever you have a camera in hand—and with whatever props are around. The left-hand image on this page was taken when my model and I went to borrow a red felt coat and a bicycle from a friend's apartment (obviously, this model likes to have a good time while she works). The near photo was snapped when the model plucked a dandelion puff and made a couple of wishes during an outdoor photoshoot.

The model and I drove to the location seen in the first image to shoot the photos on pages 65 and 304. We also happened to have a large magnifying glass in the car and, in spite of the day's finger-freezing temperatures, we felt the urge to see what we could do with the glass before hurrying on with our planned work. In the adjacent image, a bowl of holiday ornaments create a myriad of playfully distorted reflections of the model's face. (Here, it's not so much a case of a model playing with props, as it is a case of props playing with the model.)

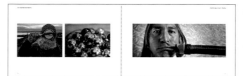

174 175

A deadpan model endures the adamant tug of a vacuum hose for the sake of a photo. (For the record, the vacuum did not leave a hickey on the model's face. Hopefully your model will be so lucky if you decide to try this one at home.)

A lot of work went into applying makeup for the shots on pages 94–97, and I felt compelled to keep taking pictures of my decorated model after the planned photoshoot was finished. Time was short, so I grabbed the first prop that caught my eye: a candle in an ornate holder. I took these photos in the corner of a darkened room, and, even though I was using a lens that excels in low-light conditions (a 50mm), I had to raise the camera's ISO all the way to 1600 to record these candlelit shots.

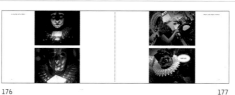

176 177

A prop as beautiful as this Renaissance-style collar deserves to be considered for all kinds of photo opportunities. In the upper image, our young model flips a pancake while wearing the collar as a tongue-in-cheek chef's hat. In the lower photo, a dog is seen proudly wearing the decorative collar around his neck. (And why not—after all, the true name for this kind of collar is a "ruff.")

My favorite detail in this photo (recorded in slanting sunlight, just before sundown) is the hint of color contained in both of the balloons' shadows. The girl in this photo is the same that appears in the next. If she looks considerably younger in this image, it's because she is. This project took three years from planning to finish, and there wasn't much I could do to hold back the effects of age on any of my models—effects that showed up most clearly in my youngest subject.

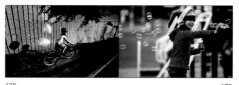

178 179

It doesn't take much to convert a jar of bubbles into a playful photographic prop. Note the blurred backdrop in this photo. If the entire scene had been recorded in sharp focus, the delicate forms of the bubbles would have had a hard time showing up against the distracting elements beyond. The shallow depth of field in this image was achieved by shooting from several feet away using a fully zoomed 70–200mm telephoto lens with its aperture opened wide.

If you have a desire to photograph a friend, or an assignment to photograph a client, how about including a prop that relates to the subject's personality or profession? And how about photographing a variety of interactions between your model and his prop? (Note: The CD was put in a microwave oven for a few seconds to create the cracked surface that shows on the disc in some of the shots. Thanks, YouTube, for that idea.)

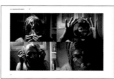
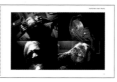

180 181

I had some help shooting this series of photos. An assistant was employed to take hold of a lamp and move it around—per my directions—as I took pictures. This assistance proved indispensable since it was a real trick to get light to fill the space between the CD and the model's face for certain photos. Also, because the reflective surface of the CD was highly affected by the position of the light, it was often necessary to make tiny adjustments to the lamp's position before shooting.

11

Suggesting Story

Journalistic photographs depict real-life events. Or maybe it would be more accurate to say that journalistic photographs convey *interpretations* of real-life events since it's difficult to do any better than that—even with photographs. In any case, however you define images shot by photojournalists, the pictures on display in this section are pretty much their opposite.

The images in this chapter are teasers. These photos hint at (rather than record or depict) stories, fragments of stories, ideas and notions. The images ahead are meant as visual gestures designed to engage the curiosity of the viewer and prompt a simple question, like "What's going on here?"

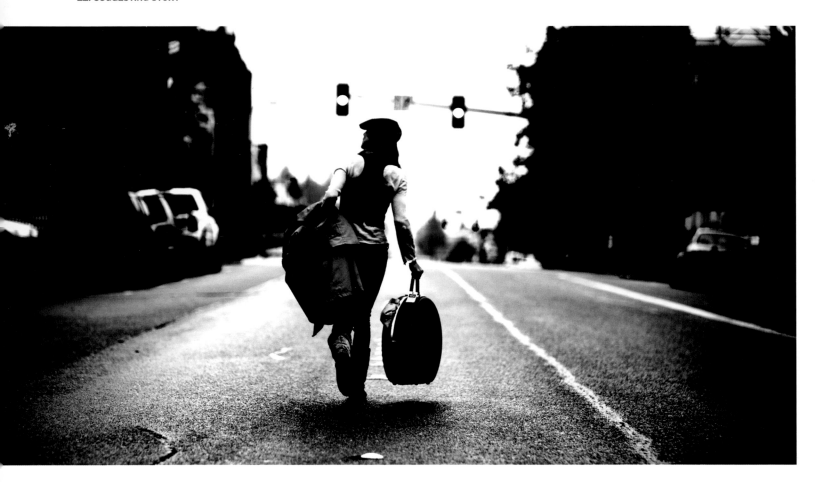

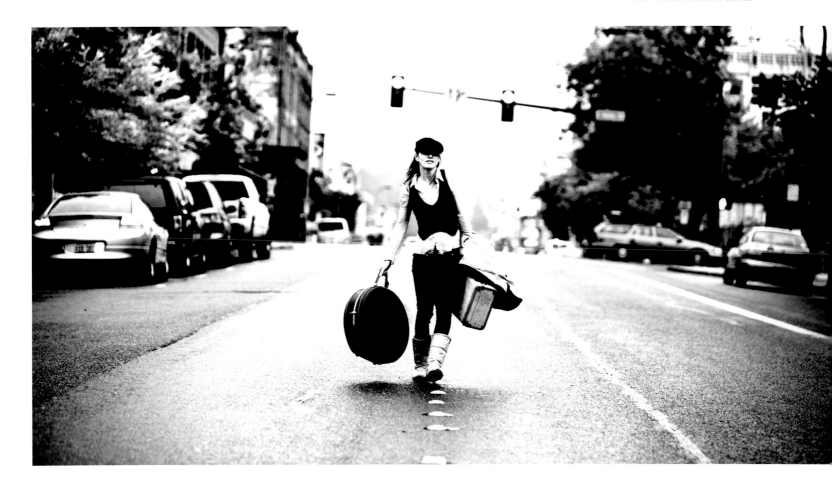

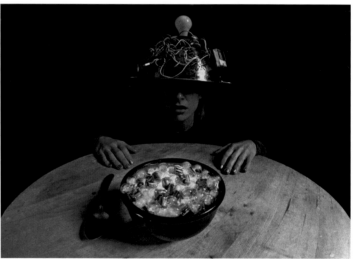

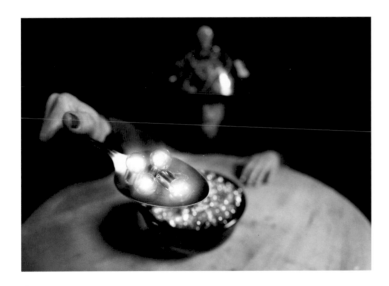
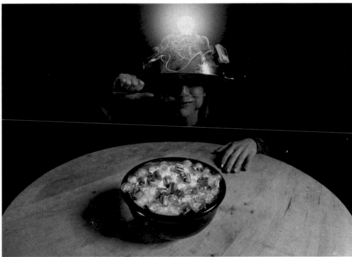

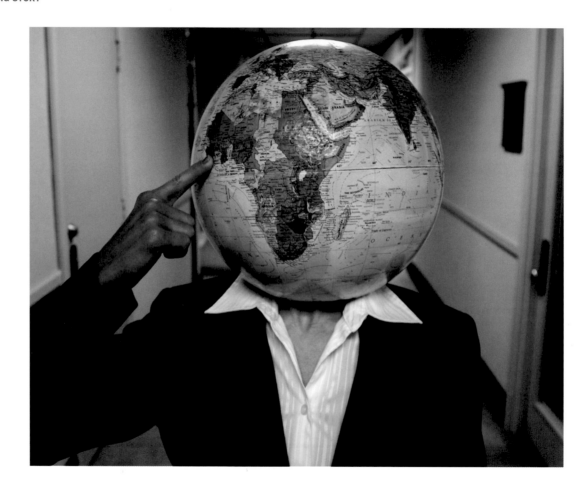

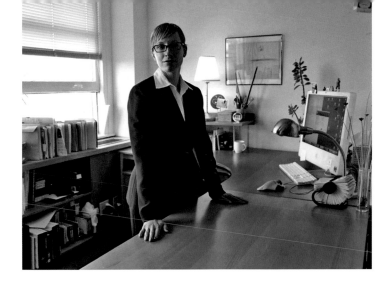

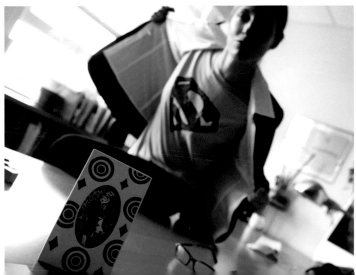

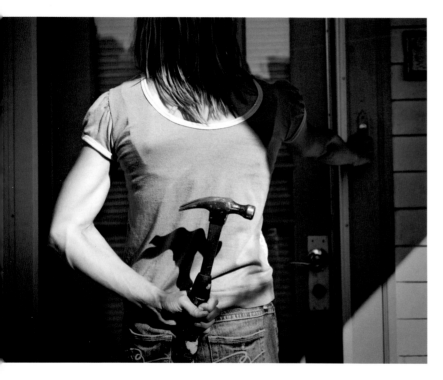

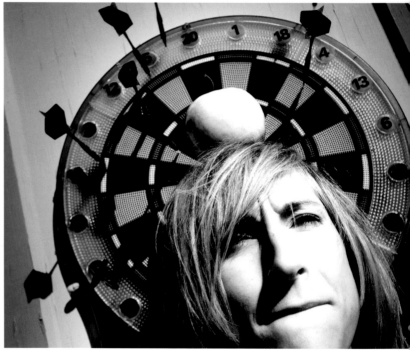

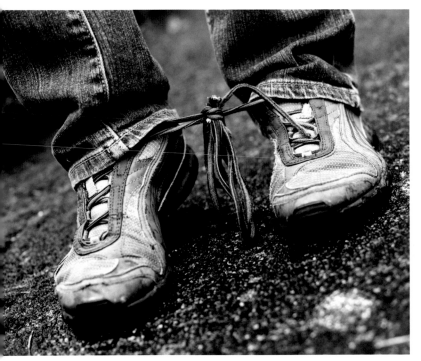

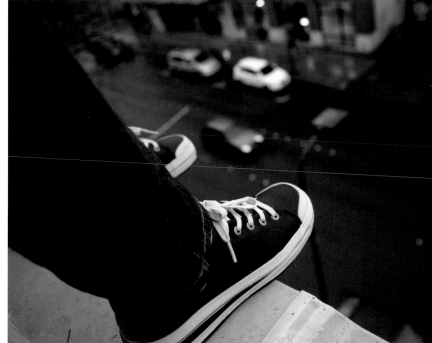

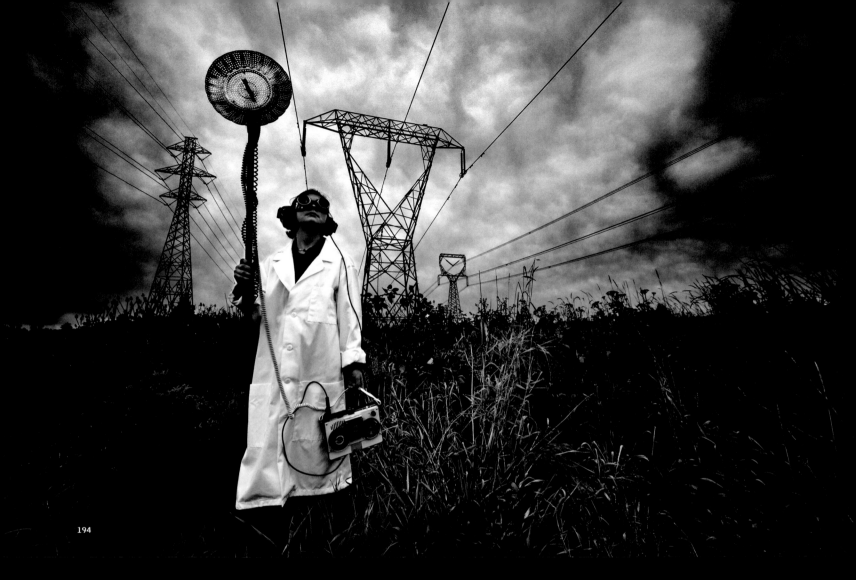

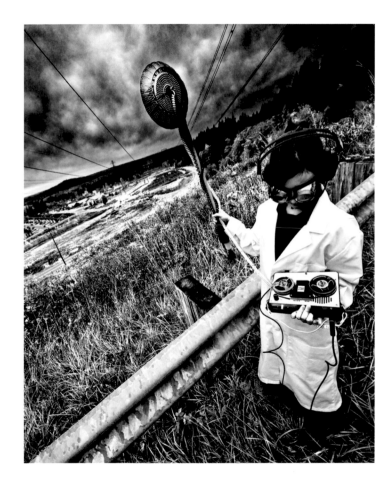

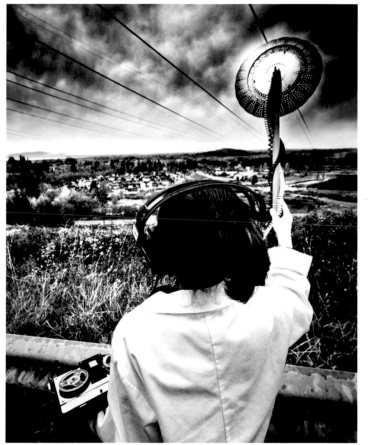

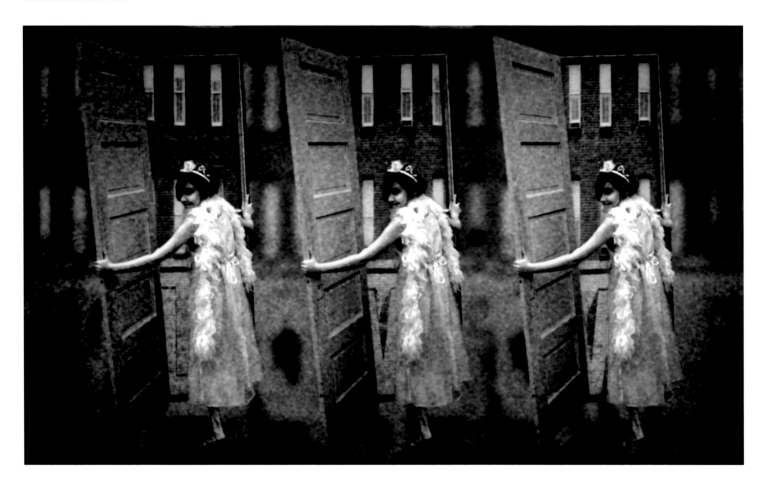

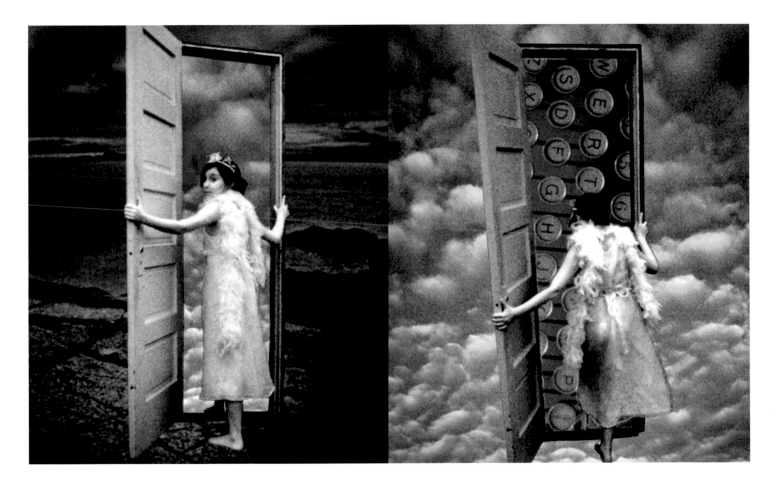

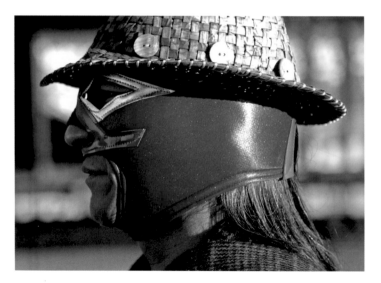

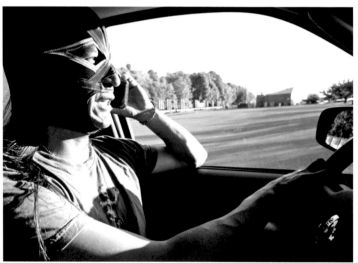

A woman bathes in the shadows of a tub filled with yellow daisies. If there's a story to this photo, the model seems to be encouraging the viewer to keep it secret. Photos that hint at larger stories are often featured at the beginning of magazine essays or at the head of advertisements. Why? Because they imply that something is happening, but aren't telling what (a sure-fire recipe for inciting the curiosity of at least some viewers).

184　　　　　185

Careful and complete lighting of the model's face is usually a primary concern when it comes to shooting a portrait. But how about going against convention for the sake of originality? What if you lit your scene in a way that puts the subject's face in semi or complete darkness? In this photo, the model has been positioned in a way that leaves her face and hands in the shadow cast by the tub's curving rim.

An escape and a homecoming: Since the near photo seemed to suggest a less happy story than the one opposite, I decided to darken the former's appearance by adding a "maximum black" BLACK AND WHITE adjustment layer and selecting "overlay" from that layer's pull-down menu. The BLACK AND WHITE controls in the far image were set to "maximum white," and "screen" was chosen from its pull-down menu. The contrast in both photos was amplified with CURVES adjustment layers.

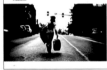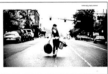

186　　　　　187

In the interest of effective composition, I chose to shoot this photo from a height that placed the horizontal line of the steel traffic light support just above the subject's head. This put a visual cap on the open space above the subject while helping form an attention-focusing frame around her torso. Also, I decided to shoot from directly in front of the subject to take advantage of the many lines of perspective (street markings, parked cars and the top of the building at upper left) that would converge upon her as a result.

Individually, the photos in this set tell fragments of a story. Seen as a series, they convey a tale that might be titled *Fuel for Thought* or *Cereal for the Cerebellum*. Another frame-by-frame visual narrative is featured on pages 160–163. How about illustrating a thought, theme or story of your own in this way?

188　　　　　189

Production notes: The bowl was filled with clear bubble wrap and topped with a layer of tiny lightbulbs; a glow was added to the bulbs by beaming a flashlight on them from above; additional bright spots inside the bulbs were painted using Photoshop's BRUSH tool; the subject's headpiece was made from a kitchen colander, a couple electronic gadgets and colored wires; a cord ran from the bulb at the top of the headpiece to an electric outlet; all the photos were taken using an SLR mounted on a tripod and fitted with a fisheye lens.

This spread features photos with ready-to-go commercial potential (it shouldn't be too difficult imagining images like these in corporate material such as a brochure or advertisement). For the near photo, the model's head was indeed put inside a cardboard globe through a hole that had been cut through the bottom. (Sometimes it's a lot easier to go ahead and build a physical prop to achieve a certain visual effect than it is to create the same effect digitally.)

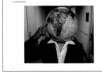

190　　　　　191

The top image on this page is a relatively ho-hum picture of a corporate executive. The bottom image is of the same exec—only now it's a photo that calls for a second look. Not all corporations would be comfortable portraying their board members as superheroes, but this photo does offer an idea or two you might want to suggest the next time a client asks you to shoot portraits for a brochure or annual report.

The near photo seems to suggest the opening line of an edgy joke—something along the lines of *"A woman with a hammer behind her back walks up to the front door and rings the bell..."* The second image conveys a modern variation of the William Tell story. How about putting the darker side of your sense of humor to work and coming up with a series of wickedly ambiguous images? There just might be some commercial potential in a set of photos along these lines.

192

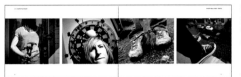

193

Say that a client has asked you to come up with photos for a difficult story—something that includes themes along the lines of suicide or violence-against-self. You might choose to go after images that spell out these themes in stark terms, or, as demonstrated in this page's photos, you might choose a more subtle visual route. For the near photo, I had my model stand on the ledge of my fourth-floor office window (I looped a couple fingers through the back of her belt with one hand and used my other to operate the camera).

Here, the model has been dressed in a lab coat and a pair of goggles. She's holding a pseudo-scientific listening device made from a steamer tray, a mop handle, an old tape recorder, a set of headphones and some black phone cords. Why all this trouble for a photo? Well, because I'd been wanting to shoot a portrait that included these electrical towers ever since I first saw them—all I needed was a character and some props that looked like they belonged in the same scene as the imposing metal structures.

194

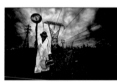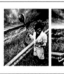

195

The colors in the photo on the opposite page were tinted with a PHOTO FILTER adjustment layer (set to "sepia"). This same adjustment layer was used to strengthen the photo's contrast by setting the layer's pull-down menu to "hard light." The contrast within the clouds was enhanced using a masked CURVES layer. The two photos on this page were converted to monochrome using BLACK AND WHITE adjustment layers. A CURVES adjustment layer was used to raise the level of contrast in these two images significantly.

A young model, an old door and a few digital effects have been used to create the three reality-bending scenes on this spread. The model was photographed standing with her hand on the door, and their forms were selected using Photoshop's LASSO tool. This selection was pasted over other images. Images were also copied into the opening of each door. All of the photos were blurred slightly, converted to monochrome, tinted and given a dose of digital noise to lend an antiquated look to the collages.

196

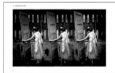

197

I bought this old framed door from a place near my home called The ReStore. It's a large outlet that offers recycled and rescued items from demolished homes and buildings. I make regular visits to The ReStore in search of affordable and one-of-a-kind props. Many cities have their own version of The ReStore. How about where you live?

On this page, lucha libre (Spanish for "free wrestling") masks are used to add flavor to an otherwise standard portrait of a man wearing a hat and a snapshot of a driver talking on his cell phone. The opposite page features a pair of Santas wearing lucha libre masks as they square off for a round of fisticuffs. How about adding a heroic mask like one of these to your stash of ready-to-go costume props? It just might come to the rescue the next time you want to infuse an ordinary photo with hints of an extraordinary story.

198

199

The same costumed person was photographed wearing two different masks for the image on this page. His form was removed from each scene's background using the LASSO tool. The photos were combined against a white backdrop, converted to grayscale and treated with Photoshop's PIXELATE > COLOR HALFTONE effect. The composite image was then converted to CMYK, and solid panels of color were added above the characters' costumes. The final presentation of the image calls to mind the look of a coarsely printed vintage boxing poster.

12

Calculating Conveyances

Introducing this chapter's cast of characters: a chair, a lamp, the corner of a room and a girl. This basic ensemble (along with a handful of props and alternative backdrops) is used to demonstrate how easily—and how greatly—a scene's look and message can be affected by toying with and shuffling the roles of both its human and nonhuman participants.

Act one of this series of photos involves looking for simple variations of a basic portrait. From there, things get steadily more complex, colorful, conceptual and, finally, cosmic. Some of the demonstrations involve few or no digital aids; others rely heavily on Photoshop layers, treatments and special effects.

203

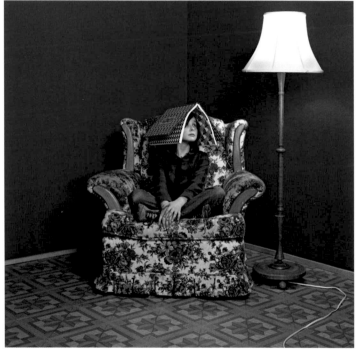

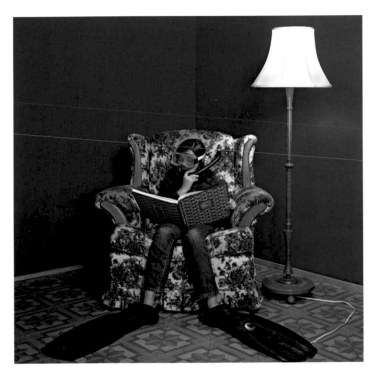

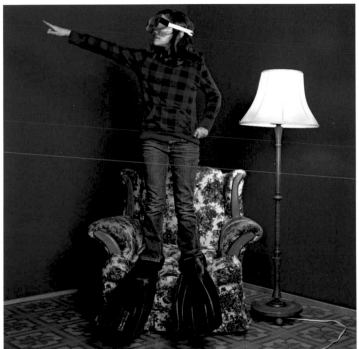

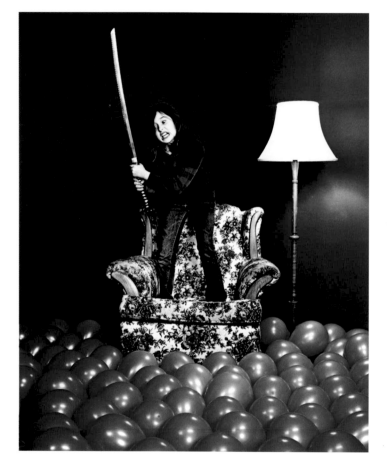

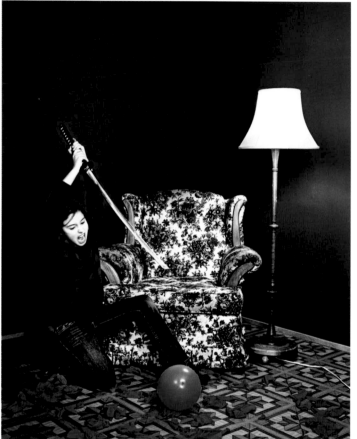

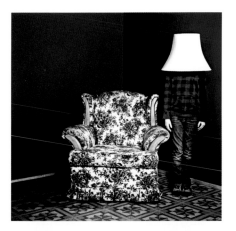
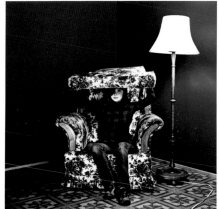
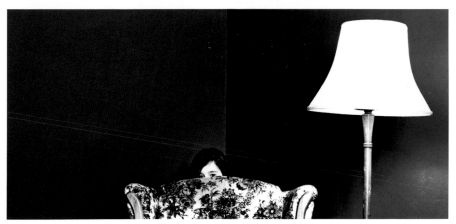

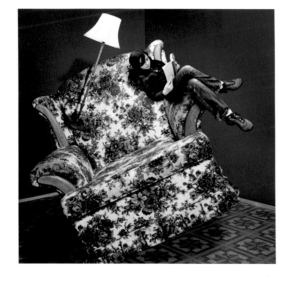

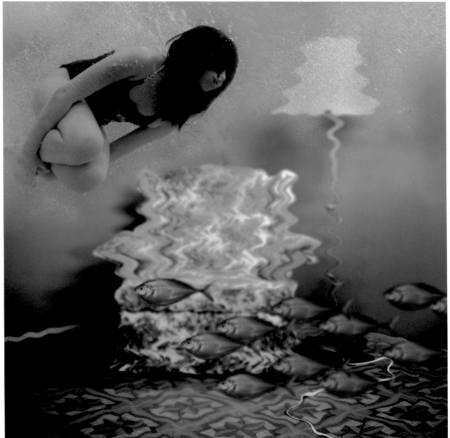

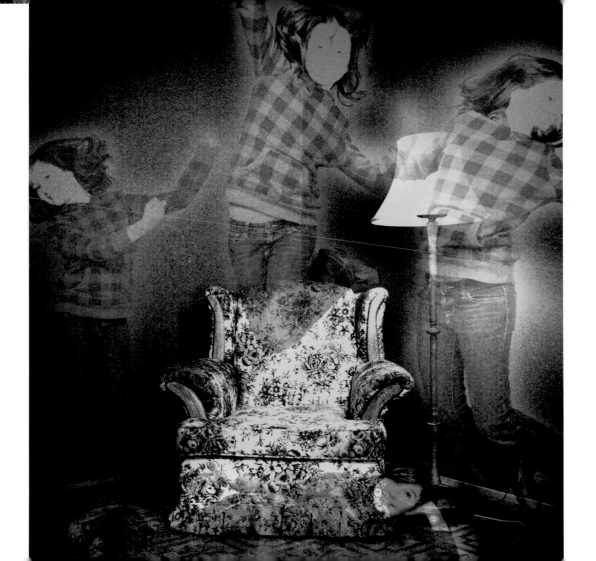

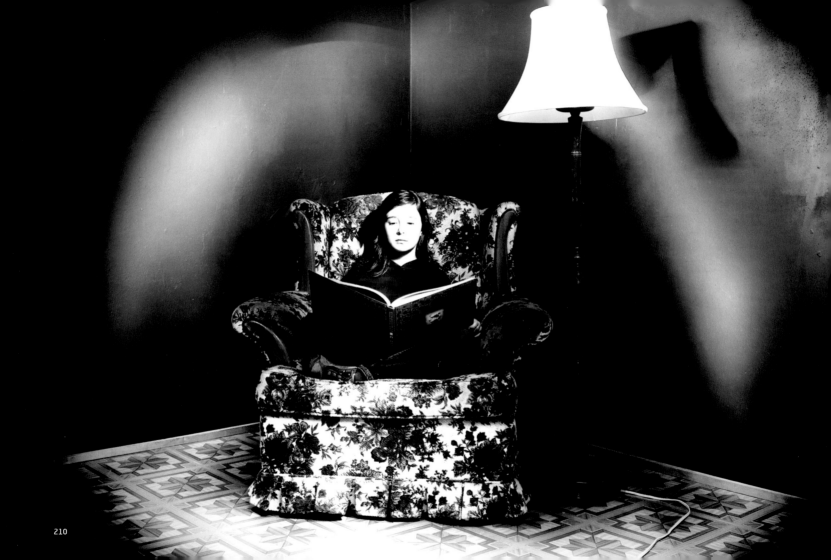

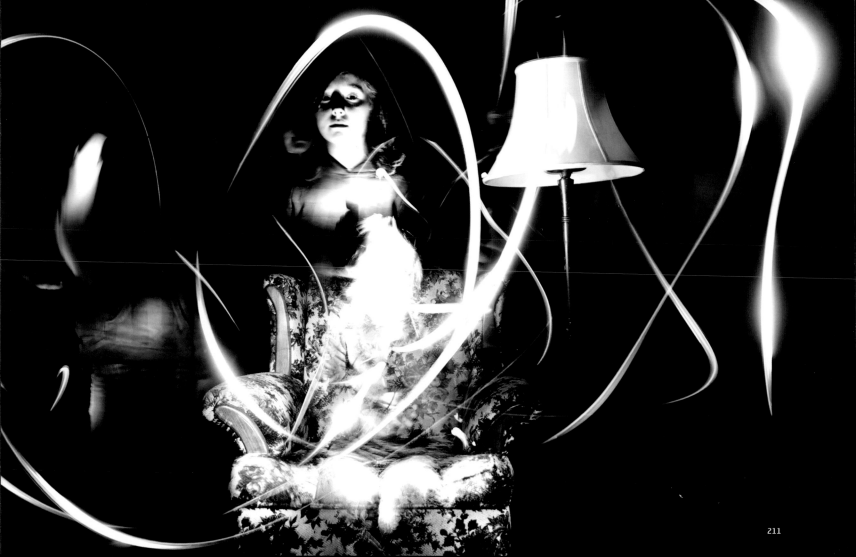

211

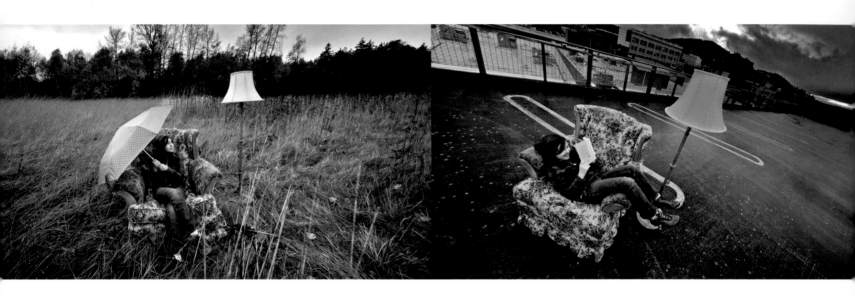

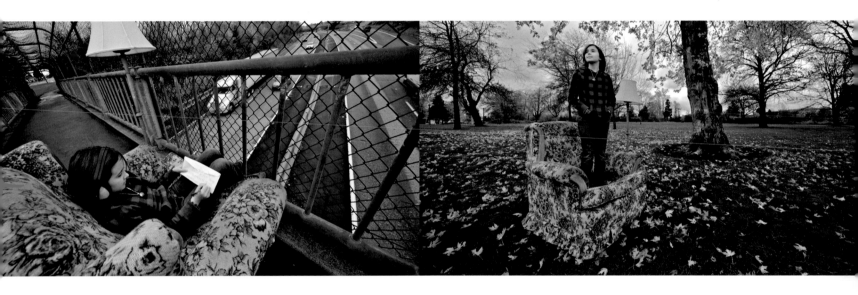

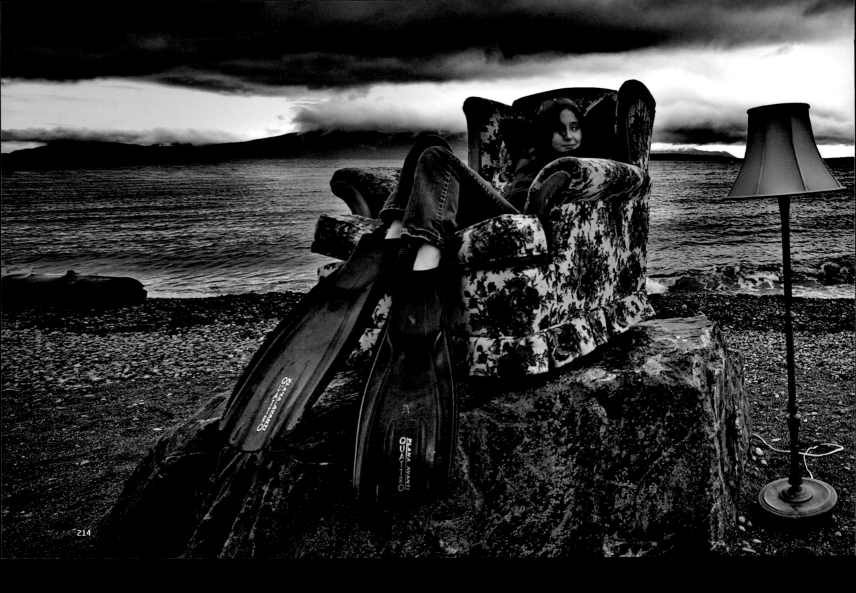

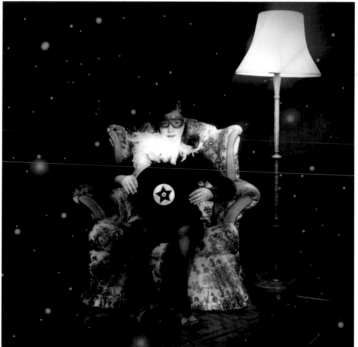

Take a quick glance at the images featured in this chapter. Pretty amazing, isn't it, the range of outcomes that can be achieved using such a basic ensemble of human and nonhuman subjects. And this, as they say, is only the tip of the creative iceberg. How about expanding upon the ideas presented here using a few home furnishings of your own? These items could come from your living room, or they could be acquired at a secondhand store or a garage sale.

202 203

A note about the "room" seen in several of this chapter's images: It's not actually a room—it's just the corner of a garage that has been given a coat of red paint and a layer of cheap vinyl floor tiles. The entire setup took just a few hours to create, occupies less than 7 feet of each wall and takes up just enough floor space to fill the camera's view. Interested in shooting some stylized interior scenes such as these? Got a corner of a garage, storage space or utility room that you're willing to transform for the sake of art?

With full appreciation of the fact that one person's "normal" might be another person's "abnormal," and that there are varying degrees of both normal and abnormal, please note that these two words are used in their most generic form to describe the actions of this chapter's model and the appearance of her surroundings. That said, feel free to apply your own definitions of normal and abnormal to the concepts described through this section's images and words.

204 205

Surprising as it may seem, a person can be only photographed in one of four ways: as a normal person posing normally, as a normal person posing abnormally, as an abnormal person posing normally, and as an abnormal person posing abnormally. It may be helpful to remember this simple way of viewing your options the next time you're considering ways of capturing a portrait (and be sure to embrace—rather than be overwhelmed by—the infinite room for expression and variation within these four categories).

The four basic ways of capturing a person's image were demonstrated in simple terms on the previous spread. Things are made a little more complex—and possibly more entertaining and interesting—on this spread and the five that follow. Props have been added here and there, the model has been encouraged to behave with greater zaniness, light has been used in alternative ways for some of the scenes, the furnishings have been taken outside for a few shots and digital effects have been used to alter several images.

206 207

What about adding props to your primary setup to enliven things? Be sure to consider both normal and abnormal ways in which your subject could interact with these props (as well as with the room's original furnishings).

Digital effects have given these images conceptual and contextual makeovers. The furnishings and model in the near photo were selected from other images using the LASSO tool. The elements were then resized and distributed over a photo of an empty room. The watery scene, adjacent, was created by layering an underwater photo of the girl—along with cut-and-pasted fish—over a photo of the room and its furnishings (treated with the DISTORT > WAVE filter). The composite image was tinted with a SOLID COLOR adjustment layer.

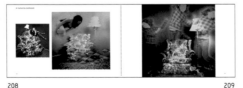

208 209

The four ghostly figures in this scene were added using the same multi-exposure image-building technique described at the bottom of page 237. The difference here is that these added figures were placed on semitransparent layers above the base image. A layer of digital noise was added to the photo using Photoshop's NOISE > ADD NOISE filter. The scene was tinted with a SOLID COLOR adjustment layer with its pull-down menu set to "color."

These two scenes have been illuminated by painting them with light (a process described near the top of page 146). The photo on this page was lit by having the model sit very still on the chair while I roamed the darkened room—shining the flashlight on selected parts of the scene—during the shot's fifteen-second exposure (I made sure not to hold still in one spot long enough for the camera to record my presence in the room).

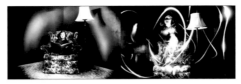

210
211

The model provided her own illumination for this scene. During this image's fifteen-second exposure, the model waved the flashlight in the air and occasionally stopped and shone it on her face for a few seconds. Take advantage of your camera's LCD when taking pictures in this way. Check out the results of each photo and make adjustments to both your camera's settings and the hands-on illuminating technique of whomever it is who's working the flashlight.

On this spread and the next, the setup has been thrown out the window. Completely and, more or less, literally. Gone are the red walls and the vinyl flooring. Gone, also, is the tripod that was used to maintain the camera's view of the prior scenes. The images on this spread were shot with a handheld digital SLR (fitted with a 12–24mm wide-angle lens) in a series of context-bending outdoor environments.

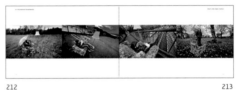

212
213

A pickup truck and an assistant were needed to pull off this series of photos (taken on a cold and rainy October morning in the Pacific Northwest). I had pre-scouted these shooting locations earlier in the week, and when we arrived at each, my assistant and I lifted the furnishings off the truck, set things up and recorded a few test images (using my assistant as the subject). This allowed our young model to stay warm and dry in the truck until she was needed for the real thing.

Here, the chair has been hoisted onto a large seaside rock beneath a dramatic sky of roiling clouds. The wide-angle lens did a nice job of taking in a panoramic view of the scene. Knowing that I might want to feature this shot as a full-spread image (and therefore not want the model to land in the "gutter" between the two pages), I was careful to frame the photo with the subject pushed well to the side of the frame. This placement also left plenty of room for an unobstructed view of the setting's lovely backdrop.

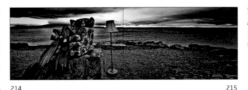

214
215

Scenes like this really mess with any notions of a "normal" context. And when context is twisted into configurations that are equal parts amusing and confusing, its ability to attract notice and generate intrigue are magnified.

The chair, lamp and model in this spread's near image have been transported to a variety of far-flung environments using Photoshop's LASSO tool, a bit of cut-and-paste and the incorporation of several different filters and special effects.

216
217

As different as these images appear from this chapter's first series of photos, they really aren't at all that far removed from their earlier cousins. Each of these photos began as the same ordinary photo of the room, furnishings and model. The LASSO tool was used to separately select each wall and the floor so that other images could be pasted into these selections. Special effects were applied to the newly pasted photos, as well as to the items appearing on the image's base layer.

13

Anti-Gravity

One of the great things about being an animal—
as opposed to a plant—is that we have no roots to
prevent us from occasionally floating clear of the
earth's surface. Unlike birds, however, we can't
stay aloft for long (not without fabricated wings of
some sort, anyway), and this is where the camera
comes in handy. Photographs of airborne humans
convey a reality that could otherwise only exist in
our imagination: the suspension of gravity through
the suspension of disbelief.

The next time you're out taking pictures of
someone, and are running short of ideas of what to
have her do in front of the camera, consider the vari-
ous ways in which you could ask her to defy grav-
ity and hold a pose in midair—even if it's only for
1/2000 of a second.

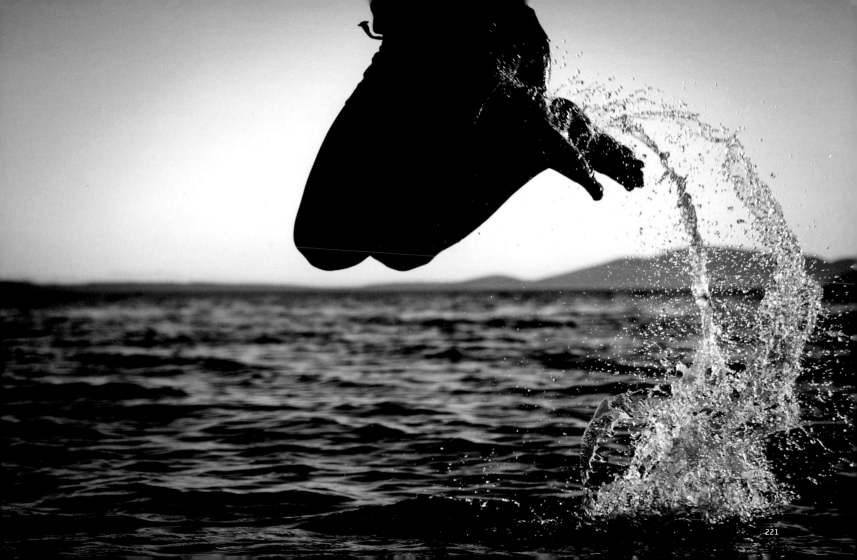

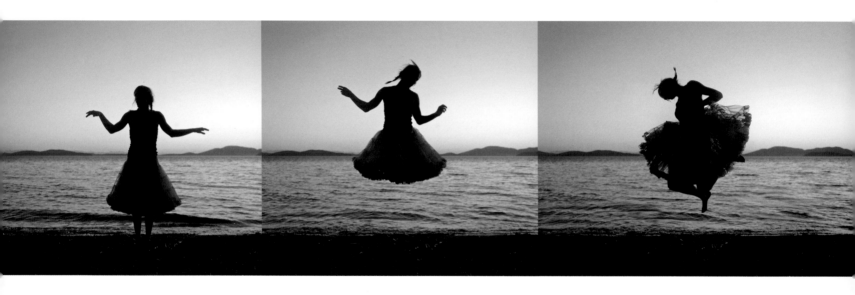

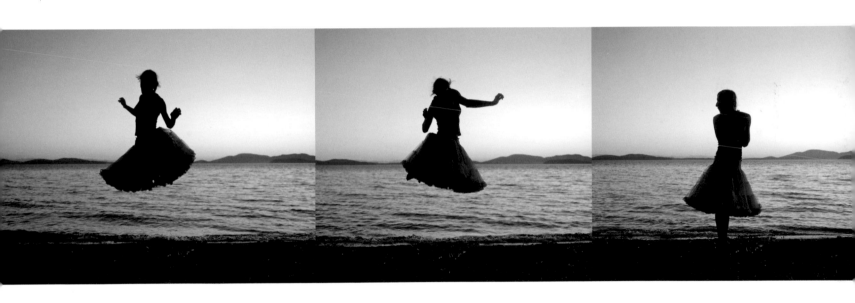

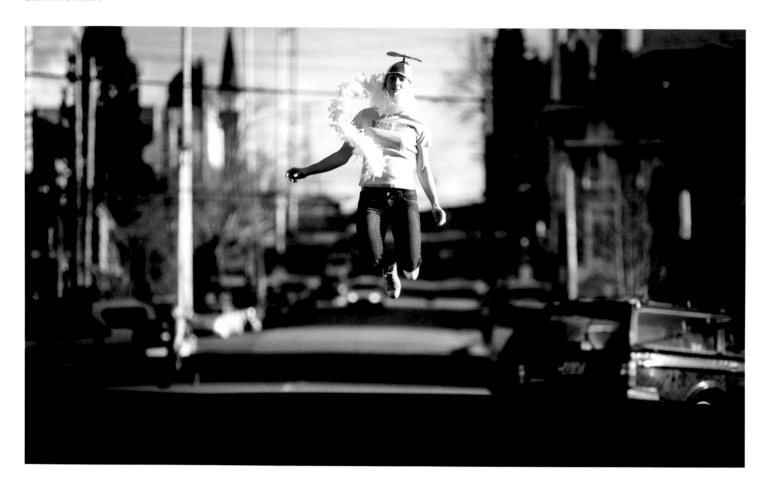

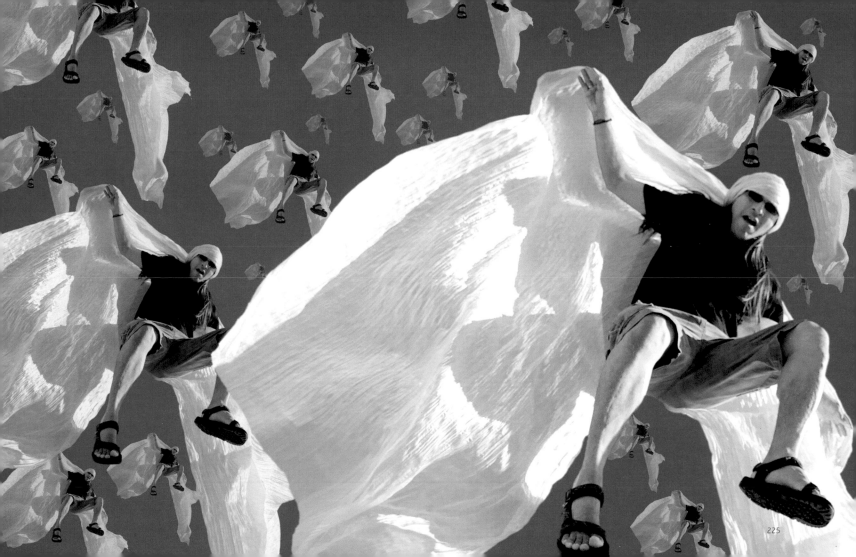

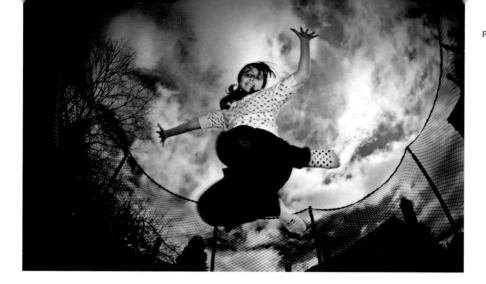

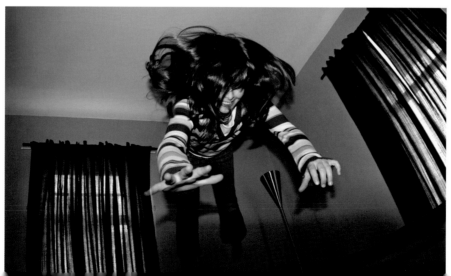

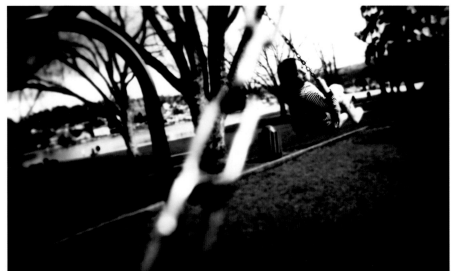

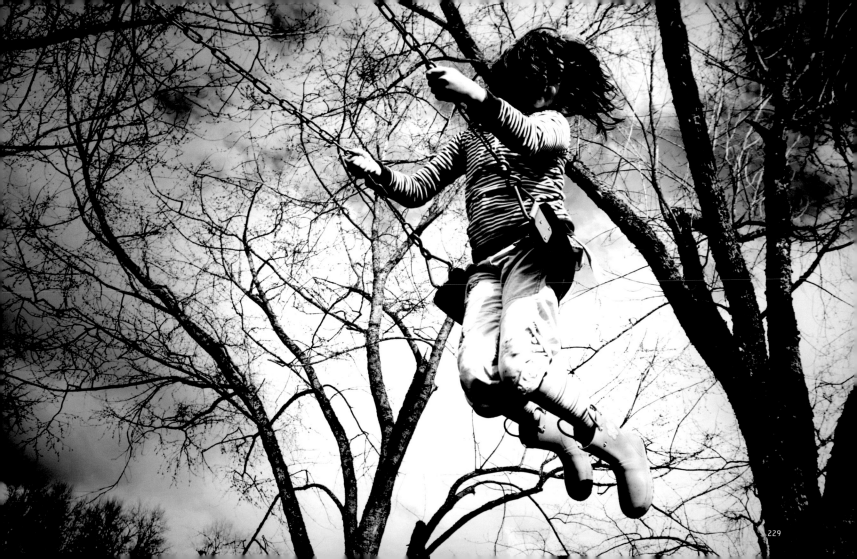

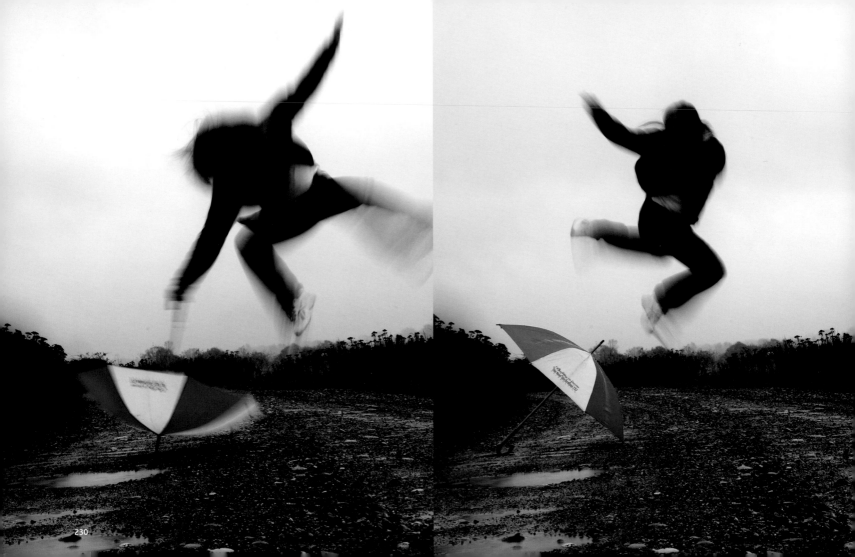

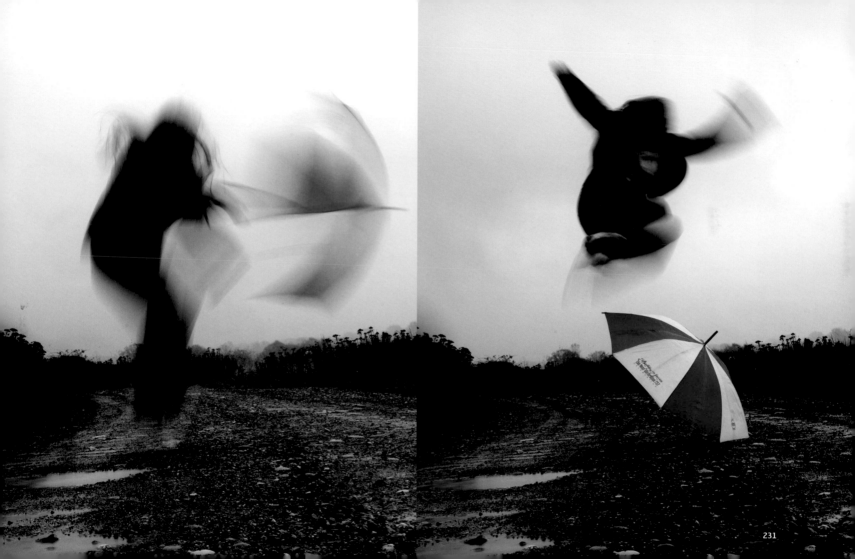

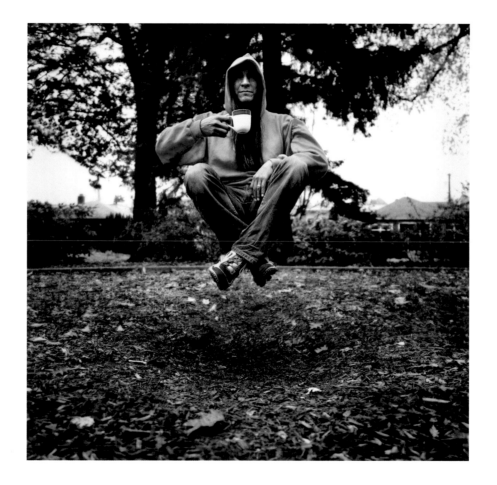

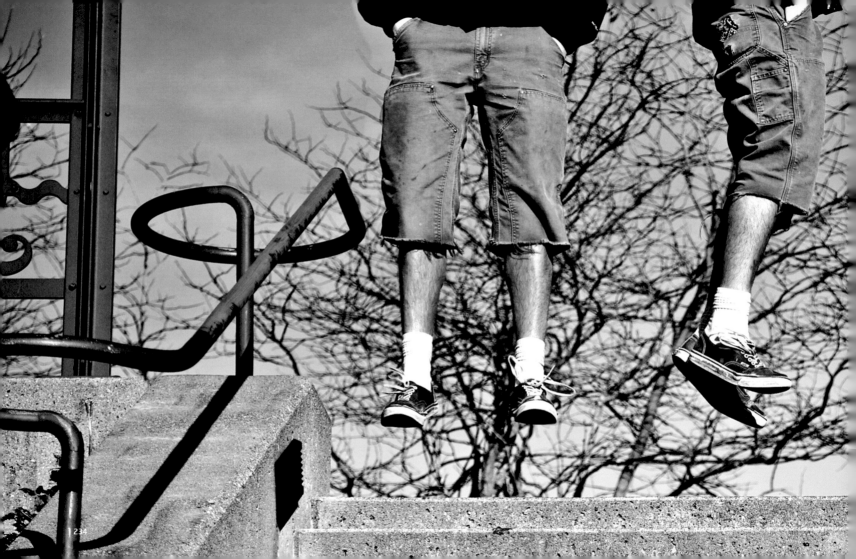

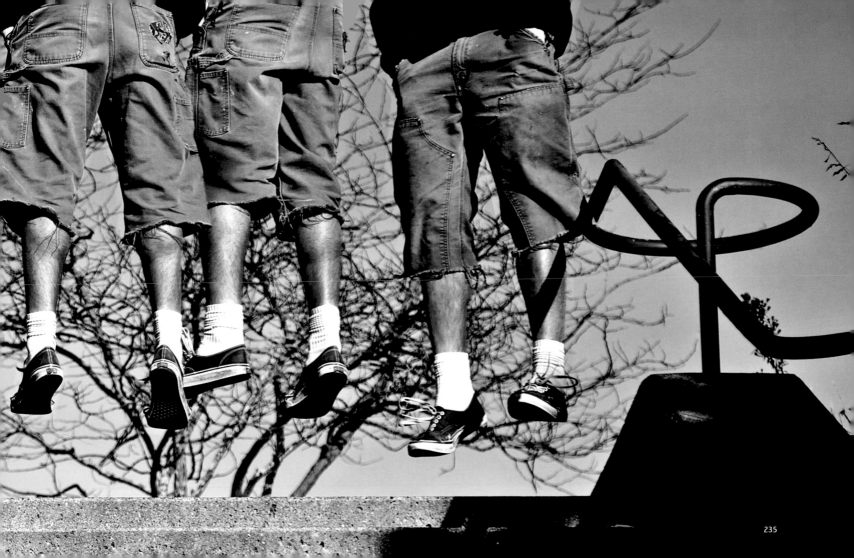

Usually, when a photo like the one seen here has been snapped, the action has taken place so quickly the photographer has no idea what sort of image has been captured until the results have been inspected on the camera's LCD. The on-the-spot ability of digital cameras to let the photographer know how a photoshoot is going is one of the great perks of shooting digitally.

220　　　221

Deep, slanting light from the setting sun provides dramatic illumination for the dual geysers that follow this pair of feet skyward. Photographers often refer to the hour before sunset—and the hour before sunrise—as *magic* (or *golden*) hours. (A professional once joked to me that this is why so many great photographers go hungry—because they are so often outdoors taking pictures during these hours instead of enjoying breakfast or dinner.)

The camera was placed on a tripod and the model was asked to jump and spin from a predetermined spot for this series of photos. The camera's shutter speed was set at an action-freezing 1/2000 of a second—an exposure so brief it created difficulties when it came to taking in enough of the dim evening light to record an image. To compensate for the low-light conditions, the lens' aperture was opened as wide as possible and the camera's ISO setting was raised to 800.

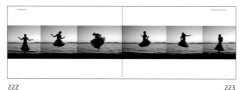

222　　　223

When a ball is tossed, there is a perceptible moment at the height of its trajectory when it is momentarily suspended between the upward force of momentum and the downward pull of gravity. The same thing happens when a person jumps. With a little practice, it becomes surprisingly easy to click the camera's shutter button right at this ever-so-slightly extended moment of suspended animation.

I stood well downhill of the model while taking this picture with a 70–200mm telephoto lens. The vantage point proved to be a good one for a couple reasons: Shooting from this point of view exaggerated the apparent height of the model's leaps while placing her in an attractive compositional gap between the buildings in the background.

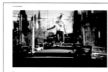

224　　　225

An image from the photoshoot featured on pages 166–169 has been used to create this armada of leaping clones. The model and his cape were selected from their original photo using Photoshop's MAGIC WAND and LASSO tools. Once this was completed, the edge of the traced area was feathered slightly so that it would meld nicely when pasted against the orange backdrop of a new document. The selection was then cloned, resized and repositioned numerous times to create the composition seen here.

Each of the photos on this page has been flipped either sideways or upside down. When dealing with images of a subject who is toying with the effects of gravity, consider toying with the orientation of the image as well.

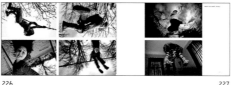

226　　　227

How about taking a friend to a trampoline and recording some pictures? (If you decide to join your subject on a bouncy trampoline, and want to sit down to record shots from a low perspective—as I did for the upper photo on this page—keep in mind that you'll have to deal with Newton's Third Law of Motion: Every time your model's feet touch down, you and your camera will be tossed upward.) If you don't have access to a trampoline, how about giving your energetic pal access to a bouncy mattress?

Don't be too quick to toss your overexposed, underexposed or blurred images into the cyber garbage can. "Imperfect" images like the ones on this page might be able to convey impressions of action more convincingly than their technically correct counterparts. When processing (so-called) flawed images, consider amplifying their shortcomings rather than trying to hide them (by raising the brightness of an overexposed image, for example, or deepening the shadows in an underexposed photo). 228

229

If you haven't been on a swing set in a while, consider visiting one. And bring a friend. Rain or shine. Hot or cold. Day or night. Seriously. (And whatever you do, don't forget to bring a camera.)

This set of in-motion images was taken after sundown. The camera's shutter speed was set at a blur-producing 1/6 of a second. Given this slow shutter speed, the camera had to be secured to a tripod to avoid blurring the rest of the scene as well (a look that's not always bad—it's just not what I had in mind for these photos). A low vantage point was selected for these shots since it added to the impression of height in the model's leaps. 230

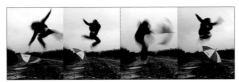

231

Recording images like these in low light allows you to choose a shutter speed that's slow enough to blur your subject's movements without causing the overall scene to overexpose. Use your LCD to review images as you go. Make adjustments to the camera's shutter, aperture and ISO settings until you get the results you're after. Not too fluent with these three controls? All the more reason to give a photo like this one a try since it clearly demonstrates the connection between these all-important camera settings.

How about showing something other than your model defying gravity? Here, the model stands earthbound while the coffee in his cup shoots skyward. These two photos were recorded by having the model toss a few ounces of java into the air just as the camera snapped a flash photo. It's not easy to get a shot like this to come out on the first—or even the twentieth—attempt. If you want to try this one on your own, plan on bringing plenty of expendable coffee with you to the photoshoot. 232

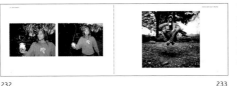

233

We were at a playground shooting the photos on the opposite page when I noticed a swing set nearby. I decided to have the model sit cross-legged on one of the swings for one last anti-gravity photo. Converting the down-to-earth original to a reality-defying image was simple: All I had to do was remove the swing's seat and chains using Photoshop's CLONE STAMP tool. The shadow beneath the model was enhanced using the BURN tool.

This image is actually a combination of five. Each photo was snapped as the subject jumped into the air from a different position. The camera was fixed to a tripod so its view of the scene would remain constant. The images were stacked in Photoshop. The LASSO tool was used to define the area around the figure in each layer. This selection was then used to add a mask, which allowed the figures in underlying layers to show. The same shooting and processing technique was used to create the multi-person images on pages 209 and 295. 234

235

This is a fun one. From a low perspective, set your camera on a tripod and have your model stand toward one side of the shot's edge. Now ask your model to jump. Take a picture as the your model is airborne. Next, have the model take a step toward the center of the frame where you'll record another airborne photo. Repeat this procedure all the way across the viewfinder's field of view, and then back to the starting point. Now review your images in quick succession on the camera's LCD. You've made an anti-gravity movie!

14

Sport and Play

The next time you're heading out with a friend or family member to get some exercise or take part in a sport, how about bringing a camera along and snapping some action shots (or inaction shots, as when the subject is taking a breather)? Photo opportunities seem to be especially abundant in the context of sport and play. So much so that it might be a good idea to keep a pocket digital camera on the same shelf as your athletic bag, tennis racquet, kite or frisbee.

And that's not to say all photos of sporting or play outings need to be of the planned variety; whenever you're with someone who has spontaneously decided to express herself physically (jump on the couch, do a handstand, dance one-legged, etc.), that's about as good a time as any to reach for a camera and begin shooting.

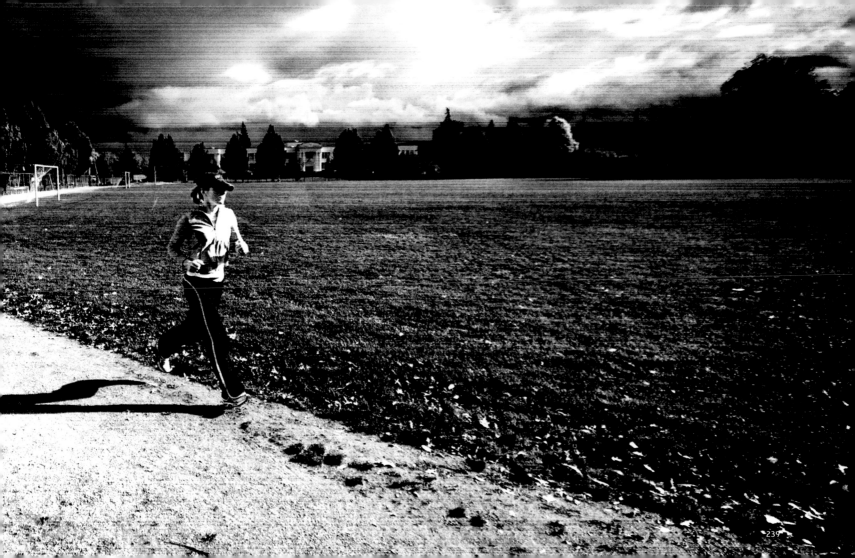

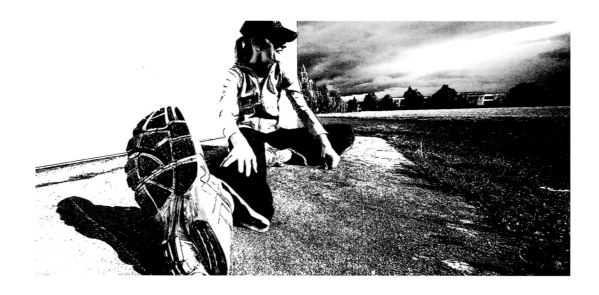

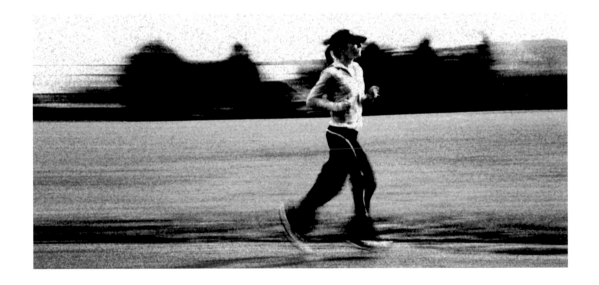

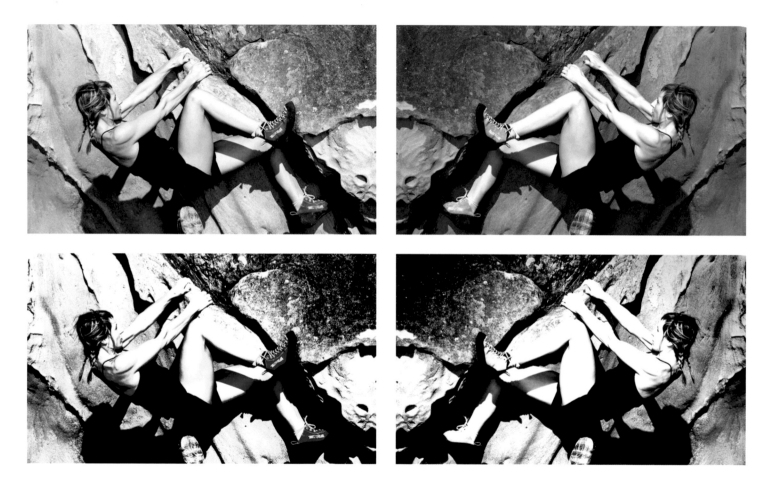

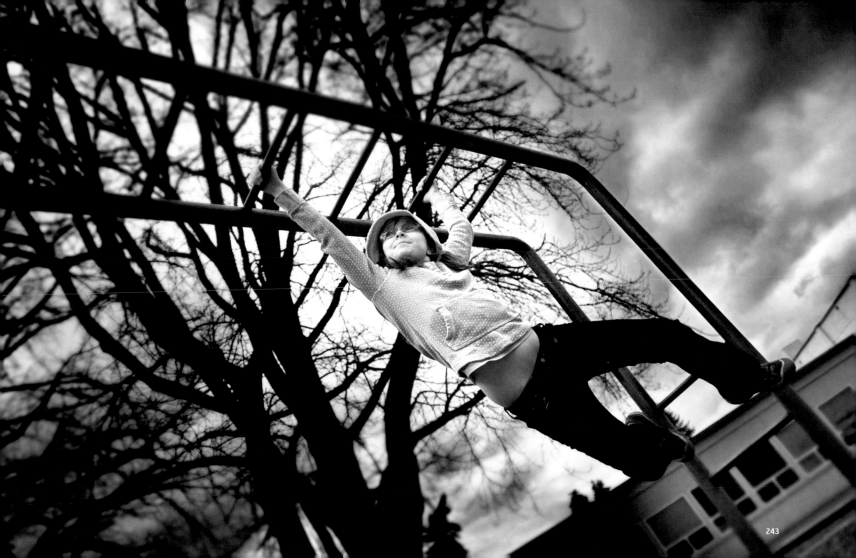

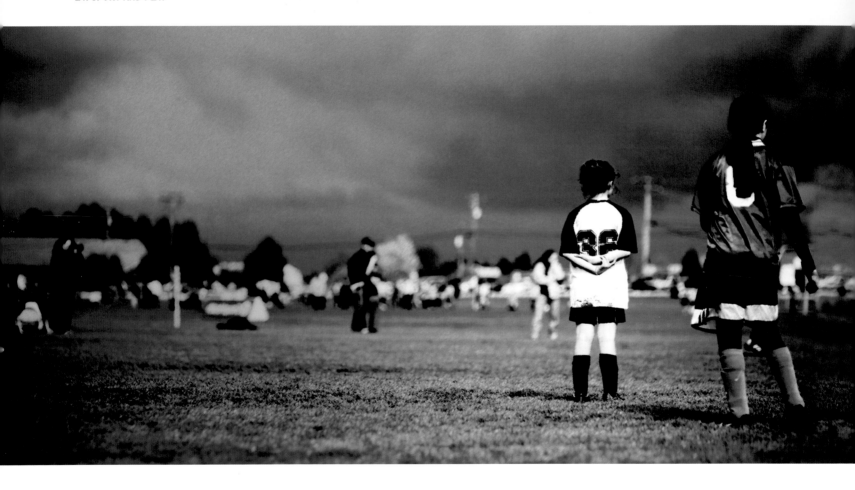

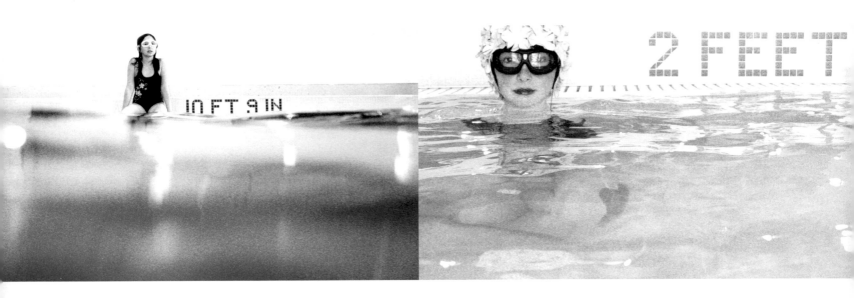

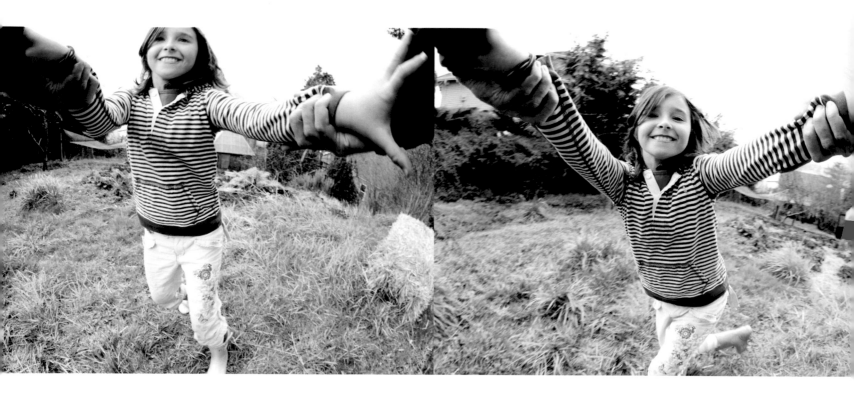

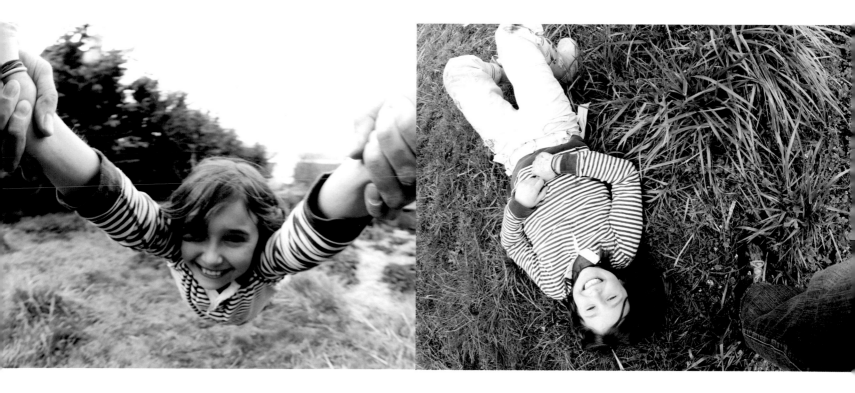

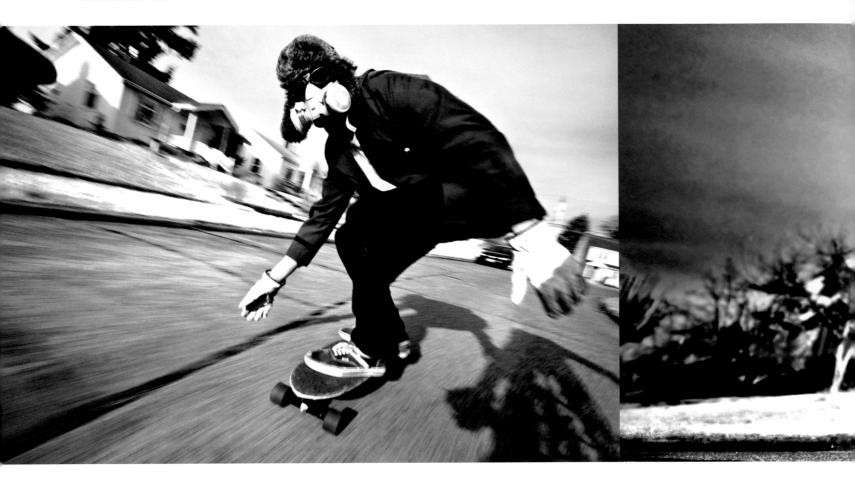

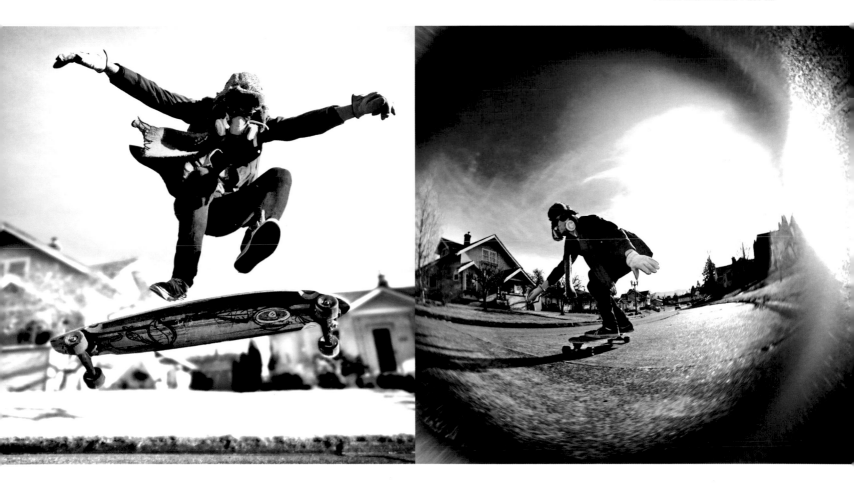

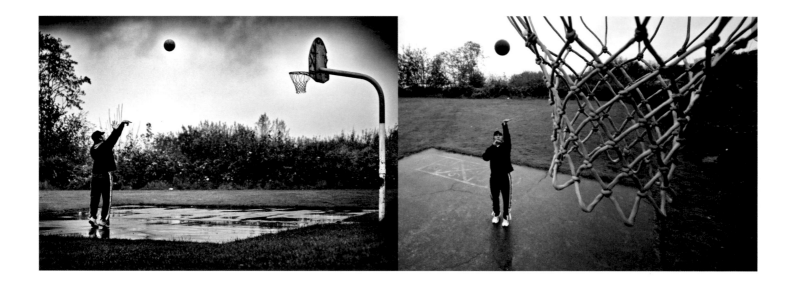

The low morning sun casts a long shadow as a lone runner makes her way around a quarter-mile track. The image was converted to monochrome using Photoshop's BLACK AND WHITE controls. Contrast was heightened with CURVES adjustments. After these effects had been applied, a visual implication of motion was added to the scene by incorporating a subtle layer of horizontal texture (created by applying the MOTION BLUR filter to a semi-opaque layer of noise that had been generated with the NOISE › ADD NOISE filter).

238

239

It's not like I arrived at this photoshoot specifically hoping to capture a dramatic black-and-white image of my model in action. When I'm taking pictures for my own enjoyment (or for my own book...), I usually wait until I see the results of a photo session before deciding which treatments will best enhance the images. Consider doing the same with your cache of keeper photos: Treat each image according to what you think will best suit that photo's content and conveyances.

The warm-up portion isn't always the most exciting part of an athlete's workout. Still, a lot can be done to spice up the more re-laxed moments of your subject's sporting routine: camera angles that create dynamic compositions can be sought; lenses that produce intriguing views can be used (the near image was shot with a fisheye lens); and color-enhancing and contrast-boosting treatments can be applied in Photoshop.

240

241

Speed can be conveyed through the blur induced by the motion of the camera and/or the subject. When you follow the motion of a moving subject (known as panning), the resulting image will tend to record the subject clearly while blurring the background (as long as the shutter speed isn't too fast or too slow). When the camera is held still as the subject goes past, the subject will appear blurred against a sharp background (again, shutter speed will affect the outcome).

A climber considers her options as she makes her way up a sand-stone cliff. Consider your options, too, when finalizing images. Con-veyances of action can be boosted by increasing a photo's contrast. How much is enough? How much is too much? Find out by using CURVES controls to push the level of contrast beyond the point of reason, and then pull back on these controls until you like what you see. Consider using the masks of CURVES adjustment layers to apply different amounts of contrast to different portions of a scene.

242

243

Clear skies are fine and dandy on my days off, but on days when I'm shooting pictures for a living, bring on the clouds. I love clouds—many or few; big or small; high or low; fluffy, puffy, stringy or strung out; with or without silver linings. The forms, shapes, values and textures of clouds within a scene can turn a ho-hum scene into a image filled with intriguing visual extras.

Time out: With her arms folded behind her back, our subject takes a breather during a soccer game. A much taller player from the opposing team keeps watch on the action as well (players come in a wide variety of shapes and sizes in the junior leagues). This photo was shot with a fully zoomed 70–200mm telephoto lens. The lens' aperture was opened to f2—a setting that resulted in a shallow depth of field around the position of the two players.

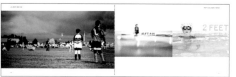

244

245

Whether you're taking action photos or photos of inaction, always look for vantage points that contribute to an interesting composi-tion. The near image was composed with the subject well off-center and pushed to the top of the frame—a composition that allowed for the inclusion of a bit of tiled typography and plenty of watery-looking water. The adjacent photo was snapped with half the lens underwater (the camera was housed in a waterproof case). More images from this photoshoot are featured on pages 260–263.

I'm holding her, so who's holding the camera? The photos on this spread were recorded by hanging my SLR by its strap around my neck and securing the strap against my body using a length of rope. Not a very elegant setup, but it worked. I put the camera in continuous-shooting mode and used a small battery-operated remote unit (on which the button could be locked in the "on" position) to get the shutter snapping photos right before liftoff.

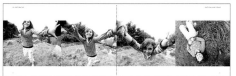

246

247

Since I was swinging my young friend in circles with the camera in continuous-shooting mode, I ended up with what looked—and functioned—like a series of motion picture frames of her airborne adventure (this spread features four of my favorite frames). How about shooting a continuous sequence of shots such as this, and then using software to compile them into a looping QuickTime movie? (Inexpensive stop-action image-compiling programs can be found online.)

Join in on the fun. The near shot was taken by riding my bike in front of the model while aiming the camera backward with one hand and steering with the other (you may have noticed my shadow to the right of the model's). Naturally, I wasn't able to look through the camera's viewfinder while taking pictures this way. The wide-angle view of a 12–24mm lens helped ensure my aim was more or less on target. The far image on this spread was shot with a fisheye Lensbaby lens.

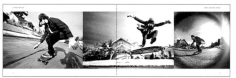

248

249

Why not add a mask of some kind to your sporty model? Here, the model has been given an industrial-grade respirator and a pair of aviator goggles to mask his identity and add ambiguous counter-culture conveyances to the images. What about dressing your model in a serious, silly or whimsical full-body costume and having him perform some action scenes?

If you have a digital SLR, then you probably also have a wish list of lenses you'd like to purchase. I shoot most of my photos with one of six lenses, three of which were used for this spread. The near image was recorded with 70–200mm telephoto, a 12–24mm wide angle was used to for the next photo, and a Lensbaby was used for the two on the opposite page. My other preferred lenses are a 50mm fixed focus, a 24–105mm standard zoom and a 15mm fisheye. My advice: Make the most of what you've got and add lenses when finances allow.

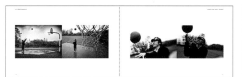

250

251

A Lensbaby was attached to my SLR to record the two photos on this page. (Lensbaby is the trademarked name of a type of lens that's mounted to the end of a short flexible tube.) When taking pictures with this lens, the photographer can bend and twist the lens' mount to achieve different focus and depth of field results. Lensbabies are relatively inexpensive. They are also small and a lot of fun to shoot with. I almost always make room for one in my shoulder bag when I'm out taking pictures.

Man or motorcycle—who's the model here, anyway? If the sporting equipment involved in your photoshoot is attractive enough, consider switching your camera's focus from the model to the machine (or the ball, racquet or mitt—it all depends on the sport). This shallow depth of field image was recorded with a fully zoomed 24–105mm standard zoom lens with its aperture opened wide. I was on my belly for this shot since I wanted the model and the motorcycle to appear on the same horizontal plane.

252

253

Speaking of low perspectives, when was the last time you crouched, sat or lay prone in order to frame a photo? Try it out the next time you're having trouble finding a satisfying viewpoint of your subject (it works for me, more often than not). If you find yourself being as fond of low vantage points as I've found myself to be, you may want to consider doing what I've done: Purchase a pair of semi-fashionable utility pants with a double layer of fabric in the knees.

15

Aqua

Colorful, colorless, agitated, placid, frozen, boiling, shallow, deep, falling, rising, flowing, still, abundant, scarce.

It's easy to think of adjectives—many of them contradictory—when describing the attributes and conditions of water. And few, if any, readily available natural elements can compete with the variety of ways in which water can be incorporated into photos of people.

Taking pictures around (or in) water means taking extra care to keep the camera safe. In most cases, the risks can be easily minimized: Many of this chapter's photos were taken from dry land, others required that the camera be carried into the water and held high, and a pocket digital camera was placed in a waterproof housing for the shots where contact with water could not be avoided.

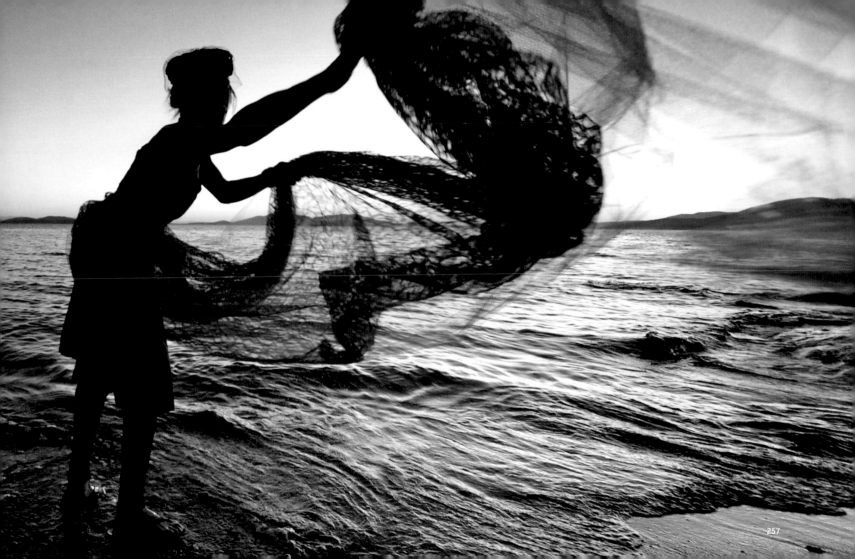

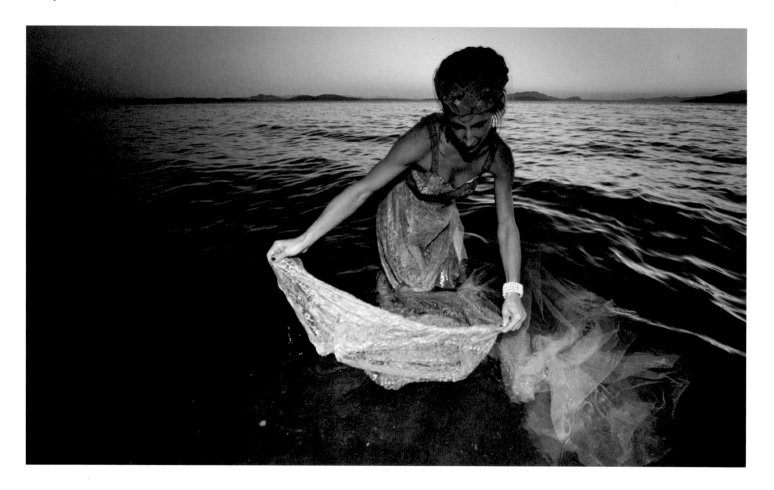

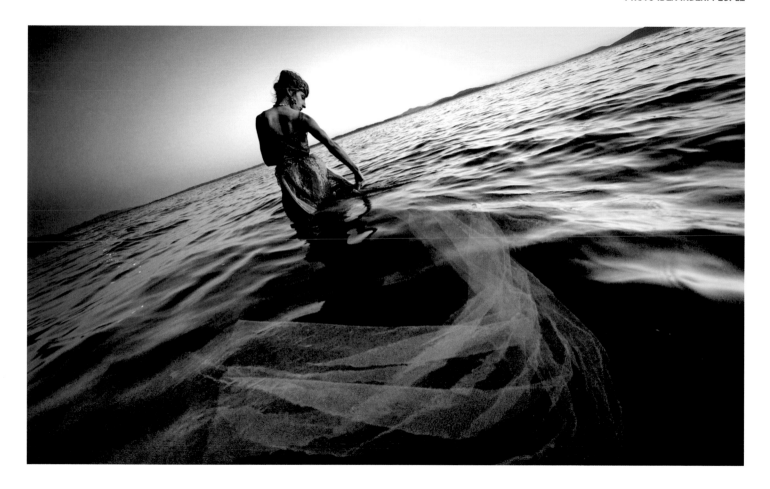

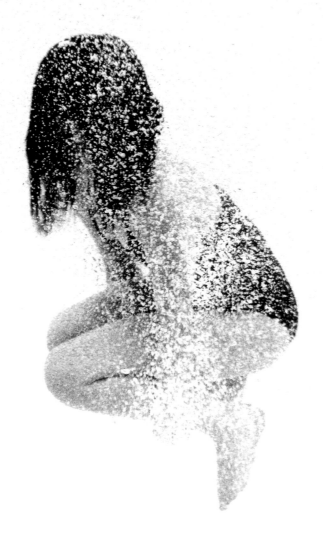

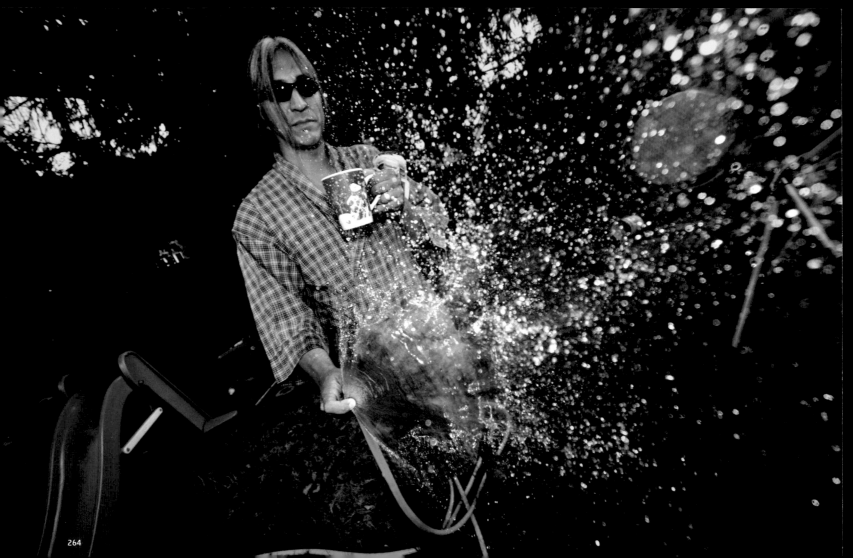

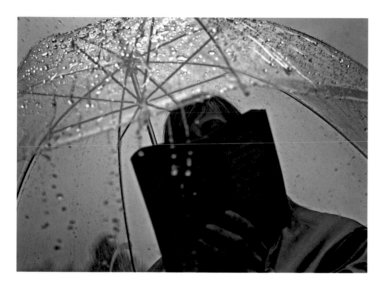
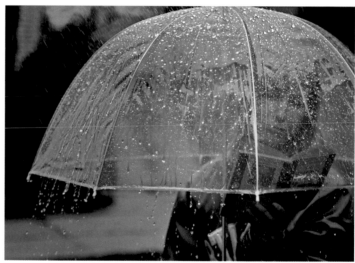

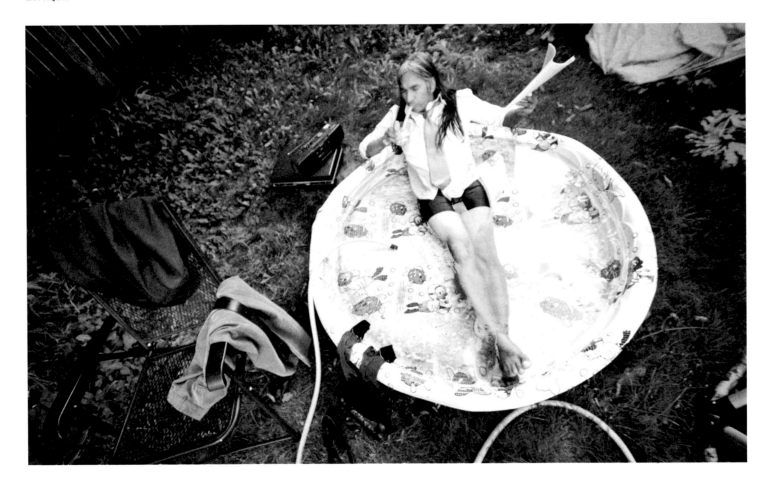

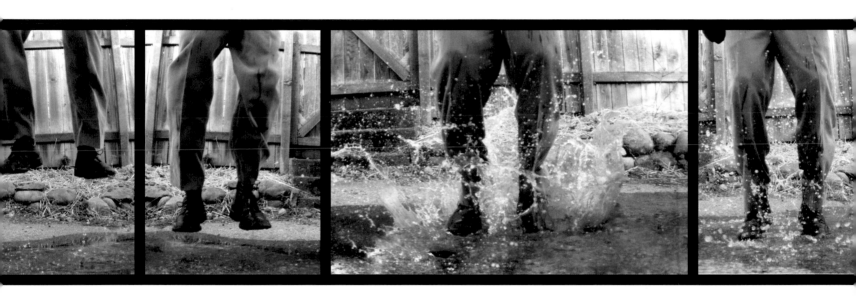

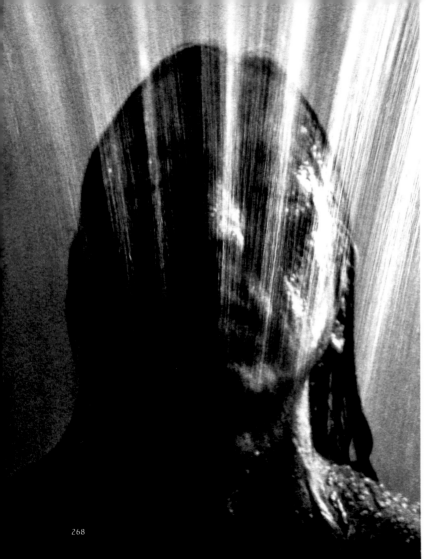

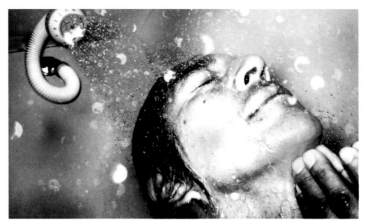

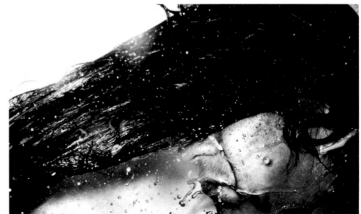

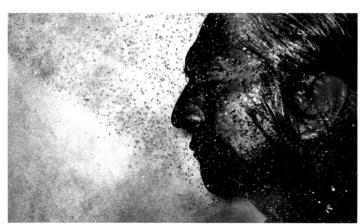

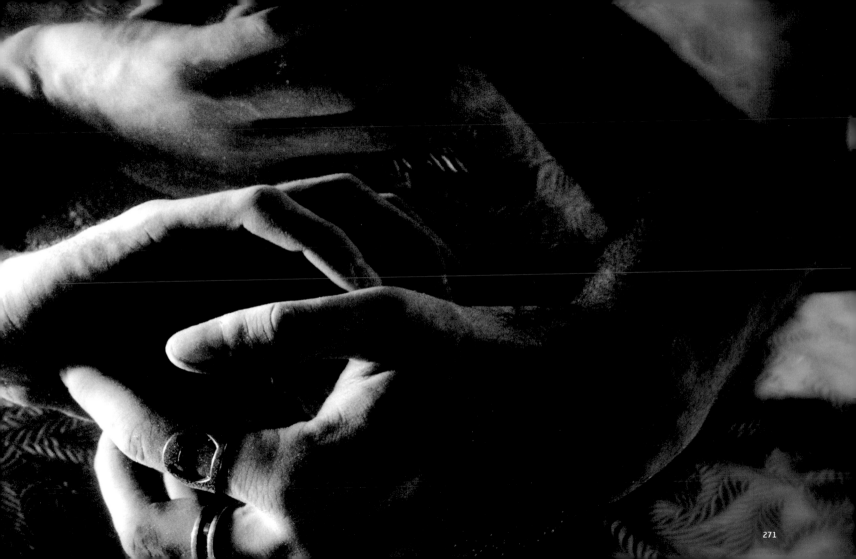

The plan for this photoshoot was to have my model wade into the tide wearing a vintage dress fitted with a long train of sheer fabric. Beyond that, there was no plan other than to see what kind of photos we could get. The evening was perfect, the dress and the model looked great, and because darkness was falling quickly I began shooting before we even stepped into the water. (And I'm glad I did; this shot of the subject fanning her train into the wind was one of my favorites from the evening.)

256 257

The seashore is a great place to visit if you want to take a lot of different kinds of pictures of one person, and want to stay in one place doing it. My model and I arrived at this beach in the afternoon and left after dark. During that time, my model posed with a veil (page 133), leapt along the shore (220), defied gravity wearing a tutu (221–222), climbed rocks (page 242) and took a walk into the waves (as seen on this spread and the next).

We hiked for two miles through a forest wearing packs filled with clothing, props, camera equipment, water and food to get to this beach. This set of photos was our last of the day, and by the time we began shooting, the September sun had set and the air felt nearly as chilly as the frigid coastal water. Wading into the ocean for these shots required working quickly. It was only about ten minutes before our feet and legs grew too numb to continue. All this to say, *thank goodness for uncomplaining models with a sense of adventure.*

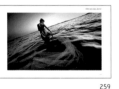

258 259

The photos in this series were captured using a 12–24mm wide-angle lens—a nice lens, but not one particularly suited for low-light conditions. A flash was used to add fill-in detail to the scene on the far page. The near image was taken minus the flash, and with the camera's ISO setting raised to 800. The colors in each picture were muted and shifted using Photoshop's HUE/SATURATION controls. Tints were added to each image using PHOTO FILTER treatments.

Waterproof cases for cameras can cost about as much as the cameras they're designed to protect—and that's the reason I don't own a waterproof case for my SLR. I do, however, own a relatively inexpensive watertight case that seals around my pocket digital camera. How about you? Interested in going underwater without going into debt? What about shopping for an affordable case that will protect your pocket digi-cam?

260 261

Given the lack of strong light in this pool's environment, my pocket camera was incapable of recording crisp, natural-looking photos (especially when shooting underwater). This prompted me to look for interesting ways of processing the photos—ways of overcoming the shortcomings of the originals. Resist the urge to panic if your photos are less than impressive straight from camera. Instead, see it as an opportunity to explore the image-enhancing capabilities of software.

The images on this spread were recorded at the deep end of the pool. I submerged by blowing the air out of my lungs until my feet hit bottom and waited there until my model jumped in from above. I had to spring to the surface after each shot and take a few breaths before going under for the next photo.

262 263

Keep in mind these pictures were snapped with a basic pocket camera in dim underwater light. As a result, the original photos were pale and lacked contrast. A strong application of CURVES controls was used to create the high-contrast images seen here. SOLID COLOR adjustment layers were used to add a wash of color to each photo (this adjustment layer's pull-down menu was set to "multiply" for the far image, and "color" for the near photo).

Watertight cases are good for more than just taking pictures underwater. They can also be used to protect the camera if you want to get close the action as a friend waters the lawn, reads in the rain, hangs out in the shower, takes part in a water-balloon fight or rides a water-based amusement park ride.

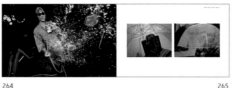

264

265

As moviemakers know, it's a real pain to shoot pictures in the rain. That's why most of the rain you see in movies isn't rain—it's the spray coming from one or more well-placed hoses. The rain in these photos was similarly faked: I had an assistant stand on a ladder and use a garden hose to spray water onto the model's umbrella.

A businessman sipping a drink while reading the paper is nothing new. And neither is a backyard swimming pool. But when a way has been found to combine the two, now that's an image that calls for another look. More photos of this kind can be seen in chapter 9, All Dressed Up and...

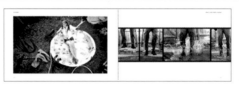

266

267

Don't have a waterproof housing for your digital SLR? Want to use it to record some up-close shots of watery action anyway? Consider wrapping the camera in plastic food wrap to protect it from the spray. When I use this technique, I pull a single layer of the thin plastic tightly over the front of the lens (more layers might interfere with a clear shot of the action) and then wrap extra layers around the remainder of the camera. The string of shots on this page were shot in this manner using an SLR set in rapid-fire mode.

The shower scene: My model and I put on swimsuits and jumped into the shower together to record the shots for these two pages. During the photoshoot, I was reminded of a bumper sticker I saw during a recent water shortage; it read, "Save water, shower with a friend."

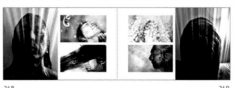

268

269

A pocket digital camera was sealed inside a waterproof housing to record the photos on this spread. The action in the four central images was frozen by using the camera's flash. (What looks to our eye to be a continuous stream of water coming from the showerhead is apparently a steady stream of water blobs—who knew?) The two outermost images were shot without the camera's flash. (In these two photos, the water appears more as it would to the eye.)

As though reaching through a silvery mirror, a pair of hands reach into a fish tank (filled with water, but empty of fish). This photo was taken by filling a fish tank with water, setting it on a stool, having the model extend his hands into the water and aiming the camera toward the fish tank from below. A sheet of silver paper was placed behind the fish tank to hide the model's body.

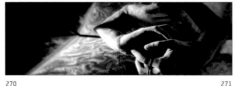

270

271

Viewed from certain angles, the surface of water loses its qualities of transparency and acts as a mirror. From other angles, water is so transparent the eye has trouble even knowing it's there. Interestingly, this photo was taken under conditions that allowed water to exhibit these opposing visual states at the same time (a few tiny bubbles on the subject's arm provide the only real clues that this is an underwater scene).

16

Word Play

Given the rise of digital media, and the ease with which words and pictures can be combined, it's a wonder there are still so many photographers who have never explored ways of adding text to their pictures. There is literally no end to the ways in which software can be used to bring letters, words, sentences, poems and stories into the same frame as a photographic image.

Many photographers are far more comfortable shooting pictures than they are with composing lines of poetry or prose. If that's true of you, consider forming a partnership with someone who is as competent with a pen as you are with a camera. How about collaborating to come up with a series of intriguing word-and-image compositions?

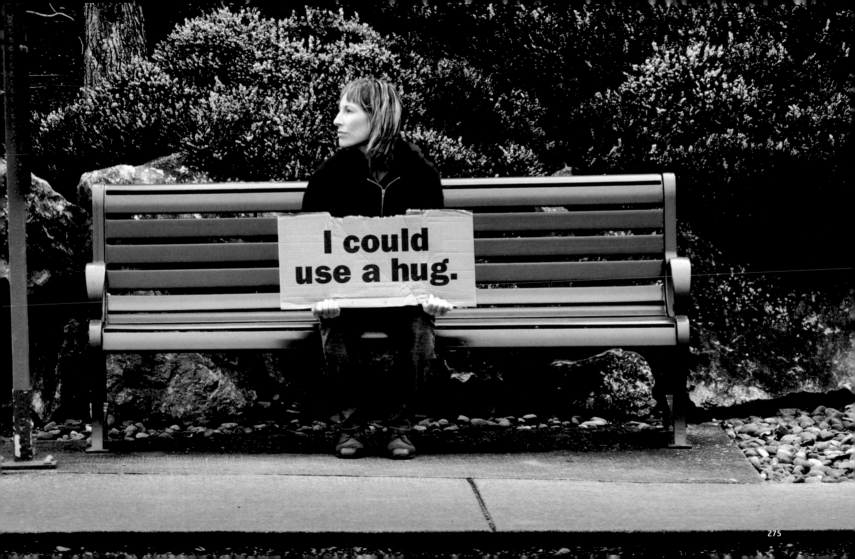

twist
and
shout

NW SCHOOL OF MODERN DANCE

jump
and
jive

NW SCHOOL OF MODERN DANCE

rock
and
roll

NW SCHOOL OF MODERN DANCE

playlist: it might be a while (3:31) everyone i've never met (4:45) i wish i could say (2:59) the blindfolded leading the blind (6:23) a risk i'll have to take (3:17) north by west by now (1:20) you don't say, or do you? (3:44) let's just leave it at that (2:22) all songs © 2010: the sock monkeys and michael mantis productions

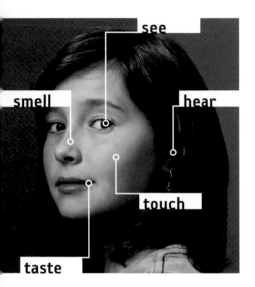

june 25 • Bellingham

CUSTOM AUTO SHOW

Downtown Arena 5

KEEPING IN TOUCH

My cellphone died last Friday evening. Its death was unexpected, preventable and entirely my fault. Without going into detail, let's just say I should have waited until *after* my shower before checking for text messages. As it turned out, it would be Tuesday of the following week before I could get a replacement. That meant going for three-and-a-half days without a phone. This, for me, was no small thing. You see,

Supercali

Can't wait
to see you.

Is that you?

Wish I
was here,
and you
were, too.

Mind if i drop in?

Come play with me

on my birthday

A bird can fly.
So can I.

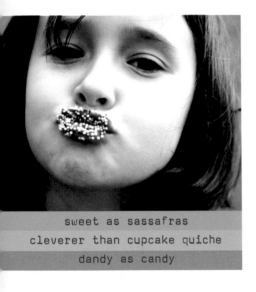

sweet as sassafras
cleverer than cupcake quiche
dandy as candy

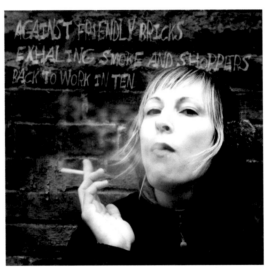

AGAINST FRIENDLY BRICKS
EXHALING SMOKE AND SHOPPERS
BACK TO WORK IN TEN

HOMES BEHIND LETTERS
ROOMS WITH A VIEW OF HAIKU
TENANTS UNDER TYPE

It's like I've reached. The small round birds
that don't fly away. As though if you looked
away & back again they might be gone
but never are. Tight toes gripping
the fence so hard. Winds here blow
trees into houses. But. Not. These birds.

Diane Ripper

POEM BY DIANE RIPPER

Words sometimes appear in the periphery of a photograph. Other times, they show up in center-of-attention roles (as in the case of this image). Words also appear on the clothing of people within a photo, and as part of background elements like signage or graffiti. Words can also be added digitally—either within, over the top of or alongside a photographed image. Examples of all these text-and-image incarnations—and more—are featured in this section.

274

275

Thank goodness for Photoshop. It was cinch using a text layer to add words to the blank sheet of cardboard my model held for this shot (hand lettering or silkscreening the font would have been far more costly—both in terms of the time and the money required). Another perk of adding text *after* the photo was taken was that I was able to think about the message I wanted to add to the scene—and try out a few different options—before committing to something final.

Going commercial: On the near page, a trio of images from chapter 6 have been used as backdrops for a set of layouts for promotional banners. On the far page, a photo from chapter 1 appears as a backdrop for a list of songs on the back of a CD package. If you are a camera-carrying graphic designer, there is no end to the ways in which your photographic skills can be paired with your design know-how.

276

277

As any graphic designer could tell you, there are infinite ways of combining text with images. Not only are there endless typefaces to consider, there are also countless ways of positioning text in ways that visually connect words with an image. If you are new to the notion of adding text to images, and would like to become better acquainted with the possibilities, begin by taking note of advertisements and other visual material that feature photos and text together. Learn through observation and hands-on practice.

Glitz by association: A model sneaks a peek into a scene that comes pre-captioned with a complementary word in the background. Keep your eyes open for interesting billboards, signs, street markings and graffiti. Consider using your pocket camera to snap photos of these textual and symbolic messages wherever you find them; snapshots like these can serve as reminders of possible shooting locations for future portraits.

278

279

What about making the words, symbols or messages on your model's attire the focus of your photo? How about shooting a "portrait" of one of your subject's favorite logo- or word-bearing shirts or accessories?

A set of labels (also known as call-outs) has been added to the first photo on this page. How about enhancing a photo of your own with informative, descriptive or humorous labels? What about using a symbol or an illustration—instead of words—to convey your subject's thoughts (as seen in the middle image). The type in the third image has been rotated and treated using Photoshop's PERSPECTIVE tool.

280

281

Photographs are constantly finding their way into advertisements, articles, brochures and promotional material of all kinds. Many graphic designers pull their images from online sources (often referred to as "stock image" sites). Consider looking into the processes by which stock-image companies go about reviewing and accepting submissions from photographers. In particular, aim for sites that carry images that are in sync with the types of photos you shoot.

Need something to say when there's nothing to say? According to the 1964 Disney film *Mary Poppins*, the word you're looking for is "supercalifragilisticexpialidocious." An extremely condensed typeface was used to squeeze all thirty-four letters of this mega-word into this spread (they're all there—though about half the letters are hidden between model's ears).

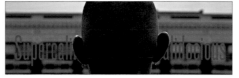

282 283

The creative possibilities are infinite when typography meets photography. You are probably well aware of the endless range of conveyances and messages that can be achieved using the camera. Are you also aware of the scope of expression available through fonts? If you enjoy combining words and images, consider expanding your collection of typefaces to include a serviceable assortment of styles. There are numerous online font resources.

Not to put down the images on store-bought cards, but don't you think your friends and family would really rather see *your* photos on cards from *you*? If you have a good quality ink-jet printer, you can easily print cards in advance of upcoming events—or spontaneously, if an event takes you by surprise.

284 285

Feeling entrepreneurial? What about creating sample greeting and holiday cards and seeing if local shop owners are interested in offering them for sale? If you do get orders for your custom-made cards, be sure to print your website on them—it just might lead to some freelance photo assignments.

The opening lines from the children's book *I Can Fly*, (published in 1951 by Ruth Krauss and Mary Blair) caption this image. The typographic message has been positioned within the scene as though it were a quiet but firm thought rising from the subject's head.

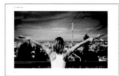

286 287

Any Scrabble junkies or crossword aficionados in the house? Here's a project idea for you: Create a set of photo-and-text images that highlight some of your favorite little-known and seldom-used words. How about creating a handmade coffee table book or a set of flash cards based on this idea? The words' definitions could be printed below (or on the backsides of) the images for the benefit of viewers who are attracted to the photos *and* the idea of expanding their vocabulary.

How about haiku? The first line of a typical English-language haiku contains five syllables, the second contains seven, and the third contains five. What about captioning some of your photos using this age-old form of poetry? Explore different ways of linking your text and image. Should your haiku verses be printed below or alongside your photo? How about integrating them into the image itself (as seen in these samples)?

288 289

Do you write poetry or know someone who does? What about looking through your cache of photos and tagging images that might pair well with a poem or a few lines of prose? To improve the readability of the text in this image, the photo was darkened in the area beneath the text using a masked CURVES adjustment layer. You may need to similarly restrain the contrast in a portion of your image if you want to add text over the top of it.

17

Multiple Personalities

The main goal of this book is to spark picture-taking ideas in the mind of the reader. And, in order to convey this goal in its clearest, most uncluttered form, the majority the images in *Photo Idea Index: People* feature just one person.

This chapter is the only one in which all three models appear together. The purpose of this section is twofold: to help generate ideas for multi-person photoshoots, and, just as important, to serve as a reminder that the conceptual and technical ideas that have been applied to this book's single-person photos are just as relevant to images that contain two or more people.

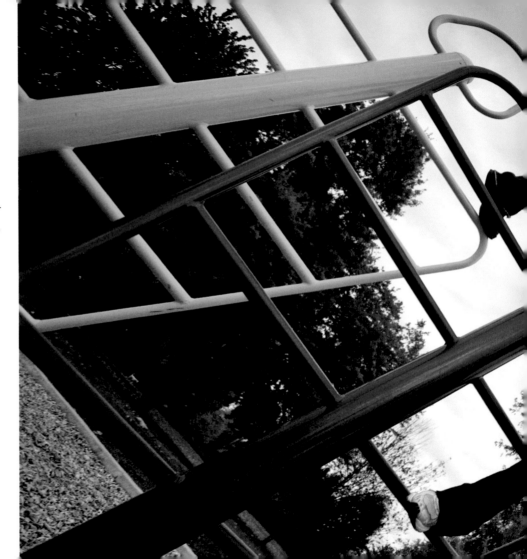

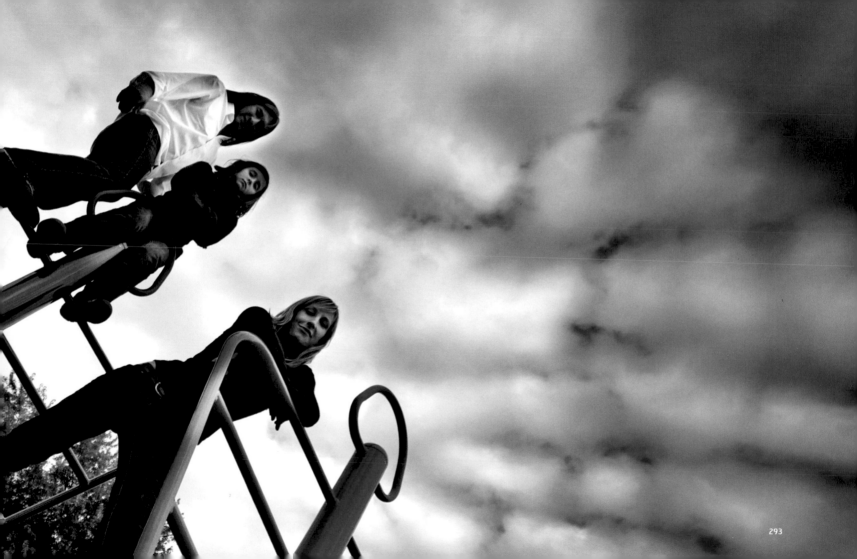

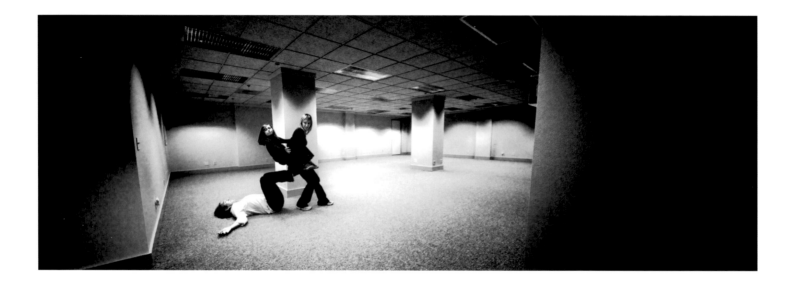

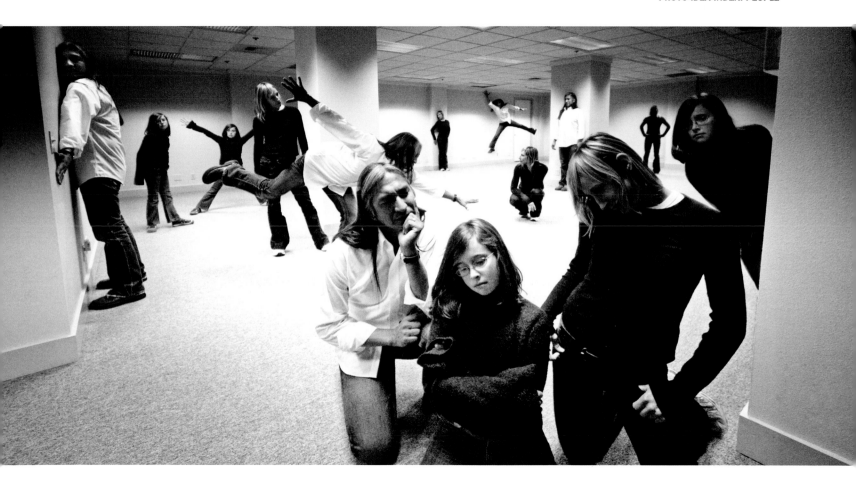

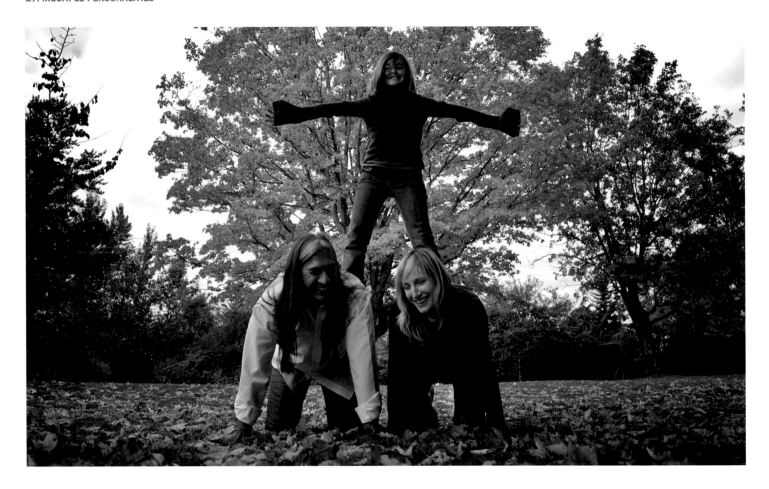

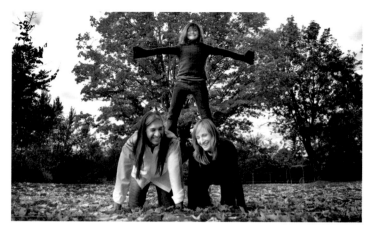

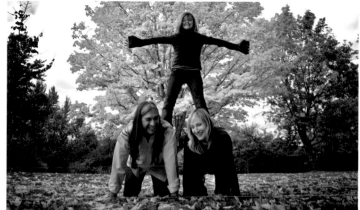

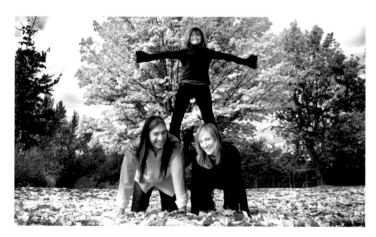

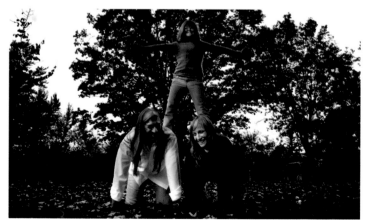

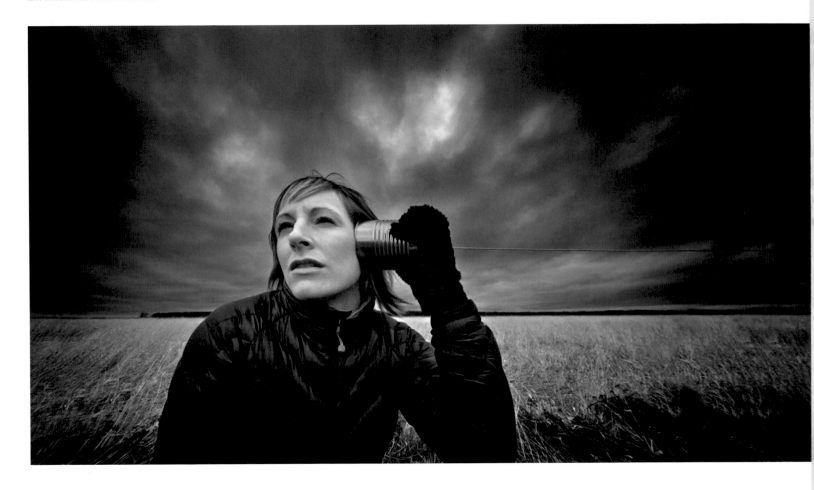

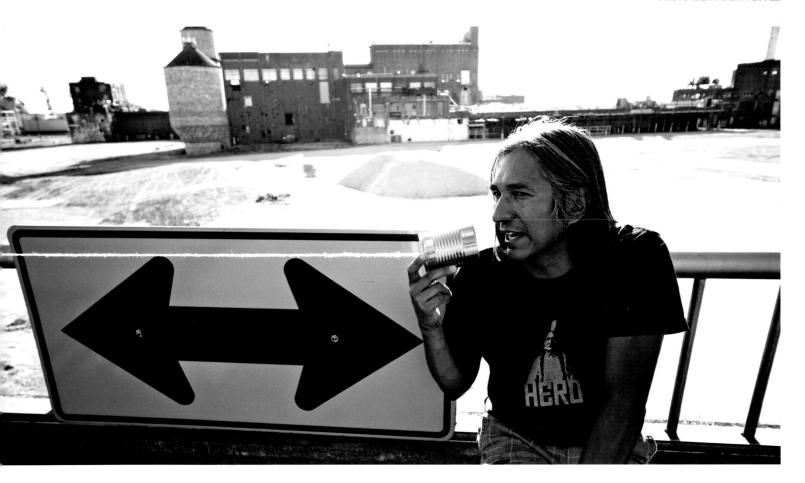

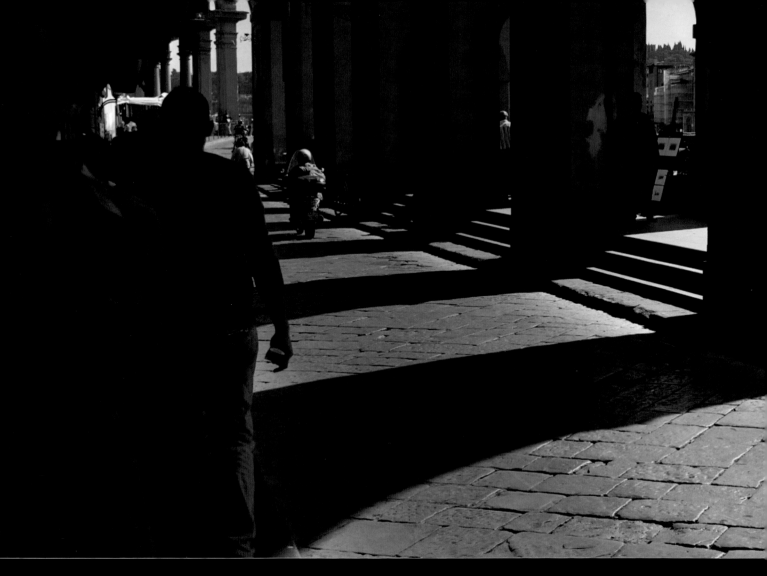

314

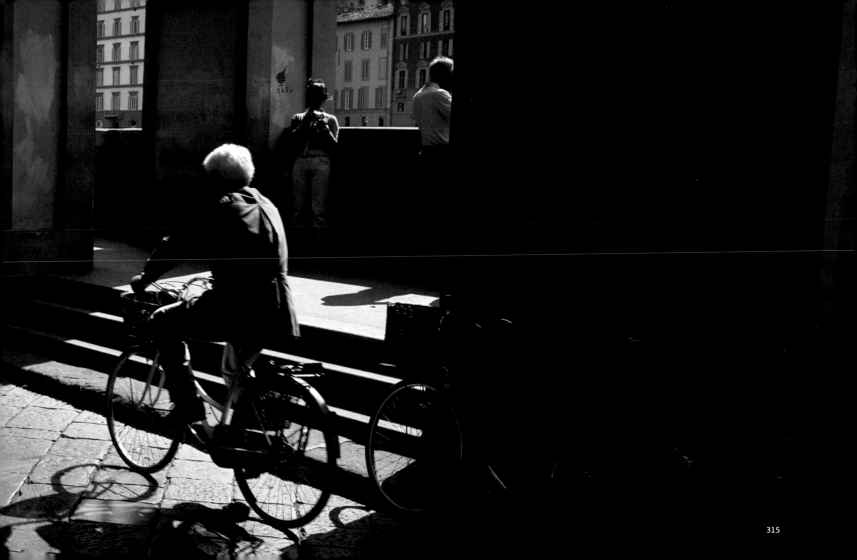

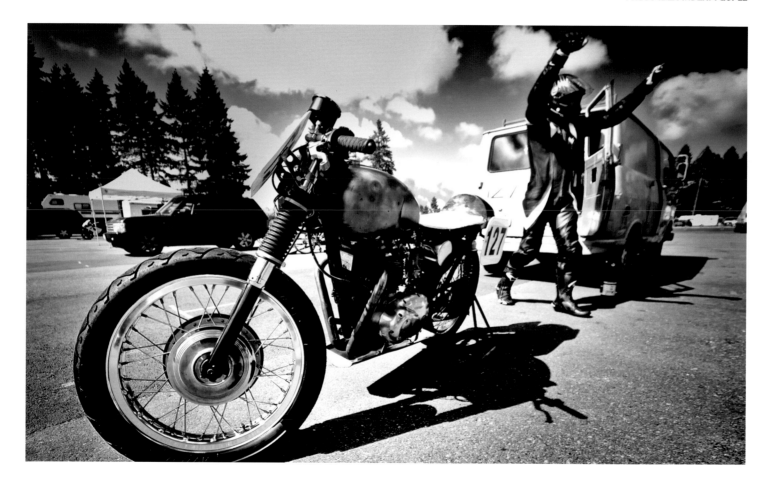

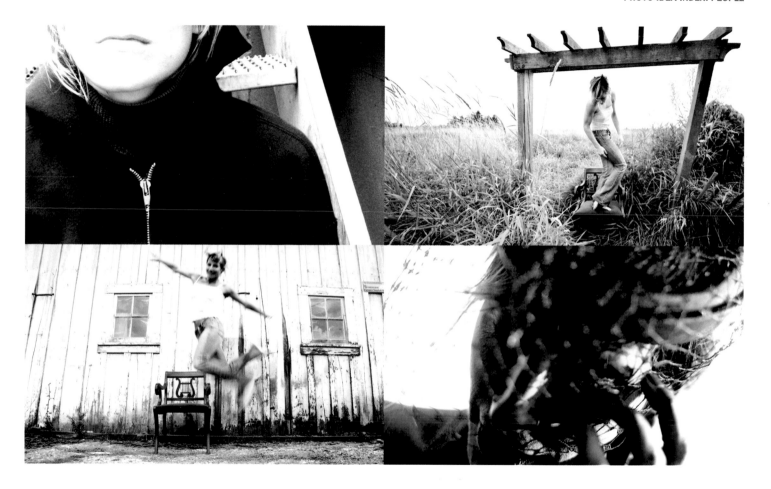

19

Hints of Humans

Ever been spooked by the human-like silhouette of a tree in a dimly lit forest? Ever had your attention snagged by a mannequin in a window (and then done a double take to see whether or not it was a real person)? And what about statues? Have you ever been delighted or moved by a piece of wood, stone or plastic that had been sculpted into the form of an amusing, beautiful or poignantly engaging human? For most of us, this sort of thing happens regularly enough; a hyper-awareness of the human form seems to be hard-wired into our brains as a matter of design.

If you enjoy taking pictures of people, consider adding this category of photos to your cache of collected images: photos that convey the *idea* of people without necessarily featuring any.

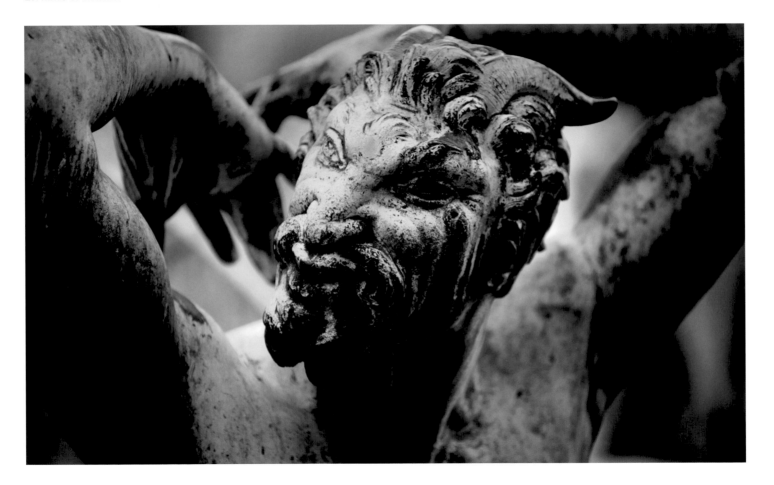

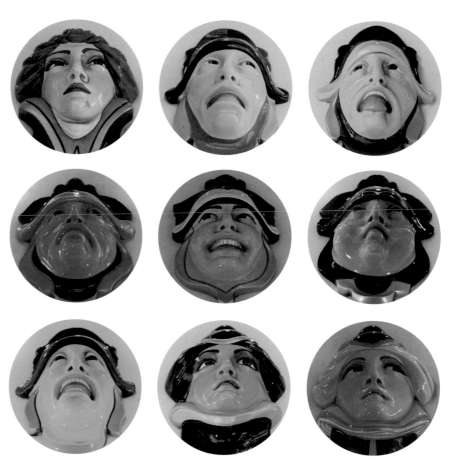

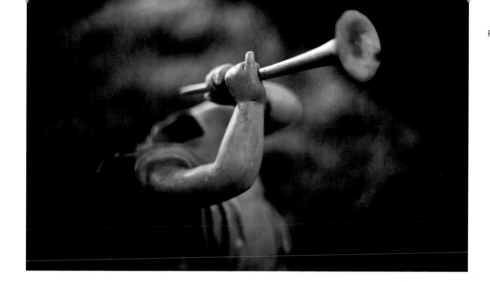

During a week-long visit to Charleston, South Carolina, I passed this building several times before noticing the two headless figures keeping watch from its upper-floor windows. A note to self (that you may want to apply to *yourself*): When traveling through cities with your camera in hand, keep your eyes moving side to side *and* up and down in search of photo opportunities.

328

329

Stark, minimalist and modern: Fine-arts photographers have been known to fill galleries with images featuring understated visual and conceptual content. Graphic designers, too, often find particular value in photos of this kind—as when they are able to pair them with similarly unembellished works of journalism, advertising, prose and poetry.

Rare is the downtown setting that does not offer an abundance of inanimate subject matter capable of delivering unmistakable connotations of living, breathing people. What about trekking through a downtown environment for a morning or afternoon with the specific purpose of noticing—and photographing—material of this kind? Do this a time or two and you'll find your awareness of this type of subject matter forever sharpened.

330

331

Some scenes practically beg to be photographed and captioned by a clever (and/or twisted) mind. How about setting up a folder on your hard drive for photos that seem ready-made for a sassy greeting card or a humorous piece of correspondence?

This page features one of the many intriguing characters sculpted by Bartolomeo Ammannati (1511–1592) that encircle the grand Fountain of Neptune in Florence's Palazzo Vecchio. One advantage of photographing expressive sculptures (as opposed to taking pictures of expressive people) is that beings of stone and bronze hold their poses much longer—and with greater patience—than their flesh-and-blood counterparts.

332

333

Here, a collection of colorful personalities have been cropped from photos taken of the sculpted characters that cap an antique merry-go-round in Santa Barbara, California. Photoshop's BLACK AND WHITE effect was used to convert the original images into strongly tinted monochromes (one original is featured to the left of the circular photos on this page).

A pair of sandals lie in the damp grass among leaves and party debris the morning after an outdoor reception. The discarded footwear conveys a reminder of the prior evening's events even though its participants have departed. The inhabitant of the adjacent photo (an image borrowed from page 153) has been converted to a colorless void after her form was selected and deleted using Photoshop's LASSO tool.

334

335

A human being's presence within a photo can be established— even if the only visual evidence of her participation in a scene is a pair of ankles and feet. In this image, a well-dressed dog hangs out with his chaperone at a Halloween dress-up party. More photos featuring glimpses of humans can be found in chapter 4, Parts and Pieces.

Empty chairs, vacant tables, hanging laundry, resting mopeds, moving cars and congregating shadows: The images on this spread are inhabited by suggestions of humans, rather than by actual people. Imagine filling the pages of an entire album with photos that deliver only conveyances of people and their habitat. What about covering an entire wall with images of this kind?

336 337

Capturing people-free photos in a place favored by travelers often means getting out of bed an hour or two before throngs of tourists have done the same. It may also mean waiting patiently until a break in the flow of humanity presents an unpopulated view of an interesting scene.

Life at ground level: A discarded bicycle frame, some unwanted building supplies and a bin of recyclables have been carried around back by the occupants of this downtown apartment. The scene caught my eye as a nice aesthetic mix of lines, shapes, tones and textures. The inherent suggestions of human participation in the composition's structure add notes of relevance and interest to the scene.

338 339

From on high: The red-tiled rooftops of Florence, stretching nearly as far as the eye can see, carry with them conveyances of generations of human inhabitants. A 12–24mm wide-angle lens was used to capture this expansive view just before sunset from the top of Giotto's tower. The photo on page 321 was also recorded from this elevated viewpoint.

Images of the afterlife: Cemeteries and graveyards are rich with stories—some etched in stone, most left to the imagination. This photo on this page and the lower image on the opposite page were both shot in cemeteries in the heart of historic Charleston, South Carolina. The upper image on the facing page was taken at a cemetery in northwest Washington.

340 341

After being converted to monochrome, the perimeter of the far image was blurred to give it a look reminiscent of an archival photo shot with an imperfect lens. The effect was accomplished by creating a blurred duplicate of the photo's base image. A mask was added to the blurred layer, and the BRUSH tool was used to control where its effects were applied. To further enhance the aged look of the photo, the BRUSH tool was used to paint a subtle transparent "stain" around portions of the picture's edge.

On this spread, the final set of images in *Photo Idea Index: People* are presented with the following suggestion: Don't forget to consider adding a piece of *your*self to some of the pictures you take.

342 343

On this spread, my thumb is inserted into gap in the mountains at Joshua Tree National Park; my body is reflected inside the frosty environs of a holiday ornament; my tennis-shoe-clad feet stand atop the cobbles in a Florentine piazza; and my shadow bids farewell from an ages-old vineyard in Italy's Cinque Terre.

Glossary

Note: Any Photoshop controls, functions or tools are denoted by the use of SMALL CAPS.

ADJUSTMENT LAYER. A layer added to an image in Photoshop to alter characteristics such as contrast, levels and color balance. Alterations made using an ADJUSTMENT LAYER can be revised by double-clicking on it in the LAYERS palette and readjusting its controls (an option that would not be available if the original adjustments had been applied directly to the image using a menu command). ADJUSTMENT LAYERS can also be selectively applied to an image. This is done by using the BRUSH or other rendering tools to create regions of varying opacity in the MASK layer that automatically accompanies an ADJUSTMENT LAYER when it is created. Consult Photoshop's help menu or manual for detailed information about these useful and easy-to-use image-editing tools.

Aperture. The adjustable iris-like opening inside a camera lens that controls how much light reaches the image sensor. Some cameras allow for manual control of the aperture opening—others handle its functions automatically. Aperture affects both exposure and depth of field.

Backlighting. A lighting arrangement where the subject is between the camera and the light source.

Bracketing. A technique of taking a set of photos—each shot at a slightly different exposure—to help ensure that at least one is properly exposed.

Most brackets are shot in sets of three images. Full-featured digital cameras usually offer an automatic bracketing feature that shoots a burst of three differently exposed shots when the shutter button is pressed.

CHANNEL MIXER. An editing tool in Photoshop that allows the user to adjust the distribution of red, green and blue in an image. These color channels can also be isolated—by selecting the CHANNEL MIXER's "monochrome" option—as a way of converting an image to black and white.

CMYK. Abbreviation for cyan, magenta, yellow and black. For most printing purposes, images need to be converted from their native RGB mode to CMYK via software.

Continuous-shooting mode. A feature of many digital cameras that allow them to take a steady stream of shots while the shutter button is held down. (Also referred to as rapid-fire mode.)

Crop. To select only a desired portion of an image for display.

CURVES. A highly adjustable Photoshop control that allows the user to control the distribution of values and hues within an image.

Depth of field. The zone in which the camera sees things as being in focus. Objects outside this zone (both nearer to and farther from the camera) appear out of focus. Depth of field is the product of several factors:

the focal length of the lens being used; the distance to the object being focused on; and the aperture opening (a narrower opening means a deeper depth of field; a wider opening means a shallower depth of field).

Desaturate. To remove all color hues from an image. Full desaturation results in a black-and-white image.

Exposure. The amount of light that reaches the image sensor to create an image.

Fisheye lens. A lens with an extremely wide field of view—from 100° to 180° and beyond.

Framing. A visual term used to describe when certain elements of a composition enclose others.

Grayscale image. Another term for a black-and-white image.

Hue. Another term for color.

HUE/SATURATION. A control within Photoshop that allows for adjustments to the color, intensity and brightness qualities of a specific hue—or all hues globally—within an image. These adjustments can be applied directly to an image through a menu command or through an ADJUSTMENT LAYER.

LASSO TOOLS. A family of tools within Photoshop that are used to manually select elements with clipping paths.

LCD. Abbreviation for liquid crystal display. A panel on the back of most digital cameras that can be used as a viewfinder, and to review images and control menu items.

LEVELS. A control within Photoshop that allows adjustments to be made to an image's range of values and color balance.

Macro lens. A lens specifically designed to take close-up photos. Most macro lenses have a magnification ratio of 1:1 or greater.

Monochromatic. An image or scene composed of values of one hue.

Overexposure. The effect that occurs when cells of the image sensor receive so much light that the corresponding areas of the image are pure white. Some photographers consider overexposure unacceptable in images—others allow it for visual or thematic effect.

Pixel. A single cell within the complex grid of individual hues that make up an image captured by a digital camera.

Resolution. The level of detail recorded by a digital camera. Also, the level of detail present in an on-screen or printed image.

RGB. Abbreviation for red, green and blue, the three colors with which digital cameras and computer monitors build images. Images in RGB format can be converted to other modes (such as CMYK) using software.

Saturation. The intensity of a hue. Highly saturated colors are at their most intense. Colors with low levels of saturation appear muted.

SHADOWS/HIGHLIGHTS. A control within Photoshop that allows the user to bring out details within overly dark or overly light areas of an image.

Shutter speed. The duration of time the shutter is open (and thereby allowing light to reach the image sensor) during a shot.

SLR. Abbreviation for single lens reflex. A camera whose viewfinder sees through the same lens that will be sending light to the image sensor. The lenses on most SLRs are interchangeable.

Standard zoom lens. A versatile lens that has a field of view comparable to the human eye's central viewing area. This lens is also capable of moderate image magnification.

Telephoto lens. A relatively compact lens capable of a wide range of telescopic magnifications.

Underexposure. The effect that occurs when cells of the image sensor have not received enough light to fully portray the corresponding areas of an image.

Value. The relative lightness or darkness of a color or shade compared to a scale of white to black.

Visual texture. A dense repetition of elements that form anything from an organized pattern to a freeform, chaotic assemblage.

White balance. The way in which a camera measures and records prevailing light so that whites—as well as all other colors—appear normal to the eye of the viewer.

Wide-angle lens. A lens with a broad field of view.

Thank you for taking a look at *Photo Idea Index: People*.

Happy picture taking,

Jim K.

The following is a list of the cameras and lenses used for this book's images.

CAMERAS:

Canon 5d Mark II

Canon 20d

Canon S5IS

Canon SD500

LENSES:

Canon 50mm 1:1.4

Canon 15mm 1:2.8 Fisheye

Canon 100mm 1:2.8 Macro

Canon 24–105mm 1:4

Sigma 12–24mm 1:4.5–5.6

Canon 70–200mm 1:2.8

Lensbaby Muse

Lensbaby Composer

Custom–made pinhole

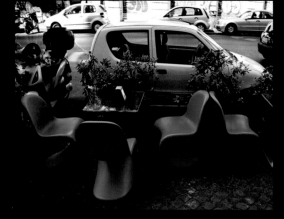

Sample images from this
book's companion volume
Photo Idea Index: Places

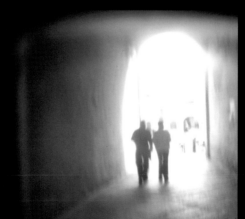

Sample images from this
book's companion volume
Photo Idea Index: Things

Get the two companion books to *Photo Idea Index: People*!

Photo Idea Index: Places

In *Photo Idea Index: Places*, Jim Krause will help you find inspiration in sweeping views of natural and man-made environments, as well as intimate shots of intriguing detail. Learn new shooting techniques—both on-site and post-shooting digital treatments—so you can train your eyes to look for unique shots and remarkable compositions.

#Z1590, 360 pages, paperback, ISBN: 978-1-60061-043-1

Photo Idea Index: Things

In *Photo Idea Index: Things*, you'll be inspired by a vast assortment of photos of household objects, plants, animals, machines, architectural details, treasure and trash. You'll learn how to use your camera to explore the world around you from different perspectives and how to capture awe-inspiring digital images.

#Z1591, 360 pages, paperback, ISBN: 978-1-60061-044-8

These and other fine HOW Books are available online or at your local bookstore.